For my sister, Mary, who has stood by me
throughout the years.

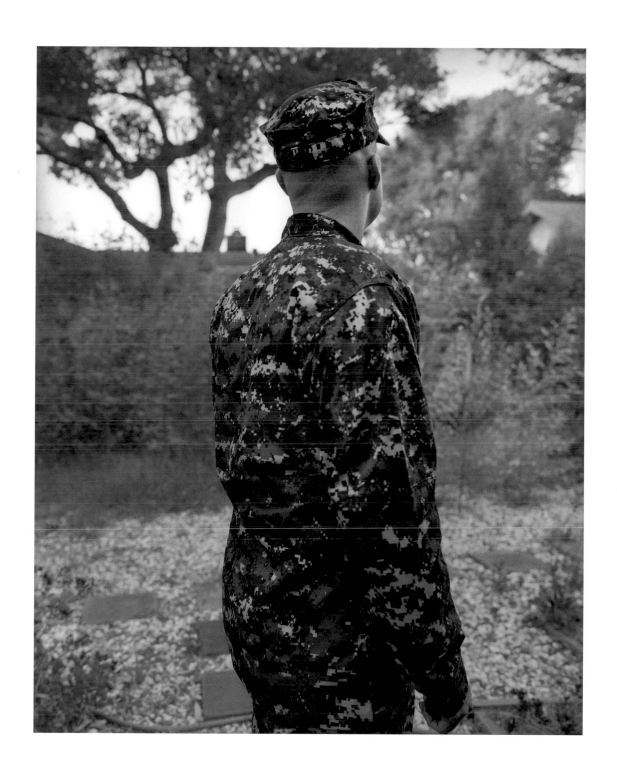

GAYS IN THE MILITARY

PHOTOGRAPHS AND INTERVIEWS
BY VINCENT CIANNI

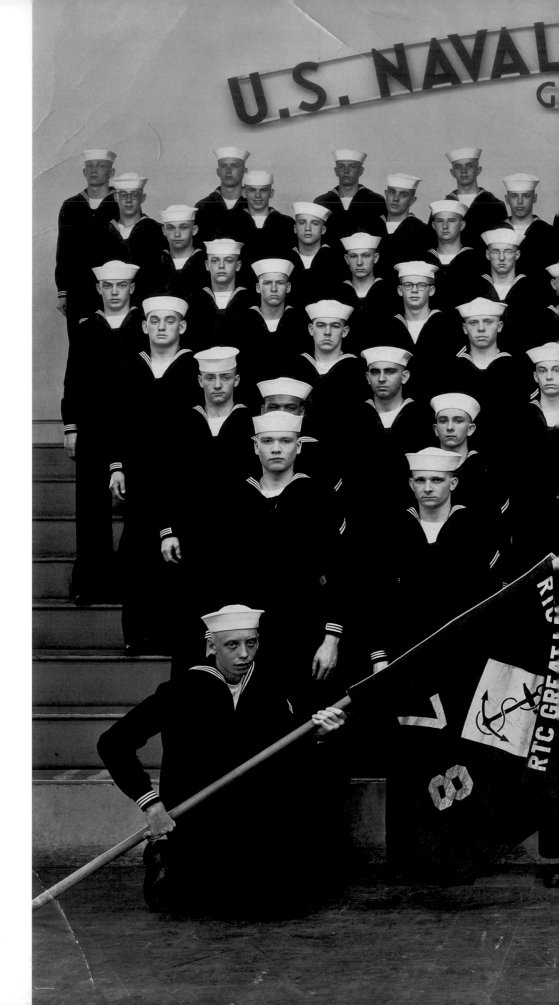

Unidentified photographer, official U.S. Naval Training Center photograph, Great Lakes, Illinois, 1962

This photograph is being used for reference only. No inference, explicit or otherwise, of sexual orientation is being made of anyone in this photograph.

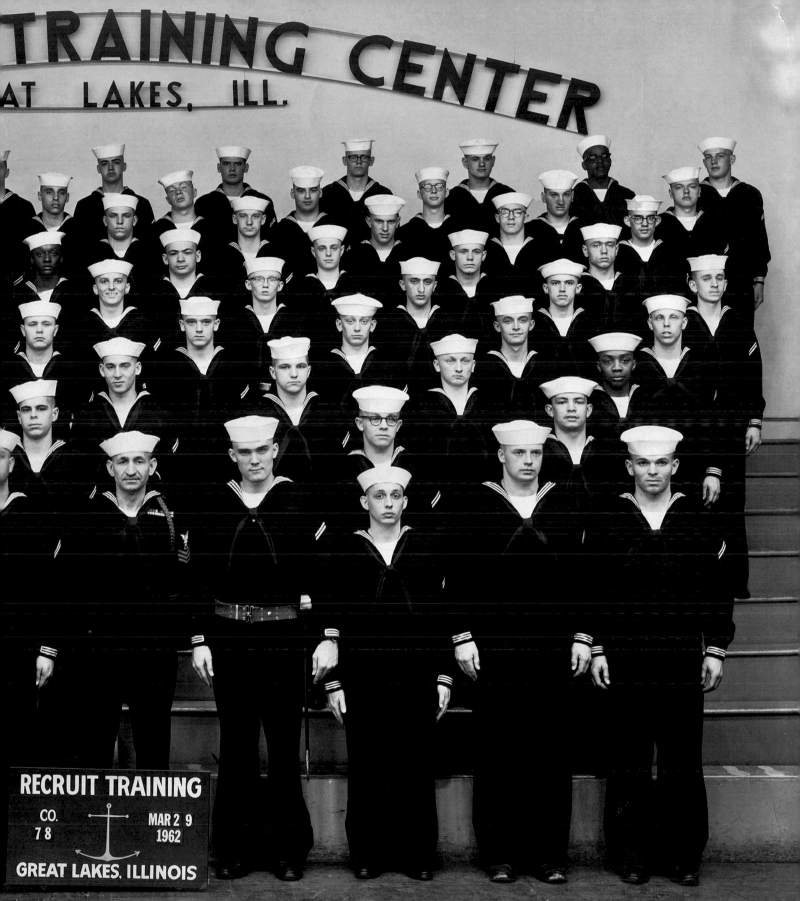

TRAINING CENTER
AT LAKES, ILL.

RECRUIT TRAINING
CO. 78
MAR 29 1962
GREAT LAKES, ILLINOIS

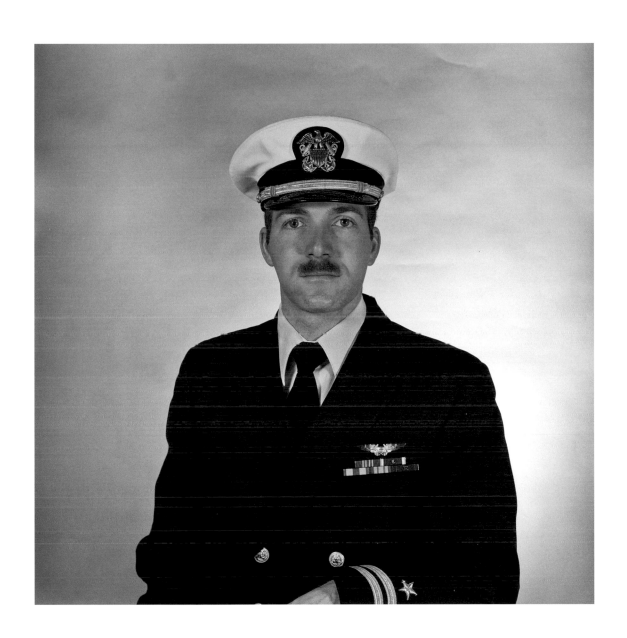

Dear Sir:

I am appealing the recommendations made by the Review Boards Office at Randolph Air Force Base, Texas, whereby they recommend denying my request for issuance of the Air Force Good Conduct Medal. I base my appeal on the following:

Criteria: " The medal is to be awarded to Air Force enlisted personnel during a three-year period of active military service OR for a one-year period of service during a time of war. Airmen awarded this medal must have had character and efficiency ratings of excellent or higher through the qualifying period including time spent in attendance at service schools. There must have been no convictions of court martial during this period."

The Review Awards Office fails to recognize the alternative period of one year war time service for which I qualify. Unless the Review Awards Office fails to recognize Vietnam as a war in direct contradiction to numerous other U.S. Agencies, then the applicant qualifies as for the required time period.

My first two years of active duty with the USAF were so successful that I was nominated by my Commanding Officer with concurrence from the Wing Commander, to assume duties as a bodyguard for Lt. General Pitts, Commanding General for the Strategic Air Command, and his Vice-Commander. I came in second in the selection process and was not selected. All of my APR's were of the highest caliber as the previously sent official communication serves to prove. (See the record)

Please note that this action took place well after the completion of my first two years of outstanding service during war time. When I said that being in the Air Force would lead to my acting out on my sexuality, I was made the Wing NCOIC for two bases for equal opportunity; a position I served in until my discharge. Ironically, it was during this period that other Airmen called the hotline on base and talked about being gay because word has spread that I was leaving and why. I personally prevented at least two suicides that were being contemplated and can be verified in official records maintained at the base for that time period.

The ban on gay and bi-sexual men was wrong then and is just as wrong now which is why DADT was finally overthrown as an regulation of mental repression. The ban on gay and bi-sexual men did nothing but create potential mental health issues with armed men who were entrusted with the security of nuclear weapons.

At no time, was I ever a discredit to the USAF. In fact, the Wing Commander at RAF Bentwaters in England, was going to assign me as his aid because of his promotion to the rank of General. I cannot tell you how much I resent the classification by the "Review Boards Office," of my service to this country in the Air Force not to mention my honorable service in the United States Navy prior to my entrance into the USAF, as having been "marred." If the ban on gay and bi-sexual men had not been in place, I would have retired from the Air Force.

I request again, that the Good Conduct Medal be awarded as earned under the provisions outlined above. If this request is further denied, I intend to take this issue national and make it political.

Respectfully,

Bruce Simpson

Bruce Simpson

264 East Main St.

Wilkes Barre, PA 18705

SILENT, CELIBATE, AND INVISIBLE

Alan M. Steinman, MD

I served our nation proudly for twenty-five years in the U.S. Public Health Service and U.S. Coast Guard. For nearly all of that time, I was a medical officer in the Coast Guard, ultimately achieving the rank of rear admiral and serving as the Coast Guard's director of health and safety. During that entire period, I remained "in the closet"; I did not reveal my sexual orientation to anyone in the Coast Guard, nor even to my family. But I was not alone in suffering the indignities of hiding my true self. Hundreds of thousands of gay and lesbian service members over the years shared with me the constraints the military imposed upon us in order to serve our country. In this book, the reader will meet some of those patriotic Americans.

The effects of the laws and policies banning gays and lesbians from serving in the military were deliberately draconian. They could not have a family; they could not share their lives with loved ones; and they were denied the opportunity to enjoy all the rights and privileges taken for granted by their heterosexual counterparts. Even though they put their lives on the line just as did their straight peers, the law required them to be silent, celibate, and invisible. Although they performed the same duties and shared the same risks, they could not be honest with their peers or with their commands. They could not honestly seek medical or spiritual counseling for their emotional problems. They were forced to violate the very precepts of integrity and honor that comprised the core principles of each of their services' code of behavior, instilled in them from the instant they joined the military.

And finally, they had to constantly live in fear that at any time, someone might find out who they really were and cause their discharge from the military, terminating their career. This meant that every telephone call, every e-mail, every photograph of a loved one, every casual conversation about what they did in their off-duty time or in their private lives had to be severely guarded lest the wrong person discover their hidden truth.

When Don't Ask, Don't Tell (DADT) was enacted into law in 1993, it was founded on the assumption that there exists in the military sufficient antipathy toward homosexuals that the mere knowledge of the presence of a gay, lesbian, or bisexual service member would degrade unit morale, unit cohesion, and combat readiness. This assumption was never supported by either academic study or objective data. On the contrary, a 1993 Department of Defense-sponsored study from the Rand Corporation found that allowing gays and lesbians to serve openly would not likely result in deleterious consequences. Despite these findings, Congress passed the DADT law and put into place a dark chapter in our nation's civil rights history.

Over the years that DADT stayed in effect, an entirely unanticipated development gradually gained force: gay and lesbian men and women began to come out to their peers, and it wasn't proving to be a problem for unit morale, unit cohesion, or combat readiness. By 2005, so many known gays and lesbians were serving that a Zogby International poll of Iraq and Afghanistan war veterans found that an overwhelming majority said they

had no problem working with their gay and lesbian peers. By 2010, the number of known gays and lesbians became such a force that the Department of Defense's Comprehensive Review Working Group (evaluating the potential impact of repealing the DADT law) concluded that gays and lesbians could serve openly without compromising military morale or operational effectiveness. This finding was dramatically exemplified in the following statement by a Special Forces warrior, highlighted in the Department of Defense study and repeated by President Obama at the 2011 signing ceremony repealing the DADT law: "We had a gay guy in our unit. He was big, he was mean, and he killed lots of bad guys. Nobody cared that he was gay."

The increasing visibility of gay and lesbian warriors in the nation's military without any negative consequences was the single most important reason that DADT was finally repealed. Vincent Cianni's photographic essay on gays in the military contributed to the recognition that real people with valuable skills and experience—indistinguishable from their straight counterparts and not some stereotype gay bogeyman—comprise those serving on active duty and in the reserves. This book will thus take its place among the documentary evidence of a significant milestone in our nation's military history: equality for gays and lesbians in the nation's armed forces.

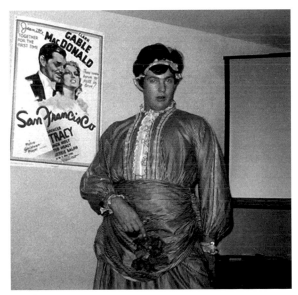

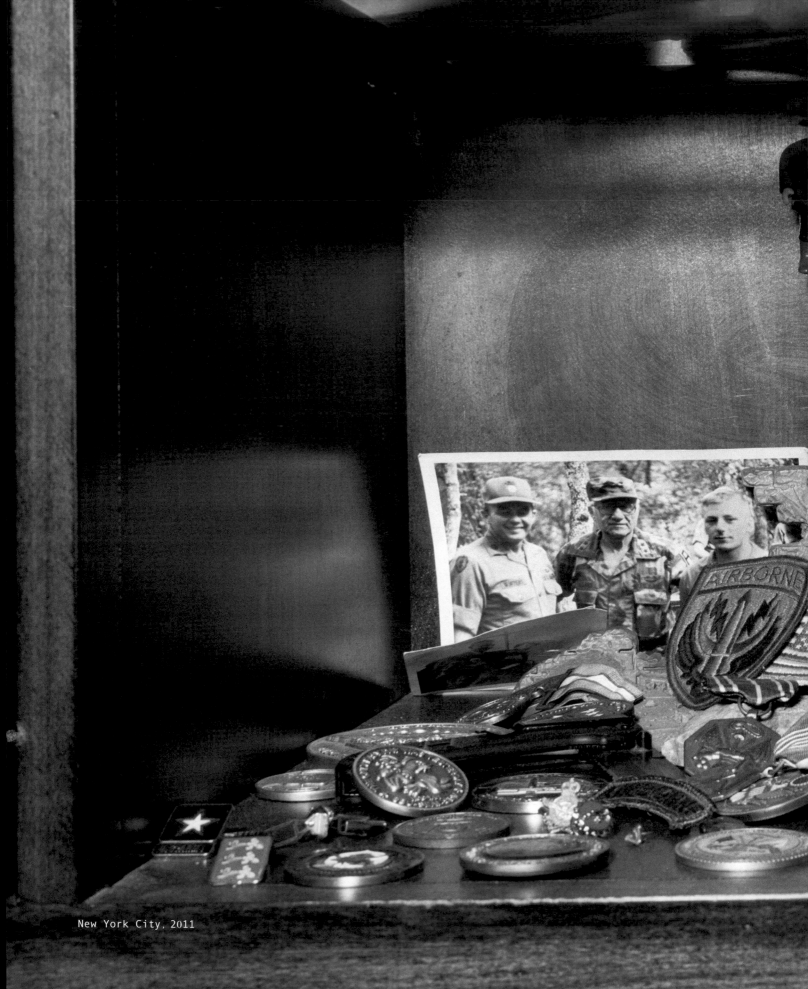

New York City, 2011

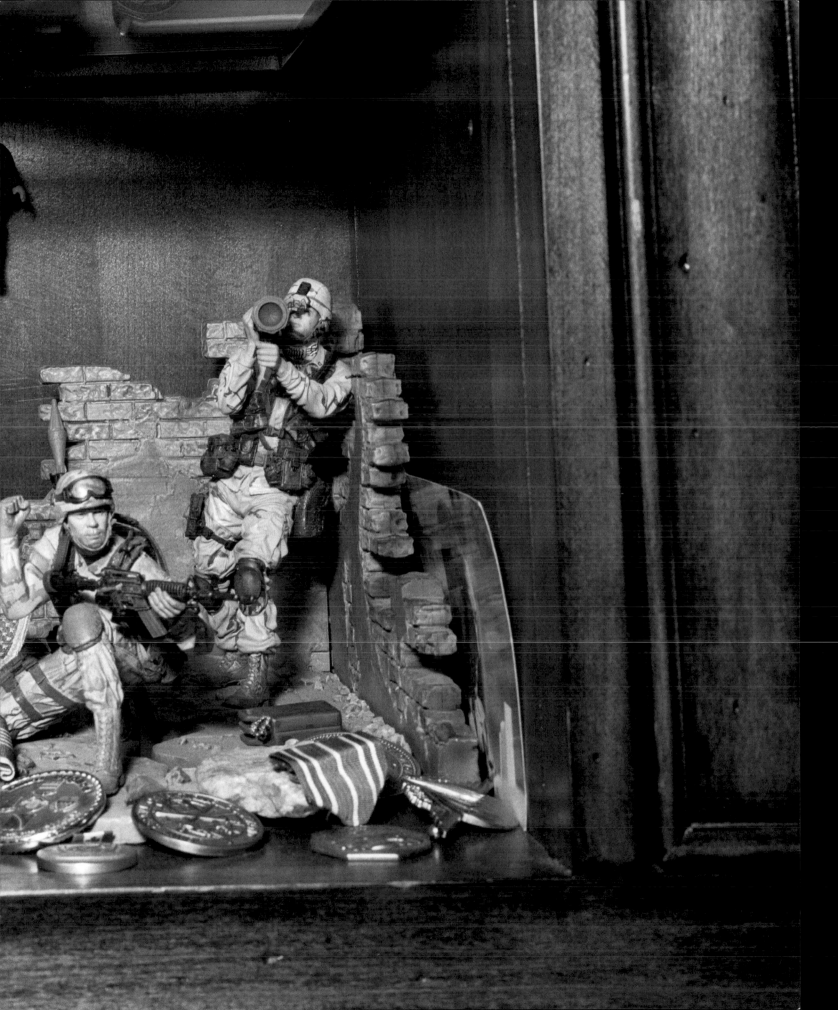

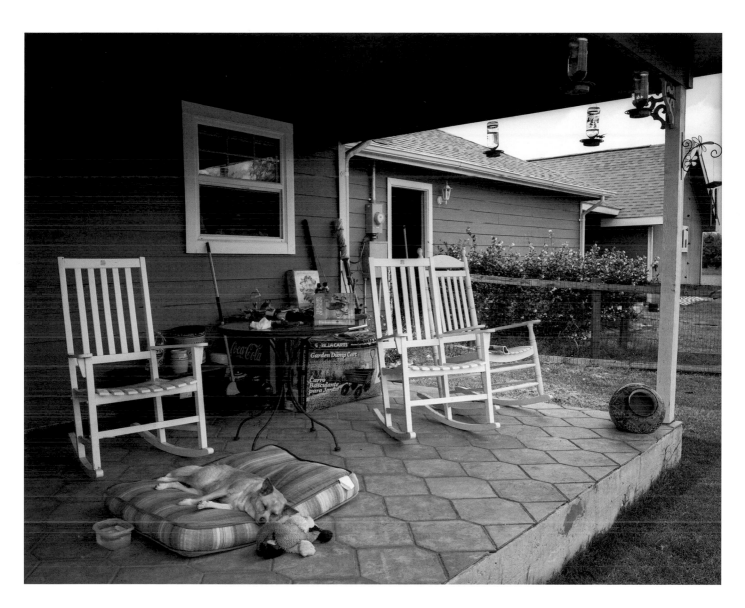

Atascosa, TX, 2012

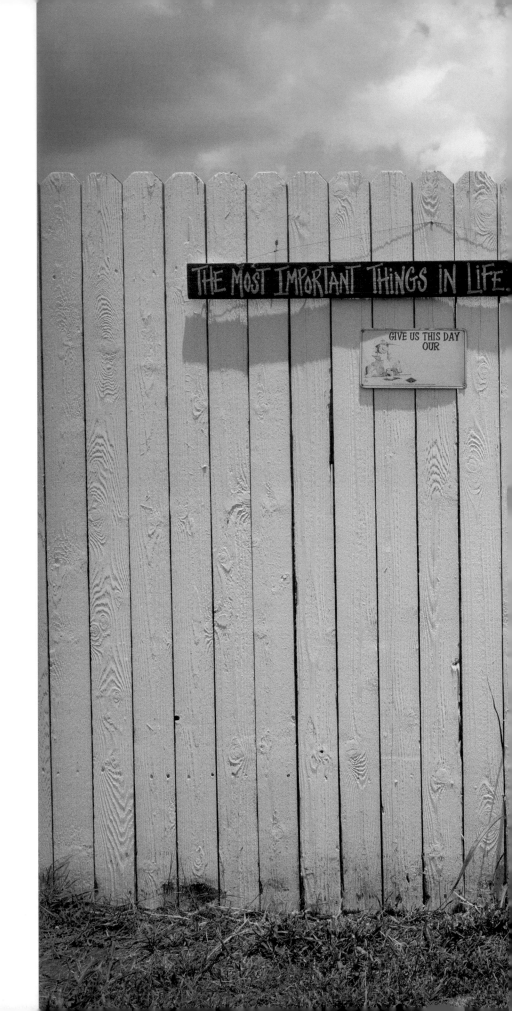

Atascosa, TX, 2012

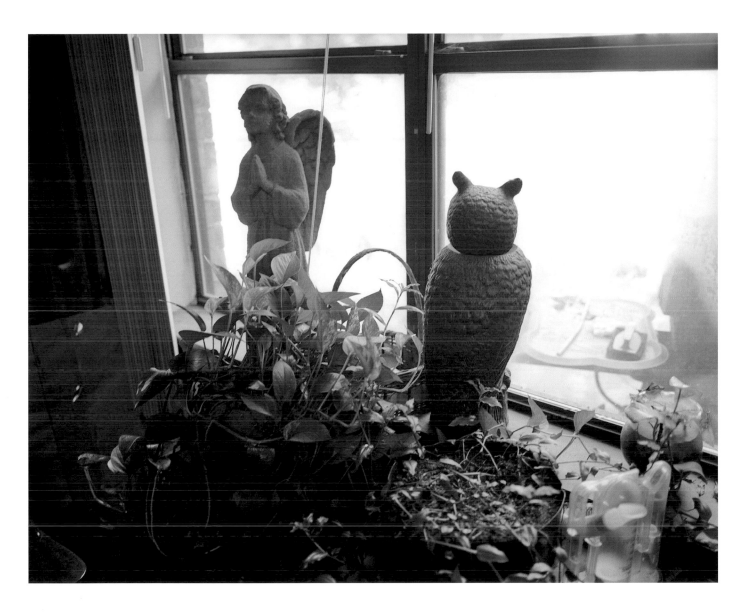

Douglasville, GA, 2012

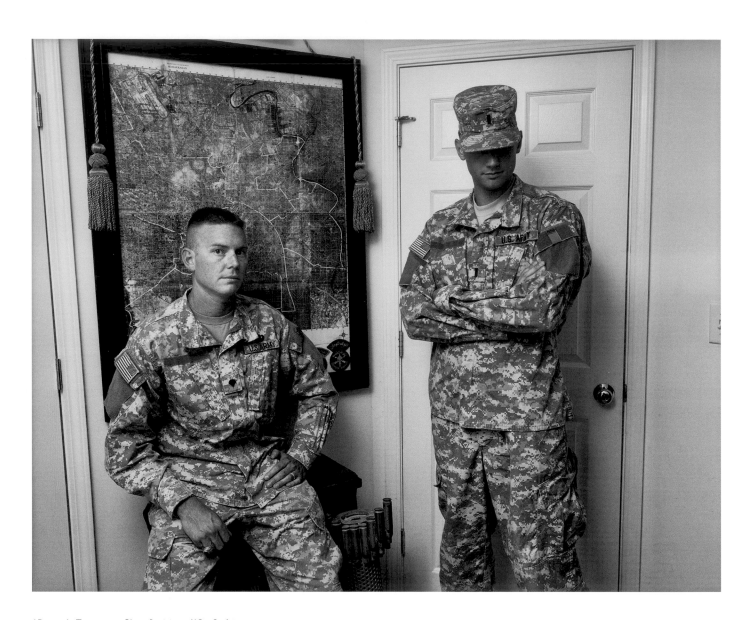

JB and Torrey, Charlotte, NC, 2010

SOUL OF A SAILOR

Lt. Donald R. Bramer

Imagine the room dark and the only glow comes from a single light dangling by a cord. It's hot and your skin is soaked from sweat. In a chair before you sits a man dressed in a *dishdasha*, his hair as black as his eyes, eyes that are filled with hate and disdain. As you begin to speak, he lunges forward with a knife, his teeth clenched and showing through his dark beard. You fight back and strike him with a blow that lands him across the room.

This event may have taken place in Iraq or Afghanistan, a foiled escape attempt by an insurgent. It is not; it is a story from within my own bedroom and one that repeated itself like others for many nights. The recipient of the blow was my partner. The man with the dark beard haunted me for many nights.

My partner and I were fortunate enough to survive Don't Ask, Don't Tell (DADT). Living under the policy was not without its challenges. One of the most memorable came in the fall of 2006. I had just come back to work at my parent command in Washington, DC, after returning from my tour in Fallujah and having a few days of leave. My chief asked me to go for a walk with him. As we headed down ladder wells and into the quiet halls of the basement, he began by saying that I was one of his best operators and he didn't care what people did in their personal life. I felt like I had been kicked in the gut. He informed me that he had been sent my blog anonymously, and he continued that, while I never used a name, or even a pronoun, all you had to do was "read between the lines." He had to report this up the chain of command and would do so in 24 hours. However, if by the time he was to file the report, the blog had been taken down, then he'd have nothing to report.

After this incident, I continued to serve and eventually left for another deployment. Shortly after I arrived in Iraq, I received a letter from my partner:

Tue., April 17, 2007

Once again I find myself driving home through the rain. Why does it always rain on these days, the days when I have to drop you off at the airport? Do you remember that Christmas Day the last time you left…when we drove to the city so you could be on your way and the heavy gray clouds threatened snow and rain? It didn't start falling until I crossed the bridge on the way home. Of course the weather never prevents your plane from taking off. We never get any extra time. I'm sorry I couldn't go with you into to terminal. I'm sorry I couldn't wait with you. We've done this too many times, had too many goodbyes. Time after time, for over five years, one of us is always leaving the other behind. First it was for my tour in Iraq and then it was yours. It seems as if we are always saying goodbye. I just couldn't handle it this time. I could not endure another passive passing of the time before you had to cross through security to the other side. I could not make idle conversation as we sat drinking our coffees, trying to be strong, trying not to give into tears and grief. So I left you in the parking garage. At

least there I could give you a proper hug and kiss goodbye.

We always have to be so careful in public. Until the military wises up and gets rid of "Don't Ask, Don't Tell," we must hide what we feel for each other. Only there, in the cool, secluded gloom of the concrete garage could I kiss you gently, forcefully. Will it be our last kiss? Will you come home from this tour? So I crossed the bridge over the river and the rain fell. It's awfully hard to steer when you are trying to see through the raindrops on the windshield and the teardrops clouding your eyes. It rained all day and night when you left. And until you come home again, every day will be like that dark and stormy day. We've had too many goodbyes. One day I hope there will be no more. So for now, it's another goodbye until it is "hello" again.

Come home to me.

Relationships survived and failed in the armed forces for decades; careers were jeopardized, and countless gay and lesbian service members stood silent in the shadows yet never lowered their guard to the oath they so proudly took. Like many of our brethren, both heterosexual and homosexual, the trials and long separations of war soon took effect on us. After eight and a half years, we parted ways. Time, distance, and our own post-traumatic stress disorder (PTSD) had taken their toll, and even love could not mend the remnants of our dreams. When my PTSD reached its boiling point, I had the resources and the support of a family to get help on my own. Unlike so many, I did not have to rely on a system that would not recognize me or the pain I felt.

I come from a family rich with a history of serving in the military;

my grandfathers and uncles have worn the uniform of sailors and soldiers in multiple wars. They inspired me to wear that uniform and carry that badge. However, the one who inspired me most was Uncle Carl. He met his partner on board ship in the Pacific during World War II, a partner with whom he shared a naval career and thirty-seven years of his life. Uncle Carl became my mentor and my guiding light throughout my own career.

And I have had the great privilege to work with some of this country's most respected war fighters. My fellow sailors are truly brothers in the field of combat, for whom I would give my life should the need arise, and it is without doubt they would do the same for me. Why? Because, on the battlefield, where it counts, it is mission first. We all serve with the same honor, courage, and commitment that we swore an oath to when we first raised our right hand to join the United States military.

The men and women I have served with have become lifelong friends and family. I have shared their hardships of loss and love, their joys of success and triumph; I have come to know them and their families. Until now, only a few have been able to share the same with me. Because I am gay, I spent the majority of my career changing pronouns and hiding the identity of the person I shared my life with for over eight years. One slipup could have ended our careers and stripped us of the pride in which we both serve. Through multiple tours, my partner and I covertly supported each other through cards, letters, and care packages. Yet we were never able to sign them or give a return address. Despite this, and despite knowing that each correspondence could very well be the last, our love for each other and respect for each other's goals gave us strength to endure.

Like other couples, we had to take care of things back home. We made sure that the other would be provided for should one of us pay the ultimate sacrifice. Under the DADT policy, we would be the last notified. We had the same bills, illnesses, and household issues. We had the same legal concerns. However, it's not that simple when, even in death, you have to protect the one you love. All of this we accomplished with little or no support network, since the groups and administrative help available to heterosexual military couples were closed to us. We carried the burden of silence and invisibility each day that we served. We fought harder and trained harder just to wear the uniform with the same distinction as those around us.

Through the years, our silent network had grown, and through multiple duty stations, deployments, and assignments, we learned that we were not alone. We found support among friends. Whether in the mountains of Afghanistan or the streets of Fallujah, aboard a ship or a plane, leading or following, there are thousands of other gay and lesbian soldiers serving each day alongside our heterosexual brothers and sisters, many of whom have opened their minds and hearts to get to know us. Some have been mentors, junior and senior enlisted and fellow officers. We train, fight, bleed, and die the same way and for the same things.

Life, liberty, and the pursuit of happiness.

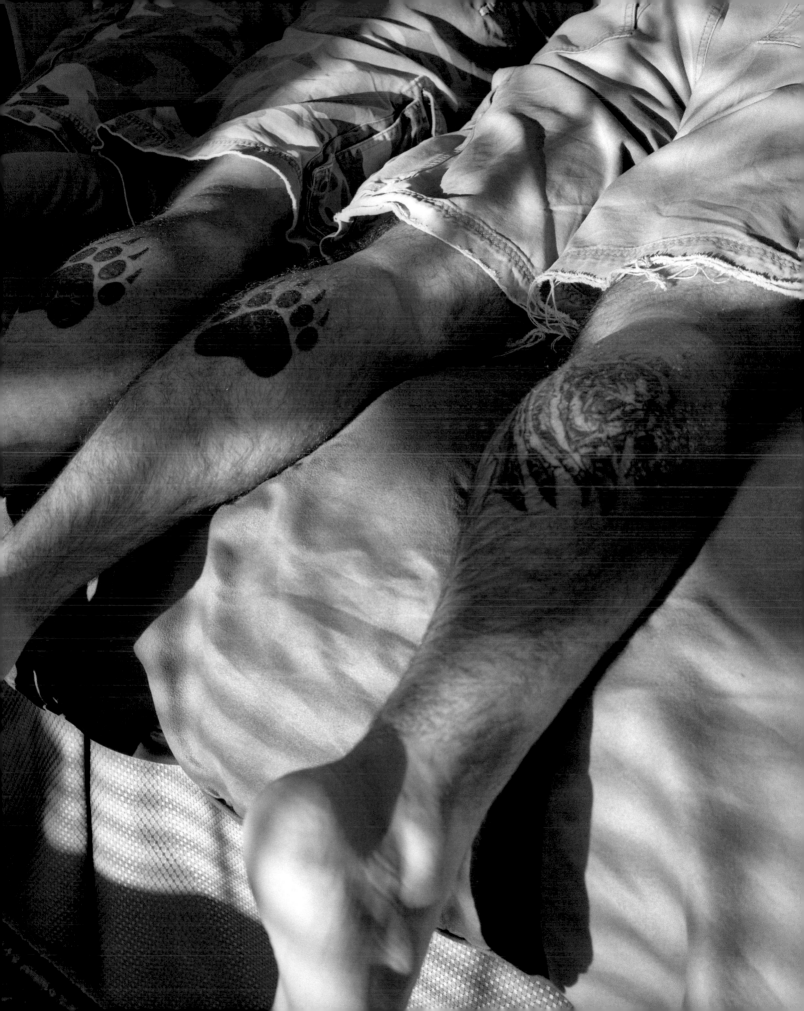

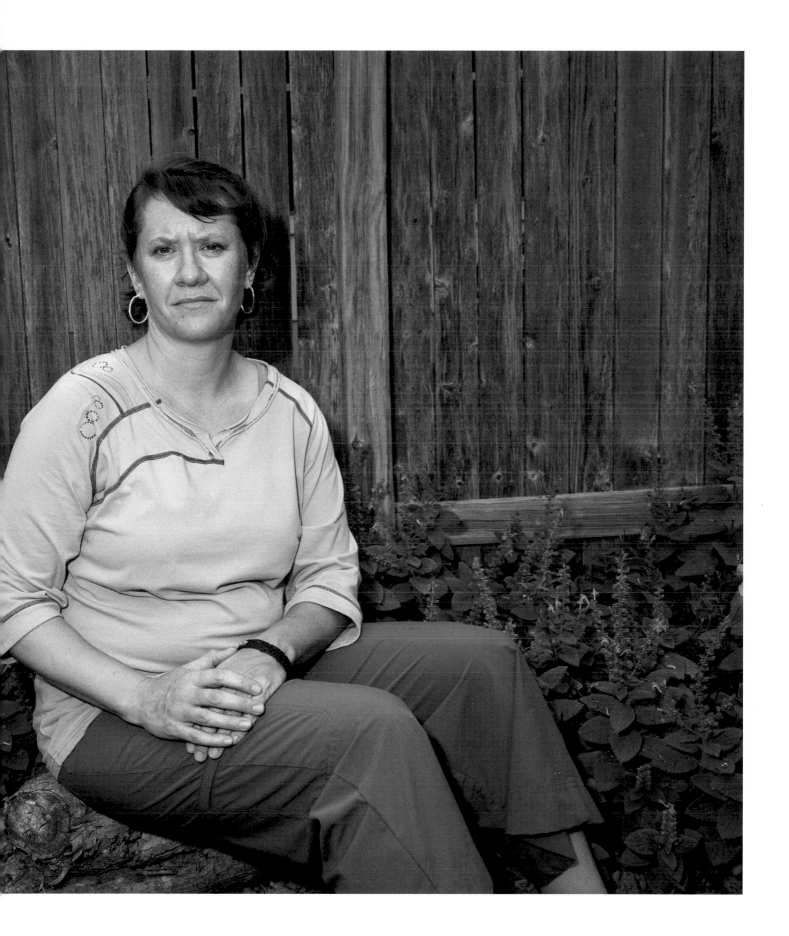

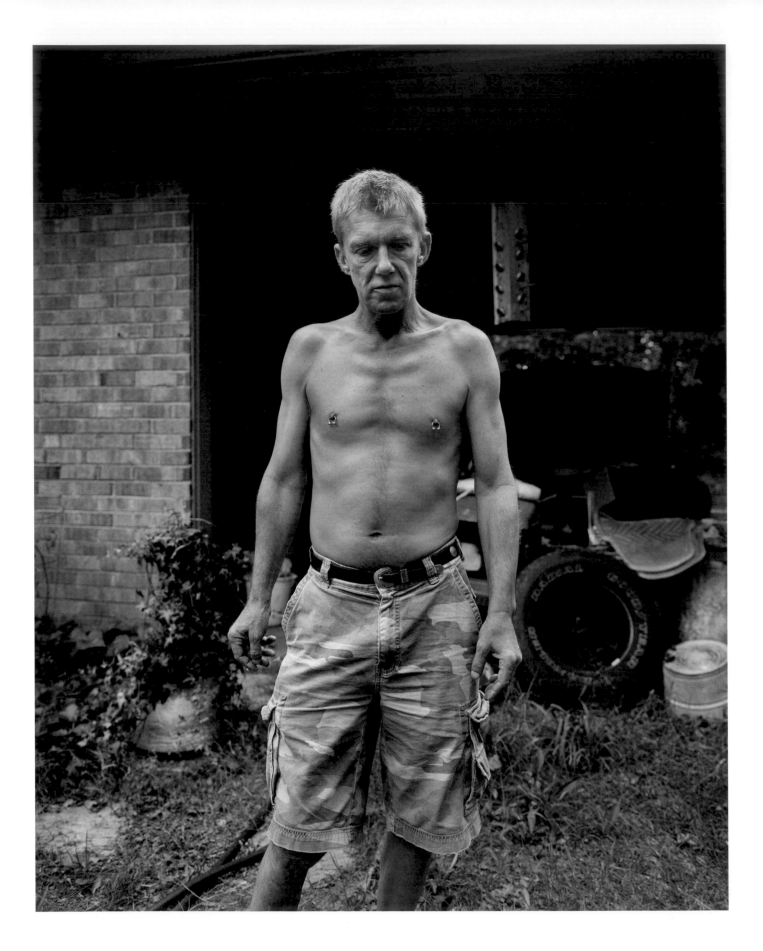

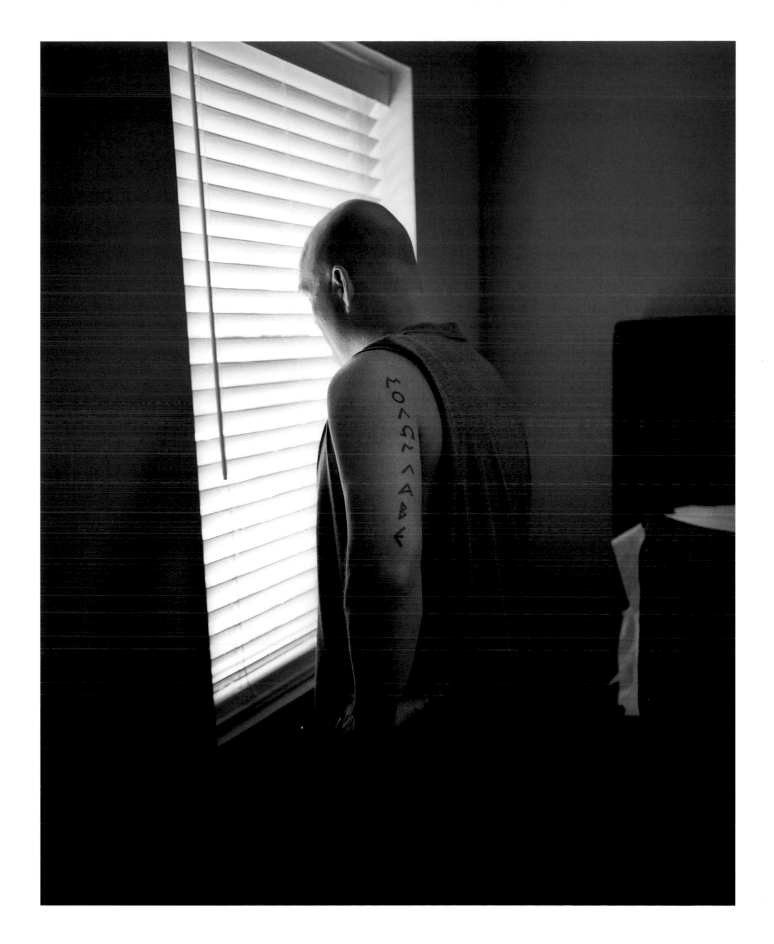

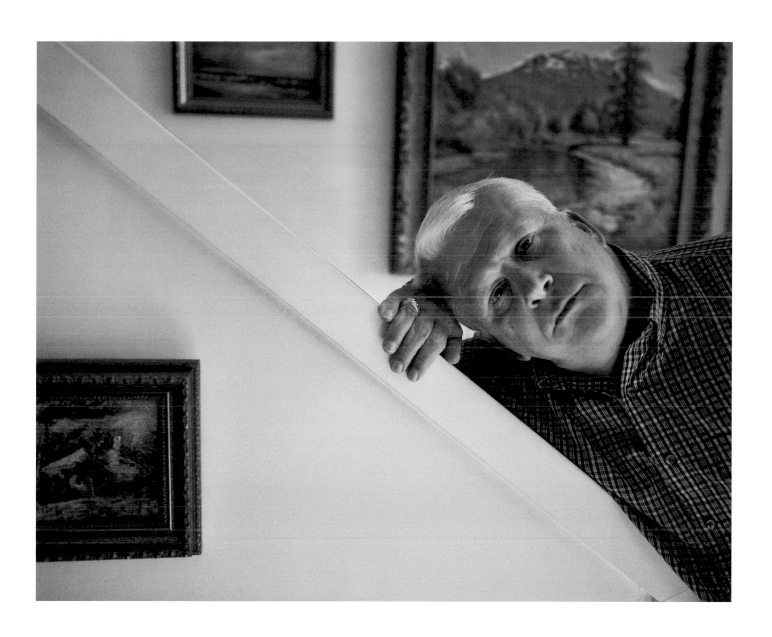

BEEN THERE:

History, Witness, and Some People We Might Never Have Known

Alison Nordström

From the time of their invention, photographs have been appreciated and understood as an undeniable record of what has been. They looked like truth, and possessed what Roland Barthes saw as an inexorable connection to the past, even at the moment of their making in the present. We can, Barthes claimed, "never deny that *the thing has been there*. There is a superimposition here: of reality and of the past." This may be true of most photographs, but it is especially the case with *Gays in the Military*, which offers us both reality and the past with the conscious intention of doing so. Vincent Cianni, its author and photographer, has crafted this book as an exercise in witnessing and truth telling. It is already an important historical document.

There are two kinds of portraits in this book and both stand as evidence—on many levels—of what has been. The book leads with an iconic full-page frontispiece of a man in camouflage-patterned fatigues, his back to the camera, his individuality hidden. The image represents, as we shall see, all of the people whom Cianni will introduce to us in the pages that follow: men and women who served in the United States military at a time when revealing their true natures would have cost them their careers, pensions, and other benefits, and caused their expulsion from the group to which they had pledged to be part. The opening image is followed

by old-fashioned formal portraits of young men: uniformed sailors in a symmetrical and precise group identified as the May 1962 Recruit Training cohort of Great Lakes, Illinois, and a studio portrait of a young navy lieutenant in dress uniform, staring self-consciously into the camera; his mustache does not disguise his youth but can be read, perhaps, as an effort to affect maturity, bravado, and individual style. These are the photographs one might send home to one's parents, or see published as grainy offset filler in the back of a hometown paper. We can feel the bored indifference of the commercial photographers who must have produced these generic images day after day.

Alan Steinman's historical essay is preceded by three black-and-white photographs and followed by two small snapshots, less completely generic perhaps than the commercial portraits that begin the book's sequence, but no less predictable. American soldiers have carried cameras, with and without permission, since the Spanish-American War, and the American culture of the camera that fascinated all of society in the 19th century has persisted in parallel in the military up to the present day. A young man in uniform sitting casually, legs akimbo, on the launch door of an ICBM capable of killing millions; a group of four women, dressed so androgynously in fatigues and Vietnam-era flop hats

that their sex is almost indistinguishable, stand casually, arms around each others' shoulders in front of a plane; a young soldier poses with a rifle; a young man stands next to a poster for the 1936 melodrama in San Francisco, bewigged and dressed awkwardly and unconvincingly in some vaguely period female costume that could be drag, could be youthful hijinks, or could be both. (It is, in fact, a Halloween costume.) In these images, only the uniform differentiates the subjects from any other young people of their time. As is common in snapshots, the people depicted acknowledge the presence of the camera. They are performing the familiar tropes of being photographed that we all know: "buddies," "soldier," "costume party." These photographs serve to connect us as viewers to the culture of the military. It's not, the pictures suggest, very different from our own, yet the placement of these images in the context of the book makes them mysterious. We scan the formation of recruits, wondering which of them has a secret he must not share.

The mundane vernacular images stand in contrast to the series of environmental portraits by Vincent Cianni that constitute the core of the book and support the ambitious documentary project of which the pictures are part. As the sequence begins, the first few images are not actual portraits at all, yet they are as biographical and revealing as any well-limned visage. There is a home-made reliquary, shrine-like in its intimacy and contents: a snapshot of men in uniform, foreign coins, military medals, Air Force insignia, and a few heavily armed toy soldiers. The childishly poignant memory box is followed by an image of a cluttered porch that could be anywhere in America, complete with Coca-Cola

crate, rocking chairs, and peacefully sleeping dog; a windowsill displaying an owl, an angel, and a houseplant. We are invited to stare into these intimately framed domestic settings and to seek out the consciousness that created them. They train our gaze to look directly at the faces that will appear on the subsequent pages.

In most of the photographs, the subject is a person. Occasionally it is two people. In several instances, at the start of the sequence they stand in shadow, turn away from the camera, or otherwise obscure their faces, a sad necessity for some when the images were made. One couple is represented only by their youthful tattooed legs. These are ordinary people, male and female, black and white, old and young, whom we might see anywhere; yet there is a vital presence to their depiction that makes us curious. Despite their immediacy, the fact that they are photographs permits us to look harder and more closely than we would ordinarily dare to. Unabashed, we try to make out hidden faces, to see through the shadows. When we can, we stare into eyes that seem to look back at us. When we see faces, the expressions are ambiguous, mingling defiance, vulnerability, curiosity, innocence, and awareness. About all of them, there is a curious intensity that indicates both the collaborative complicity between photographer and subject and the seriousness with which the participants treat the moment in which the image is being made and preserved.

We do not generally pay much attention to the act of photographing. It is usually the product of the act that interests us, the images that preserve reality and what has been. Yet it is worth noting that every individual depicted in this book is engaged in doing something special: posing for

the photographer. This is an act so familiar, it usually goes unnoticed, but in Cianni's project, the act of making the photograph itself is significant and triumphant. These ordinary people, who had been forced to hide and lie because of homophobic prejudice and archaic received conventions, are able, with this act of presenting themselves to the camera, to say, "Here I am."

The genre of documentary photography embraces a long tradition of portraiture. Lewis Hine's child mill worker turning from her loom to face the man with the camera, or Walker Evans's sharecroppers collaborating with strangers to reveal and record their lives, are real to us today because they were photographed by people concerned with telling us the truth. Those photographs, like Cianni's, make us witness to injustice, while personalizing and putting an accessible individual face on what might easily be dismissed as an incomprehensibly vast social issue or somebody else's concern. The images are collaborations; the photographers' skill and compassion empowers the people he photographs. They are also collective; brought together in this book, the people in Cianni's photographs stand shoulder to shoulder to assert themselves as a group.

While the portraits of *Gays in the Military* are what first engage us, this project is much more than an assembly of faces. It is the accompanying texts and the sequence of images as a whole that make this book historically significant. Begun in the period of Don't Ask, Don't Tell, and completed in the transitional months after the policy's repeal, the interviews set down the stories of men and women who

were forced to keep their essential selves secret from their comrades in arms. In recording their fear, isolation, humiliation, and anger, the book helps us understand the imperative rights of all to dignified selfhood, and it records the damage done to us all when such rights are denied. Someday people born long after these times will turn to this book to learn what it was like to be gay and in the military before things changed, as we look now at mid-twentieth century images of racially segregated busses, restrooms, water fountains, and restaurants, with sad wonder that the world could have been like that back then, and a happy conviction that things have finally begun a slow movement toward the good. This book marks a point in a long unfinished journey. There is still, of course, much work that remains, but Cianni has helped us understand where we are. We are fortunate that the people who made this book with him had the will, courage, and openness to share their lives with us, to show us their faces when they could, and be part of this record of our times.

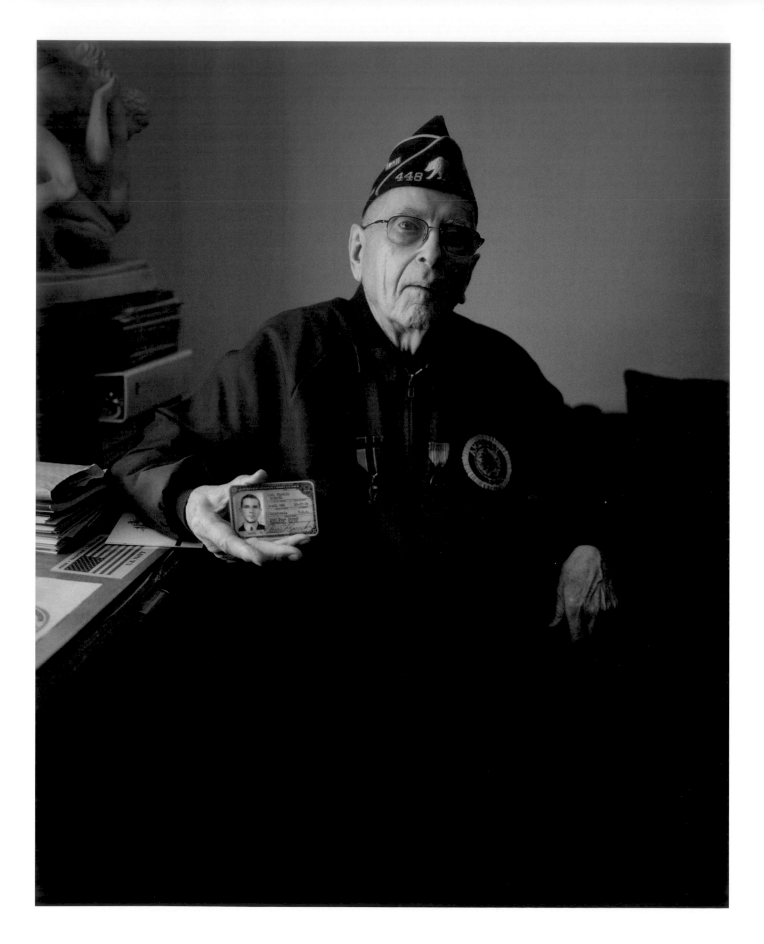

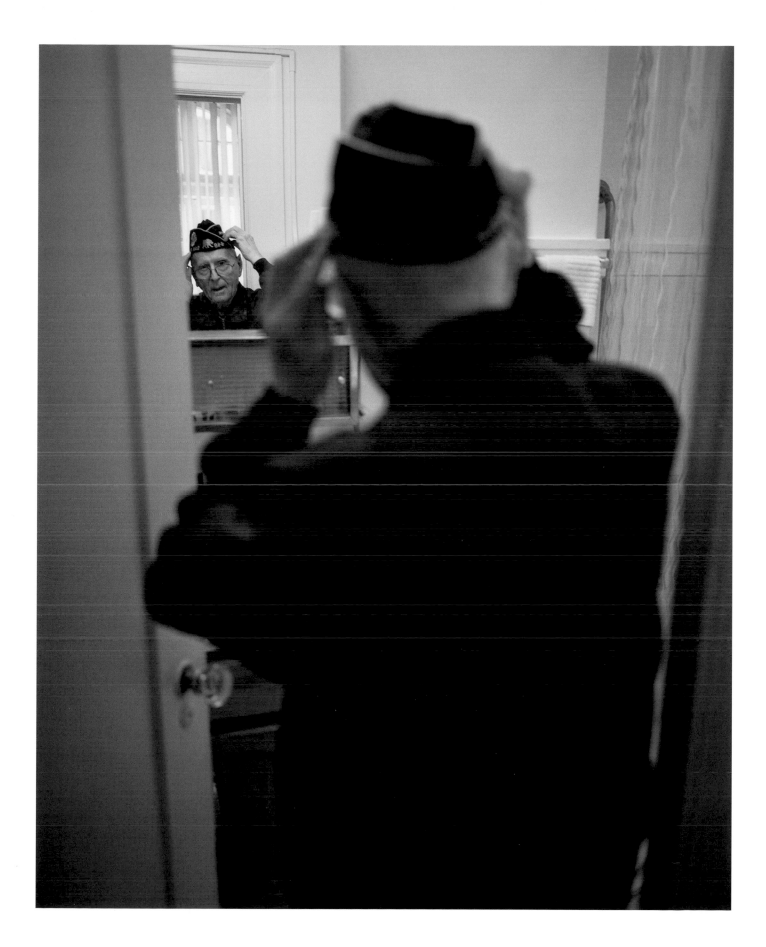

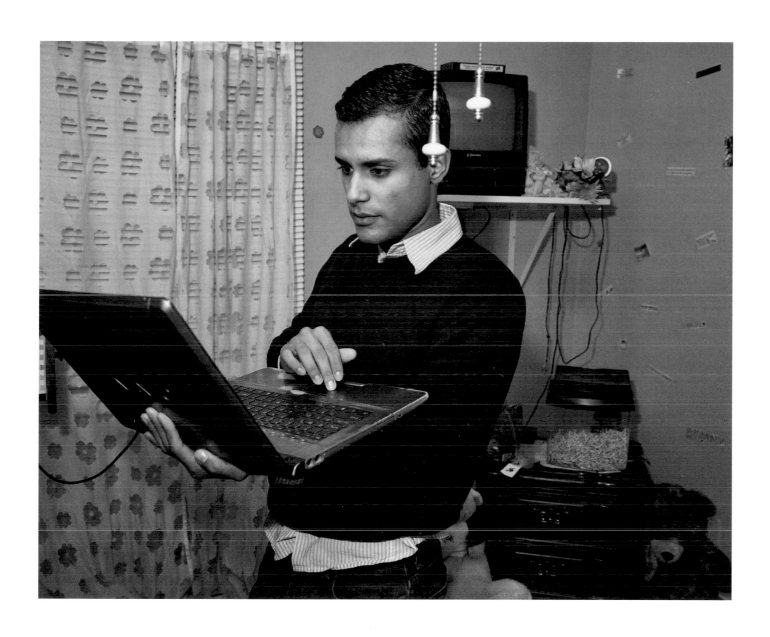

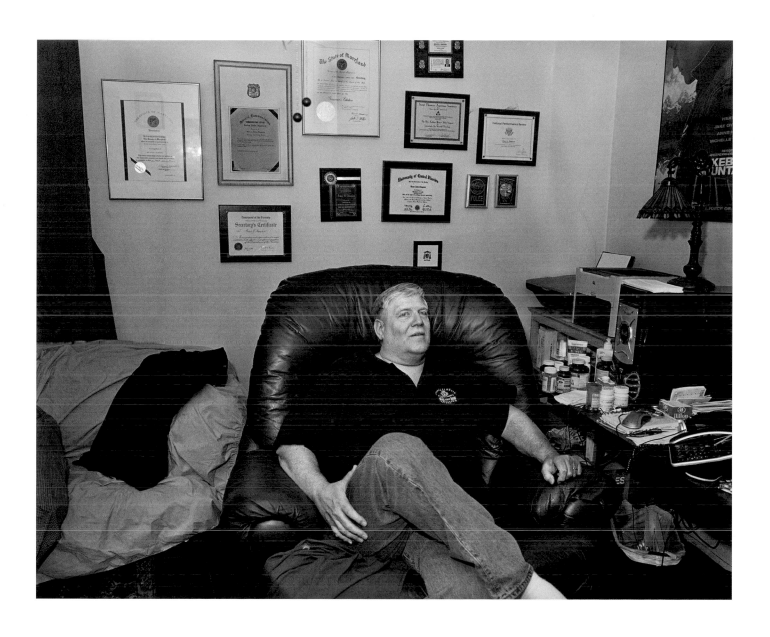

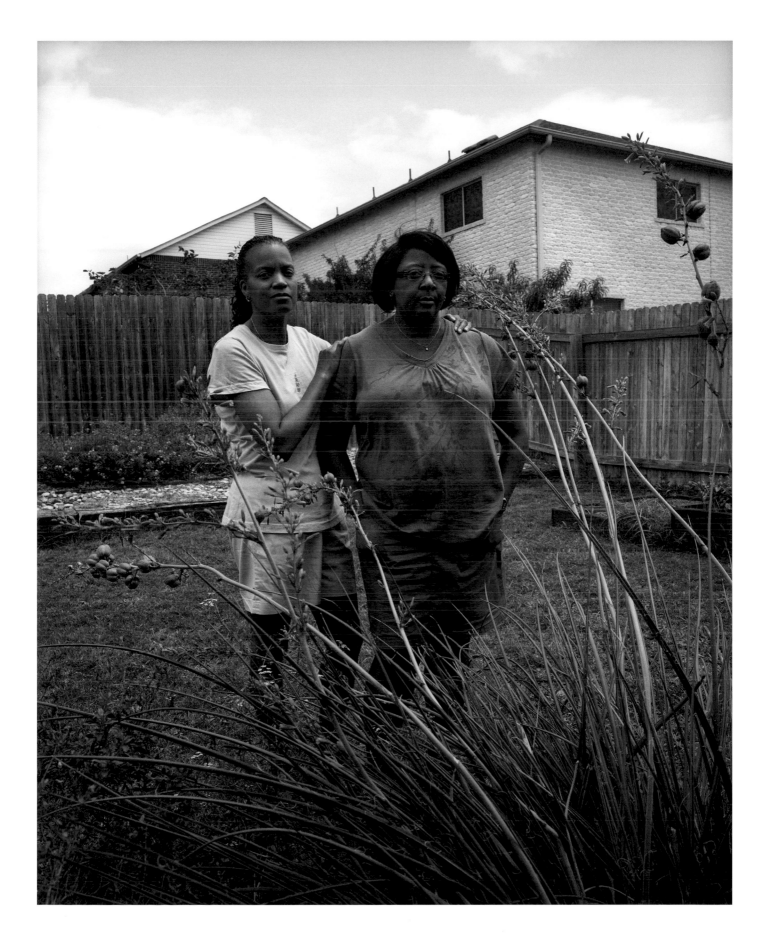

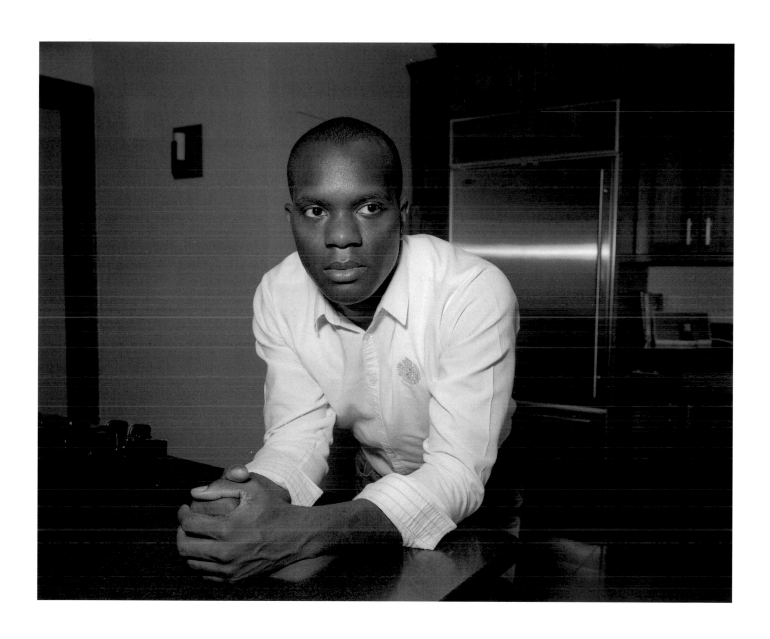

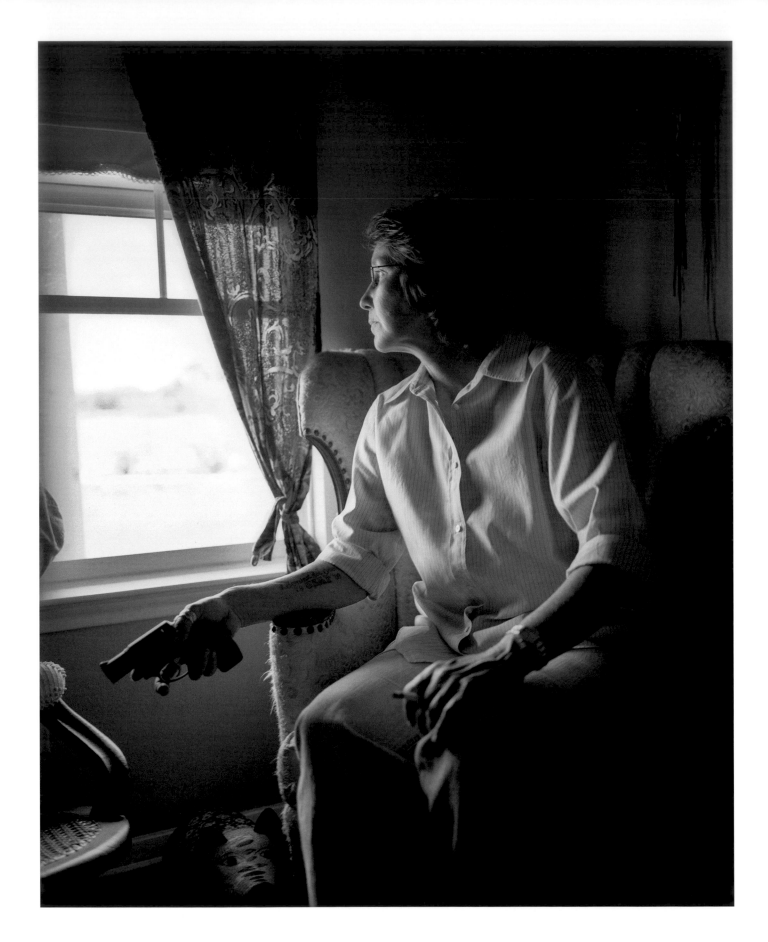

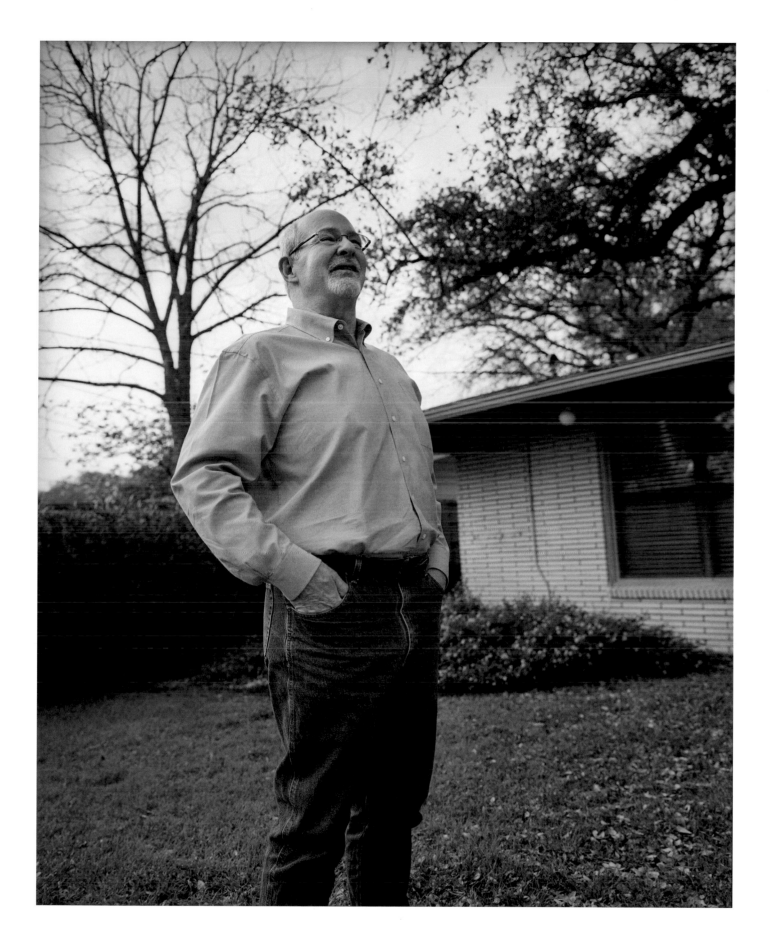

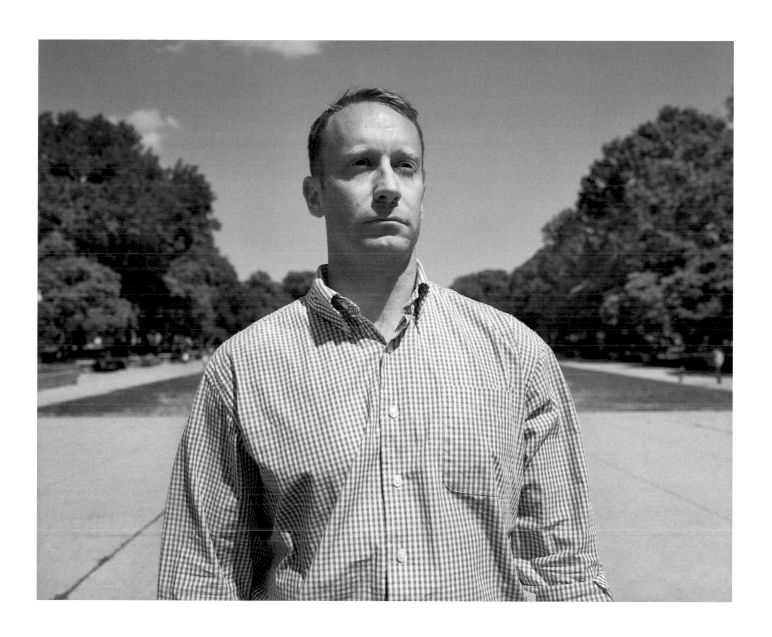

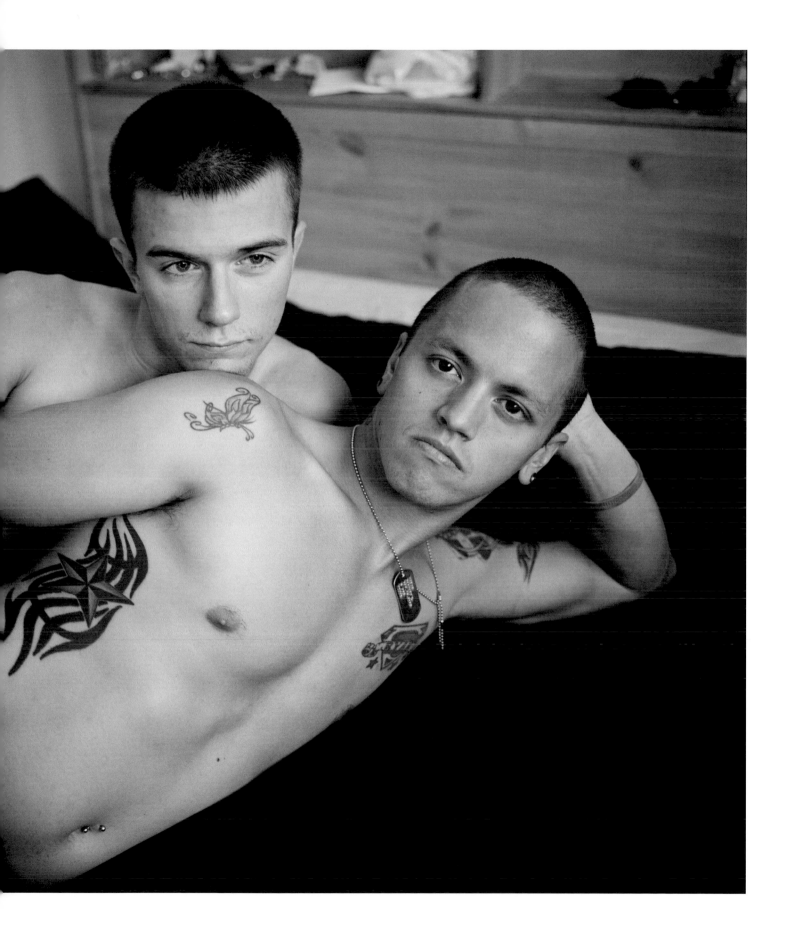

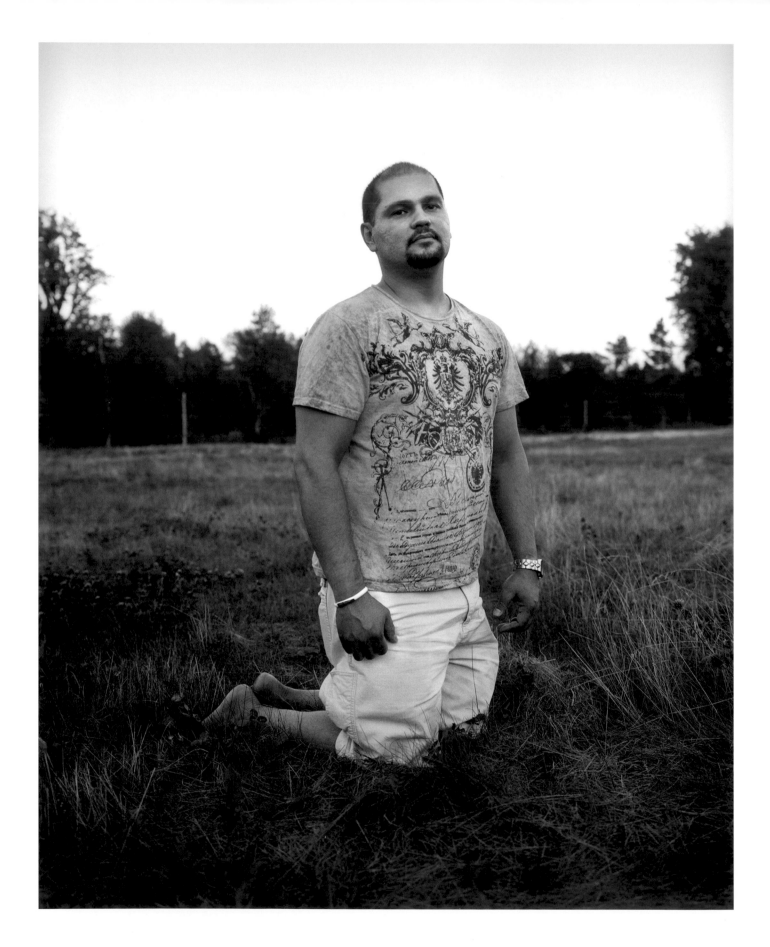

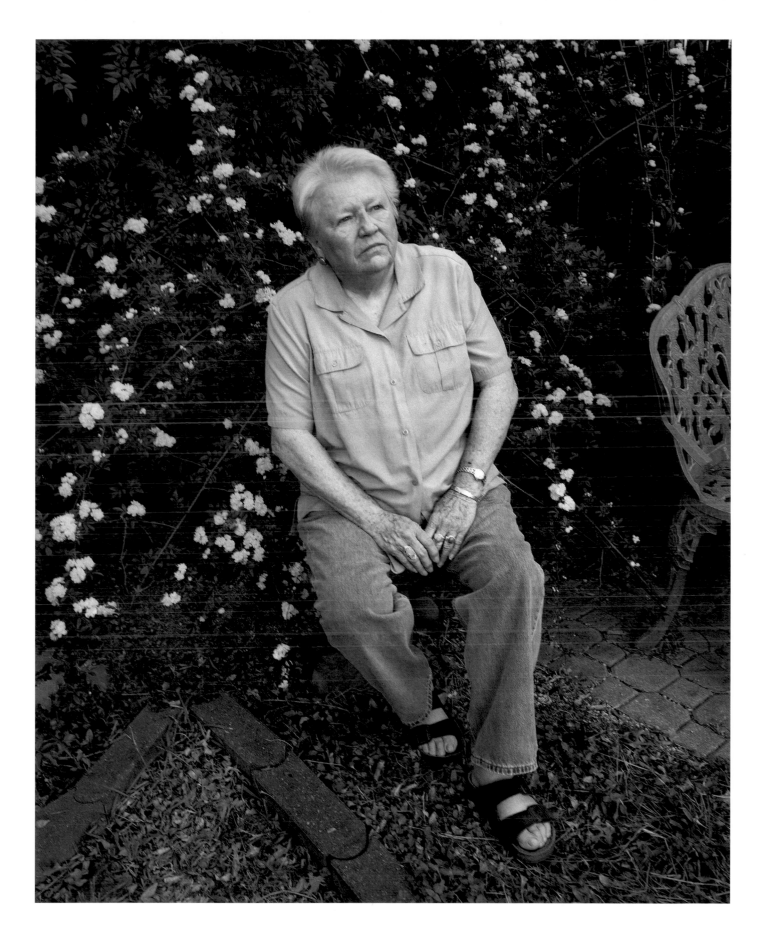

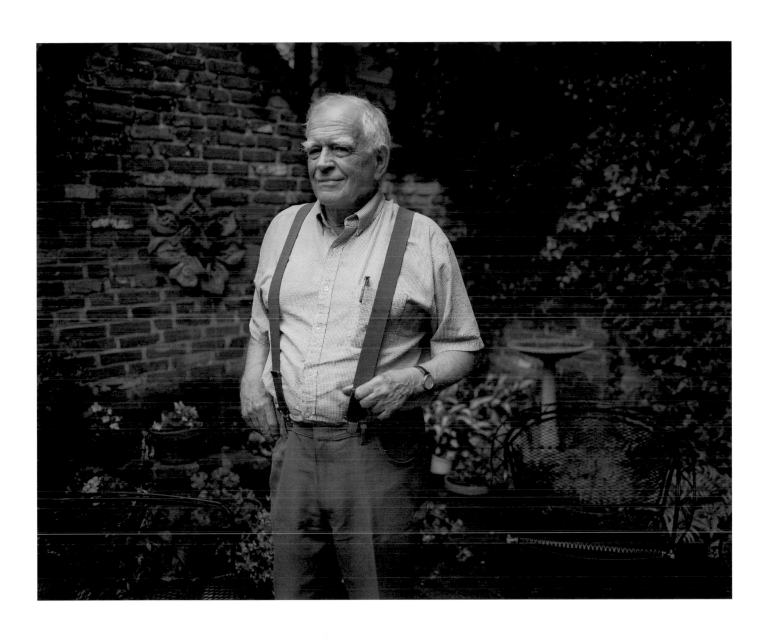

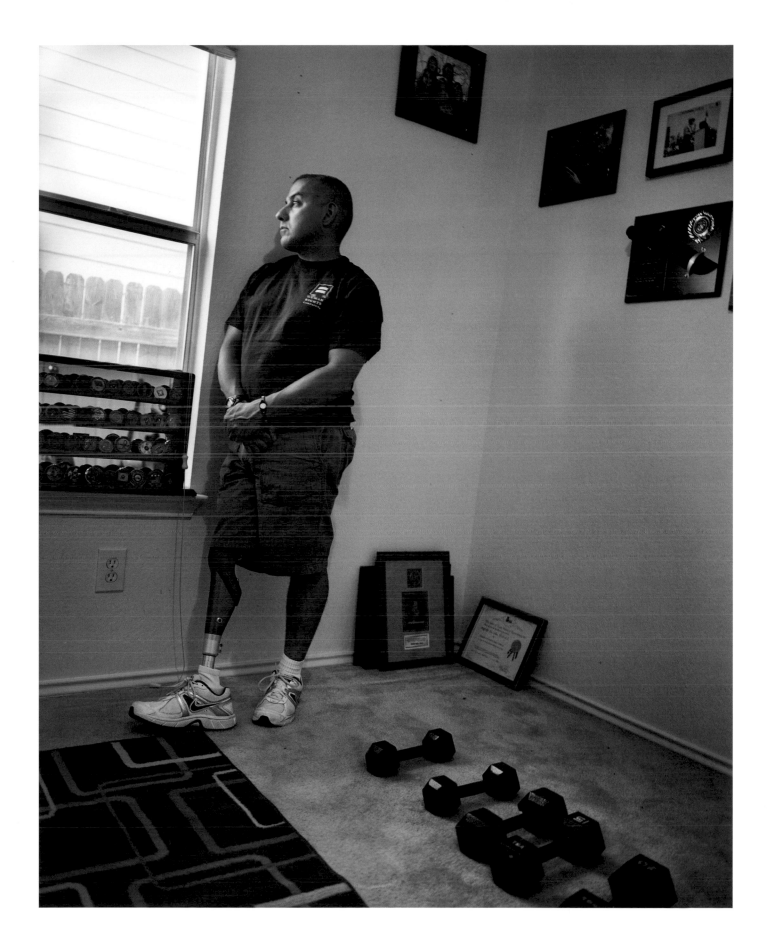

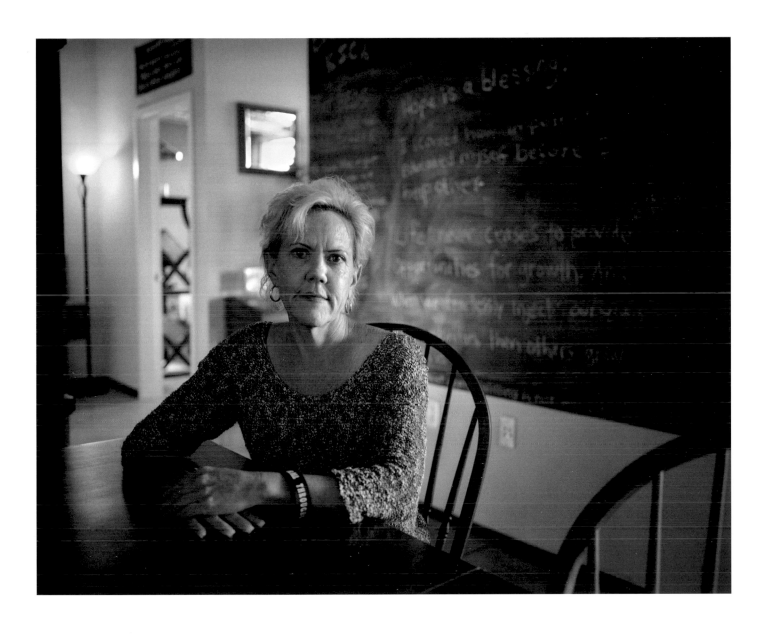

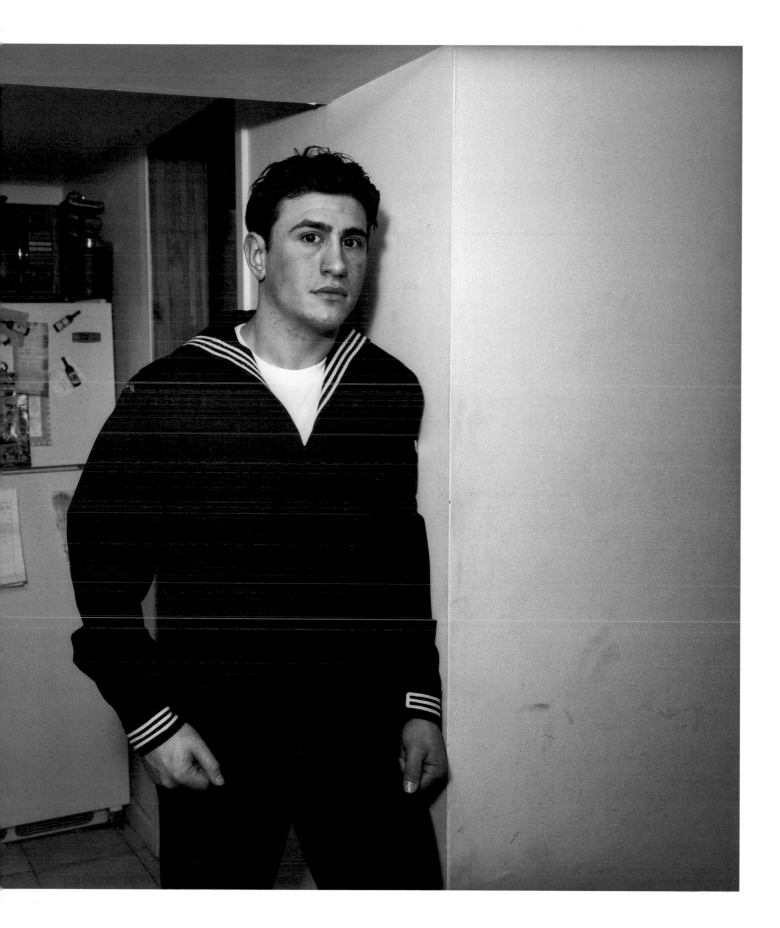

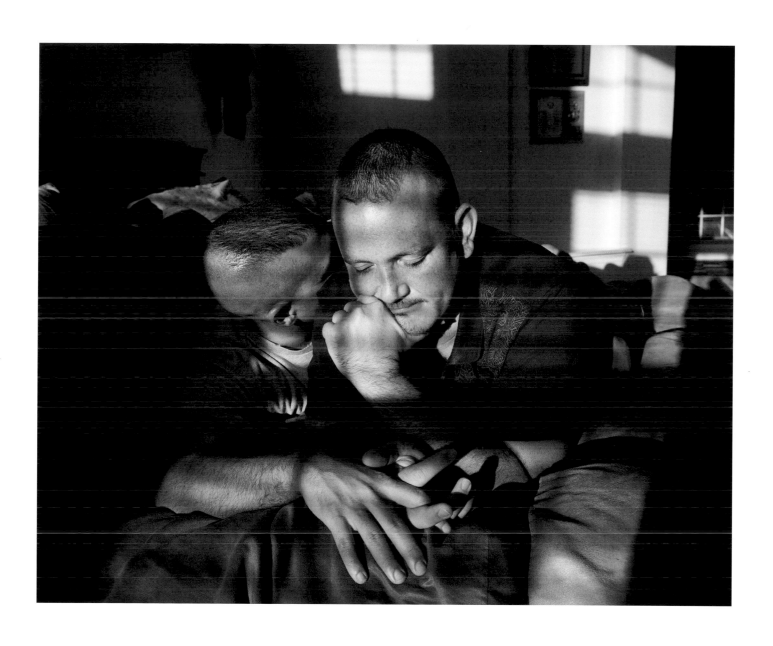

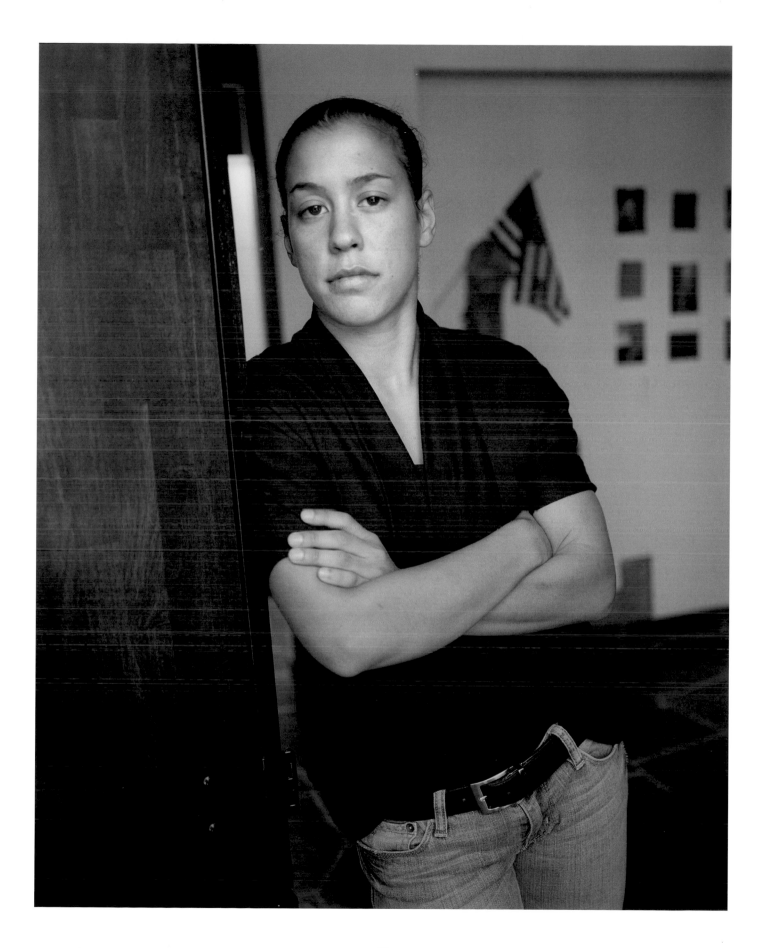

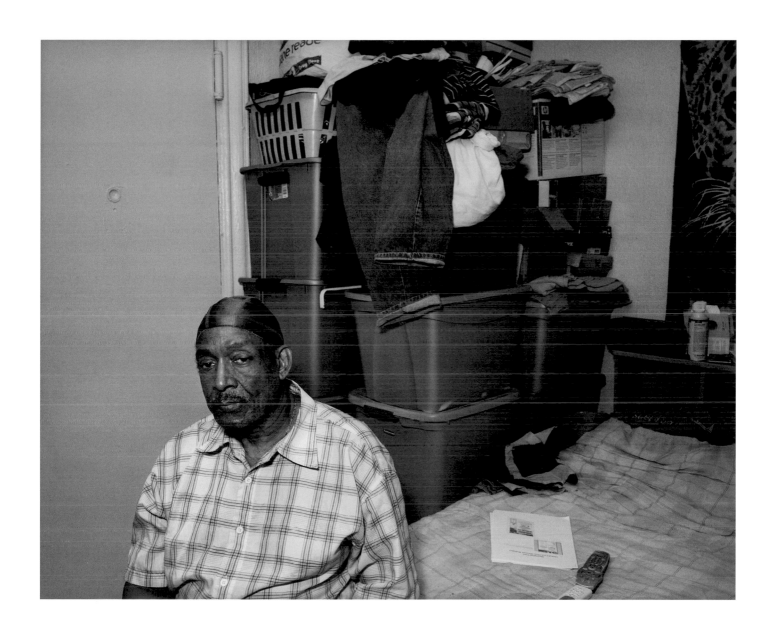

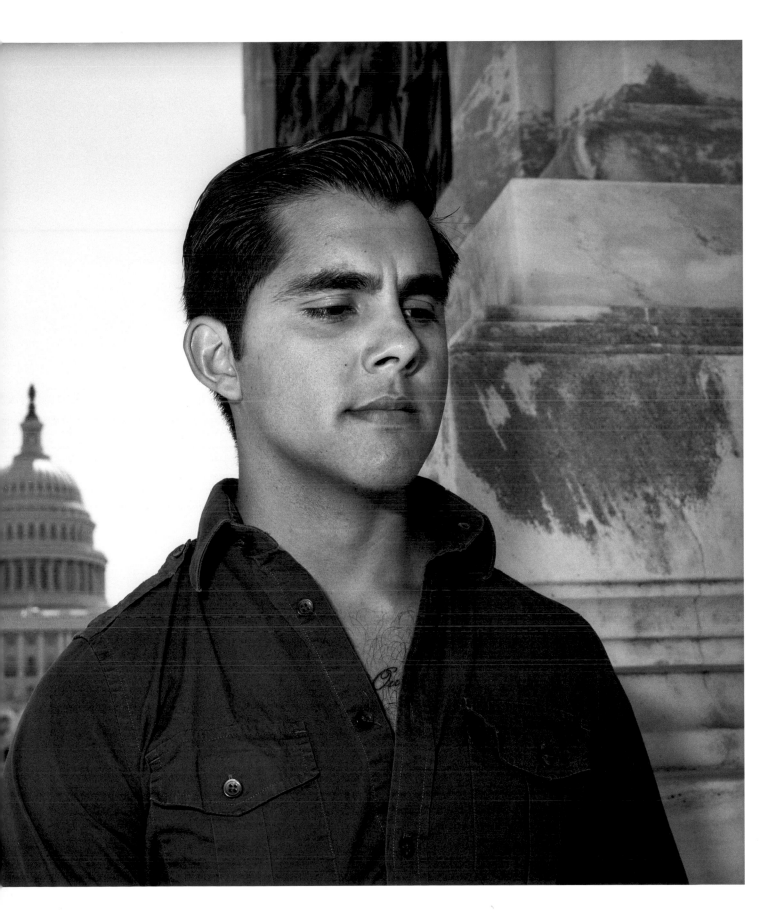

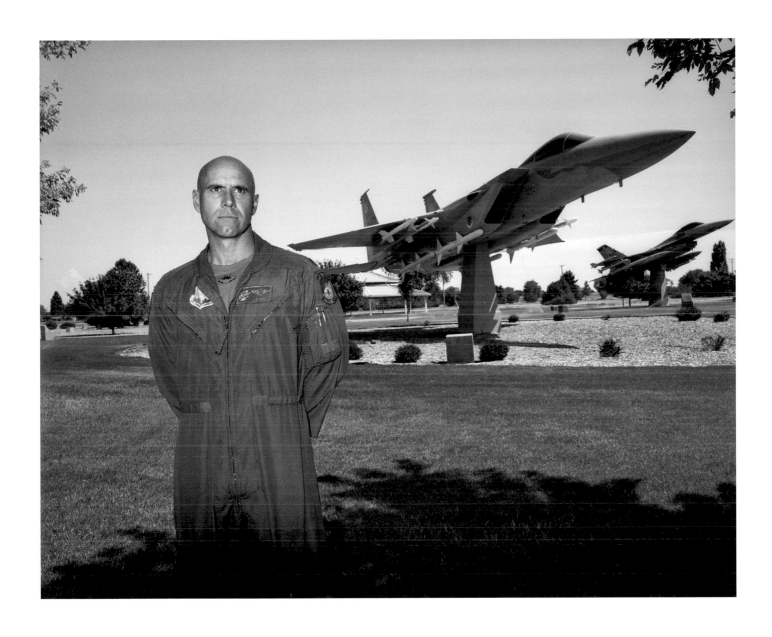

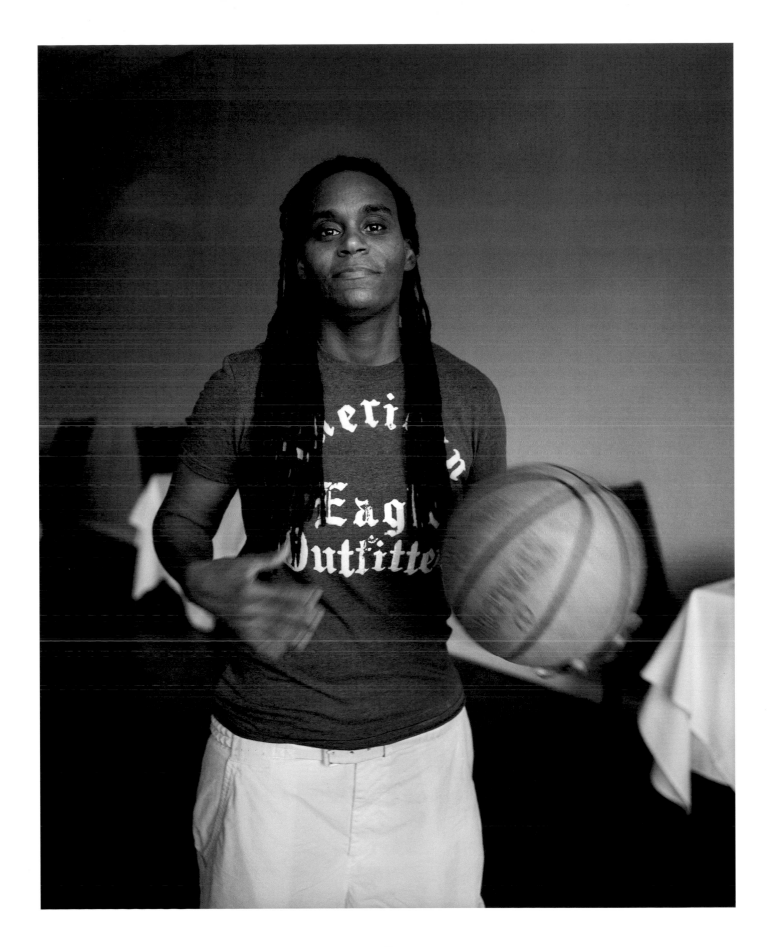

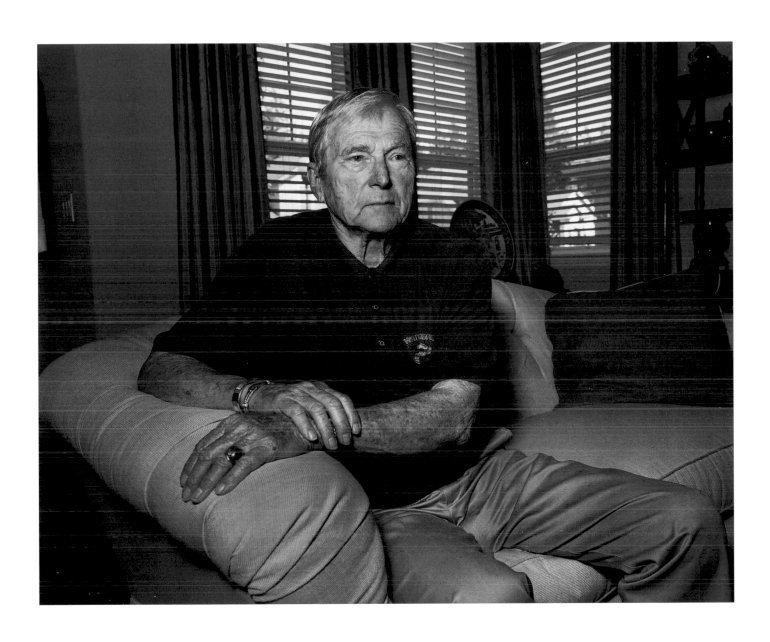

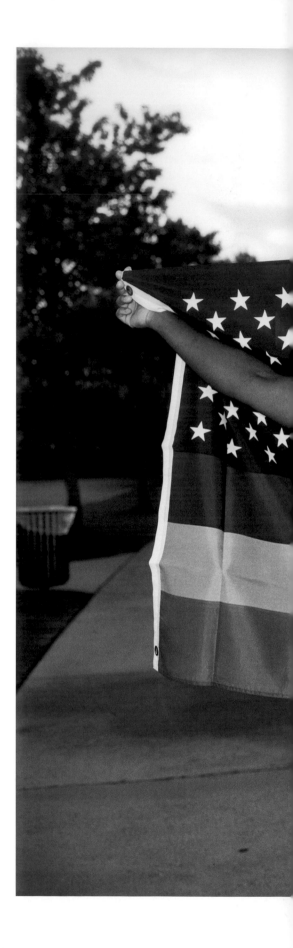

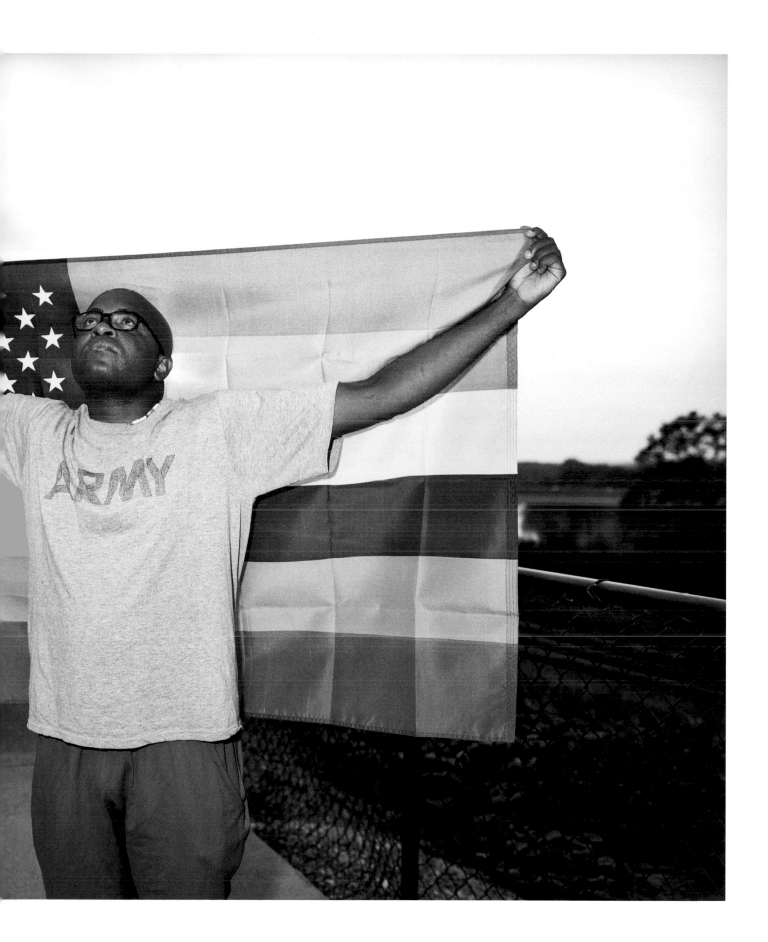

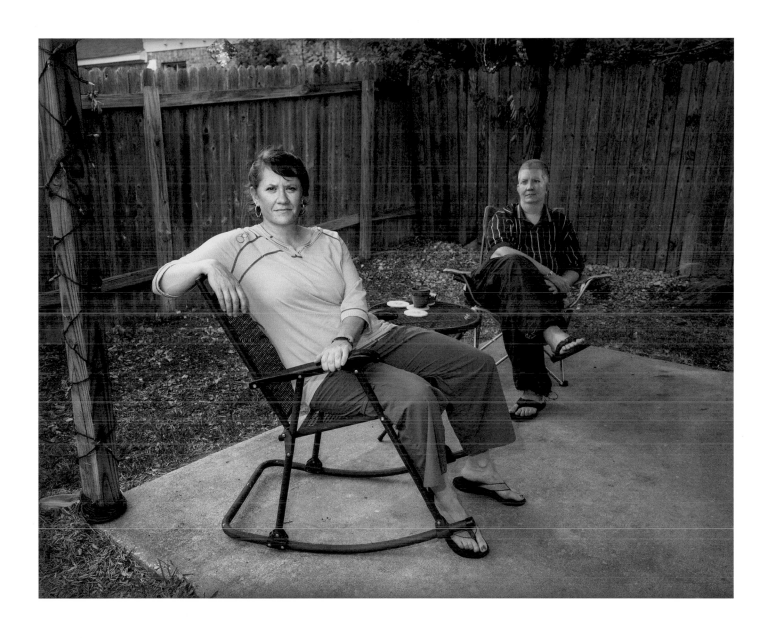

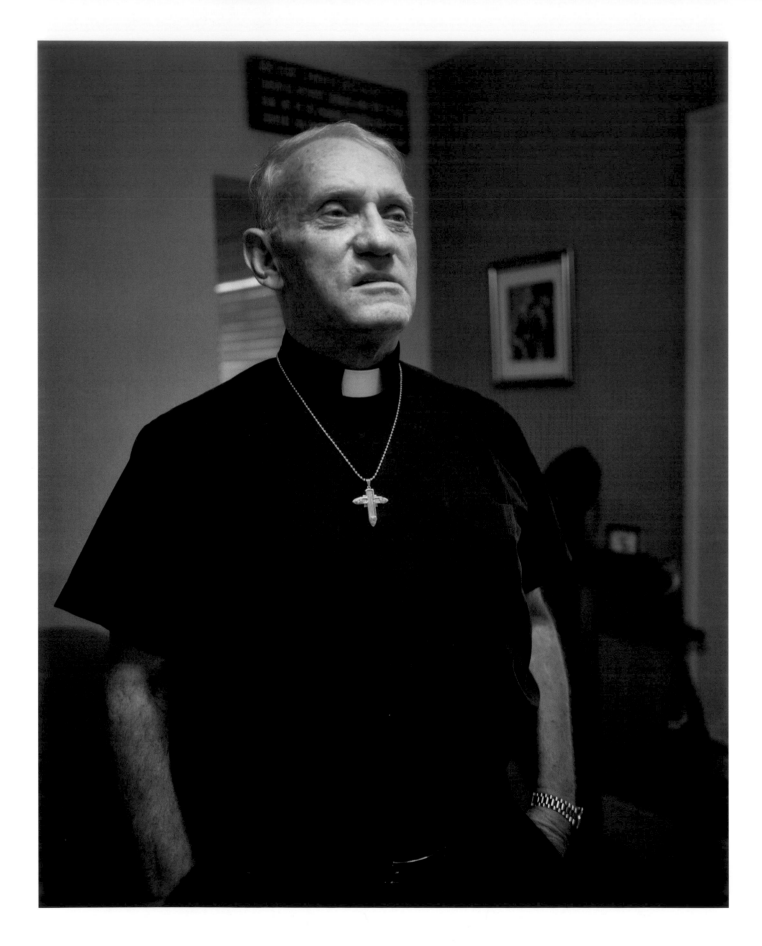

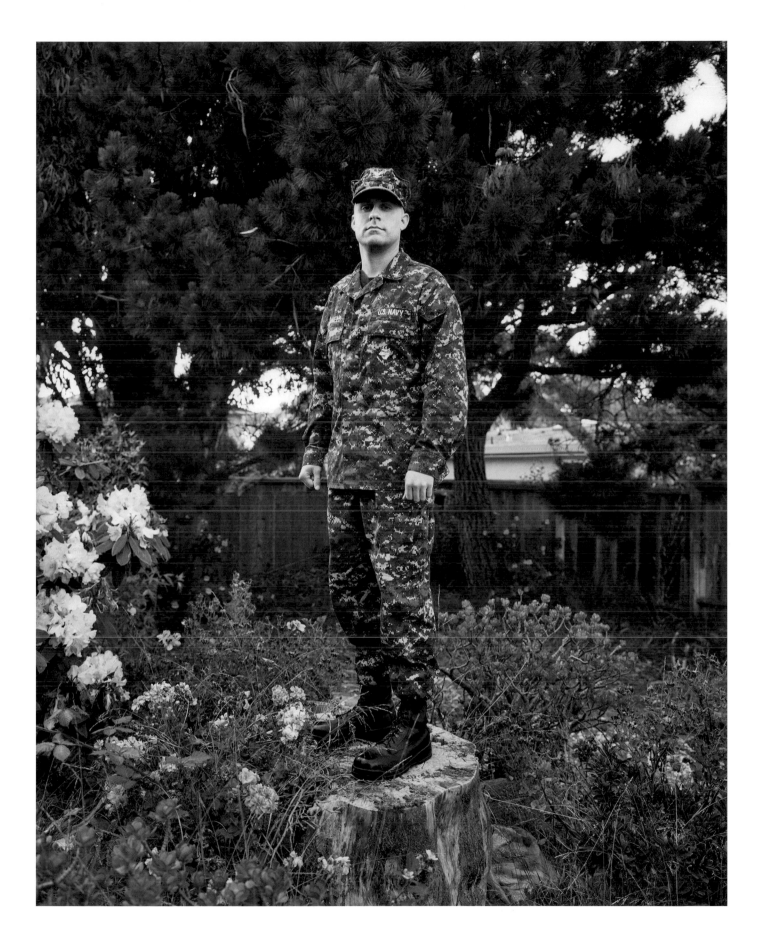

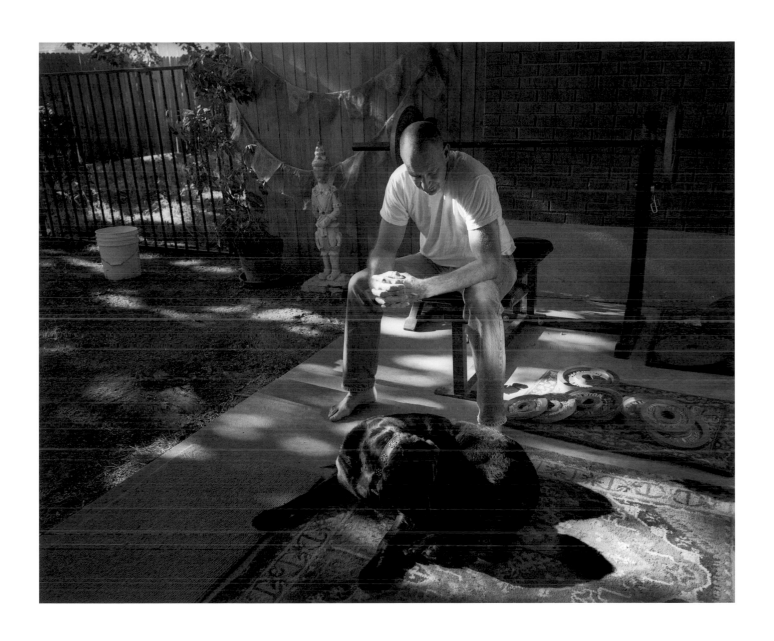

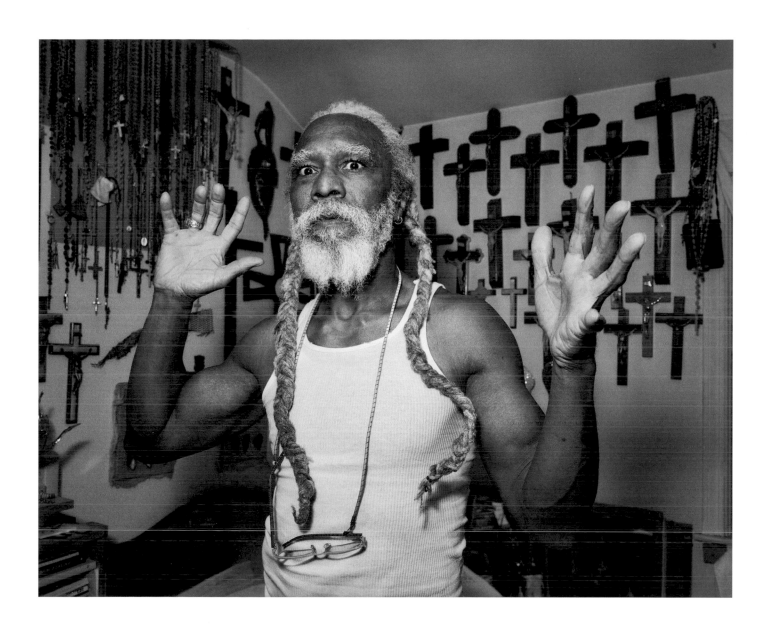

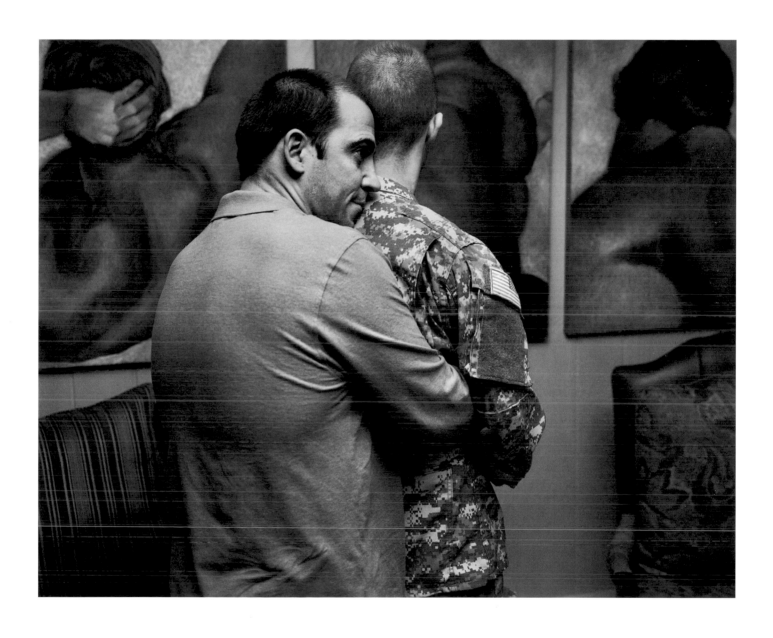

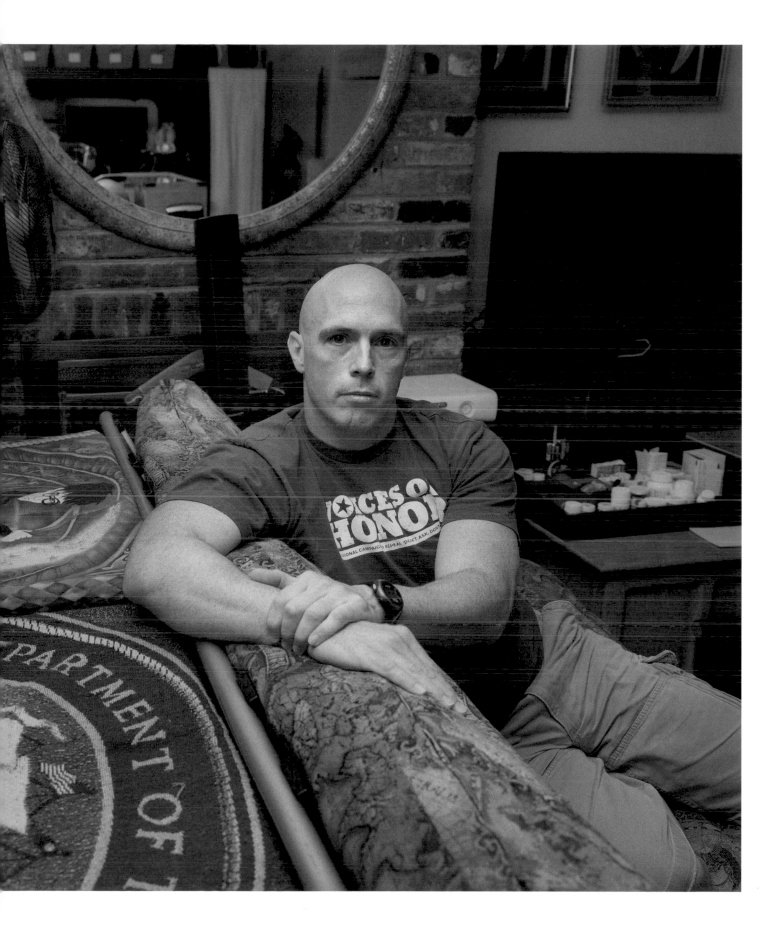

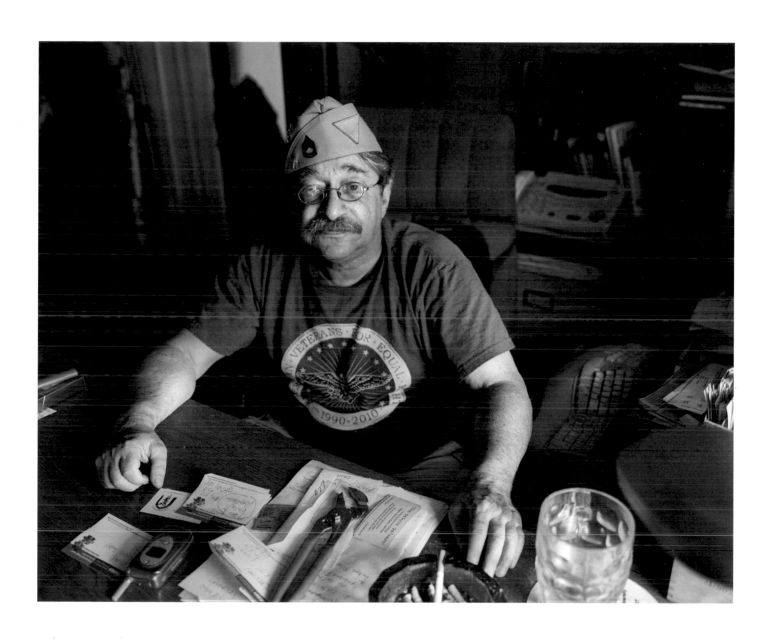

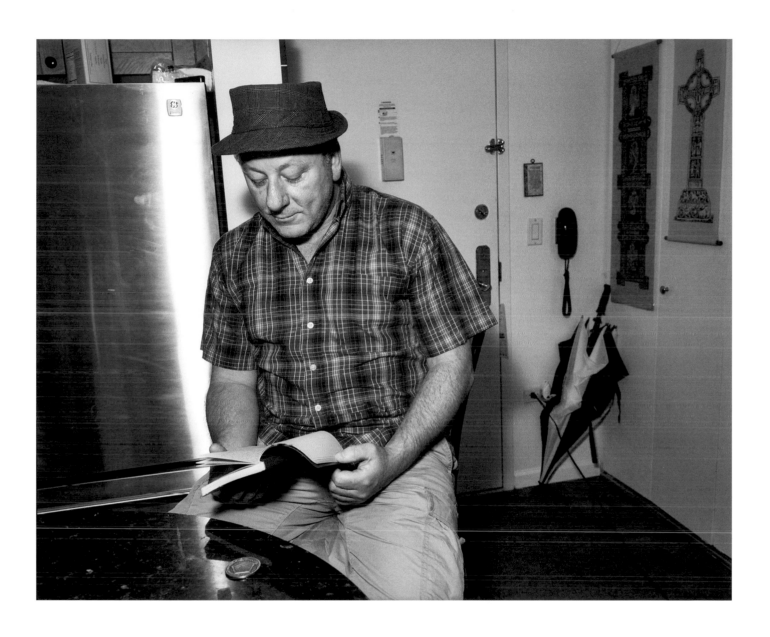

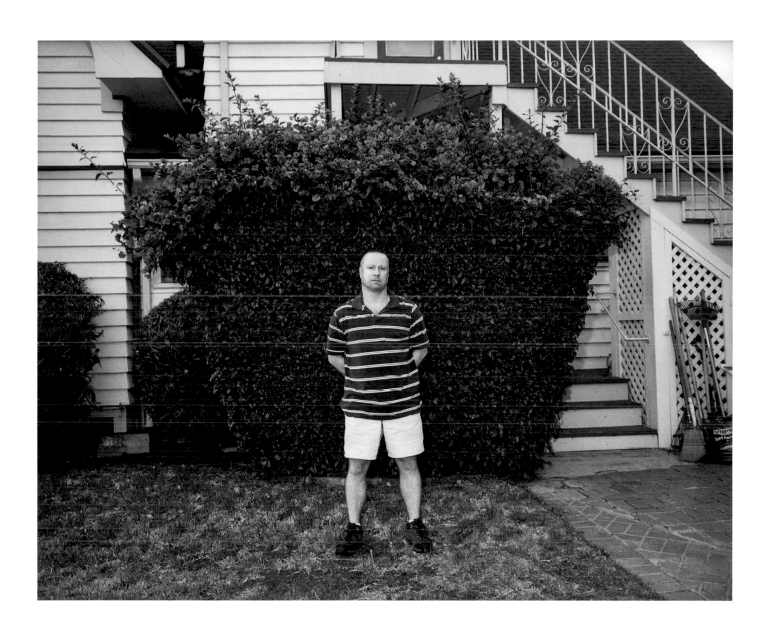

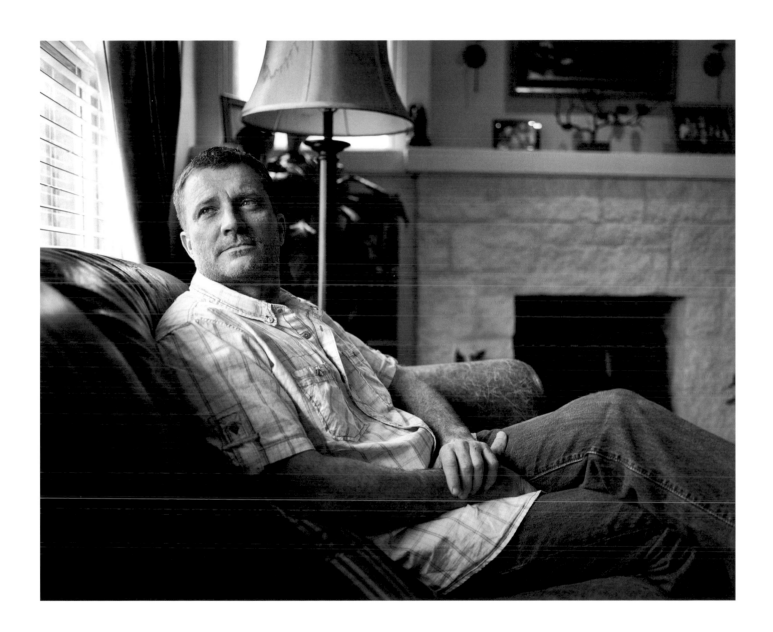

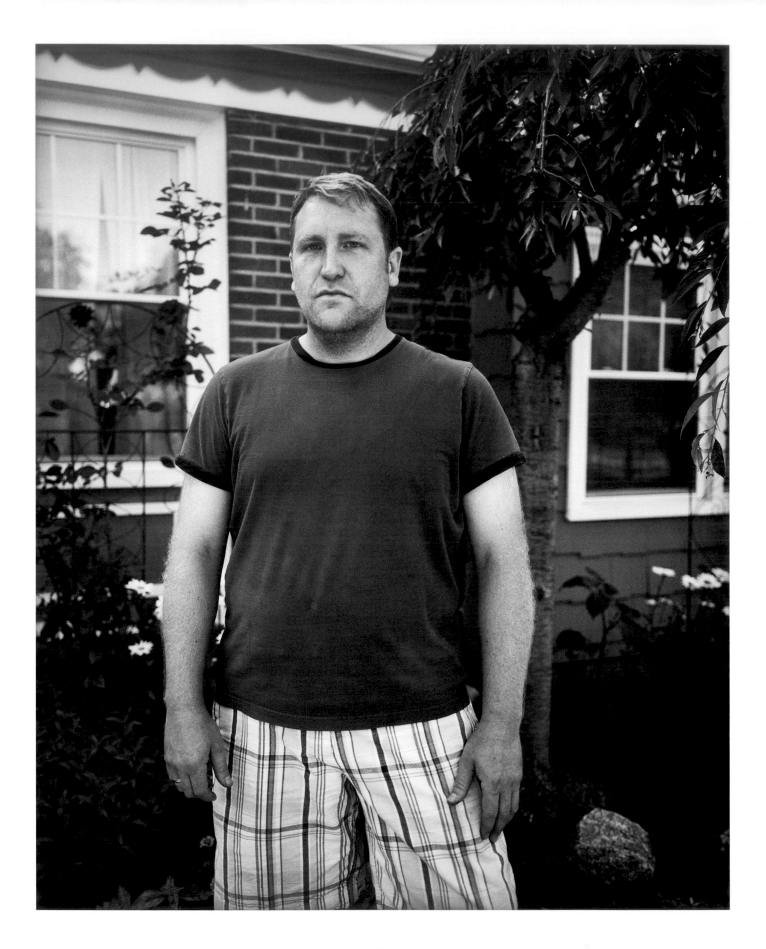

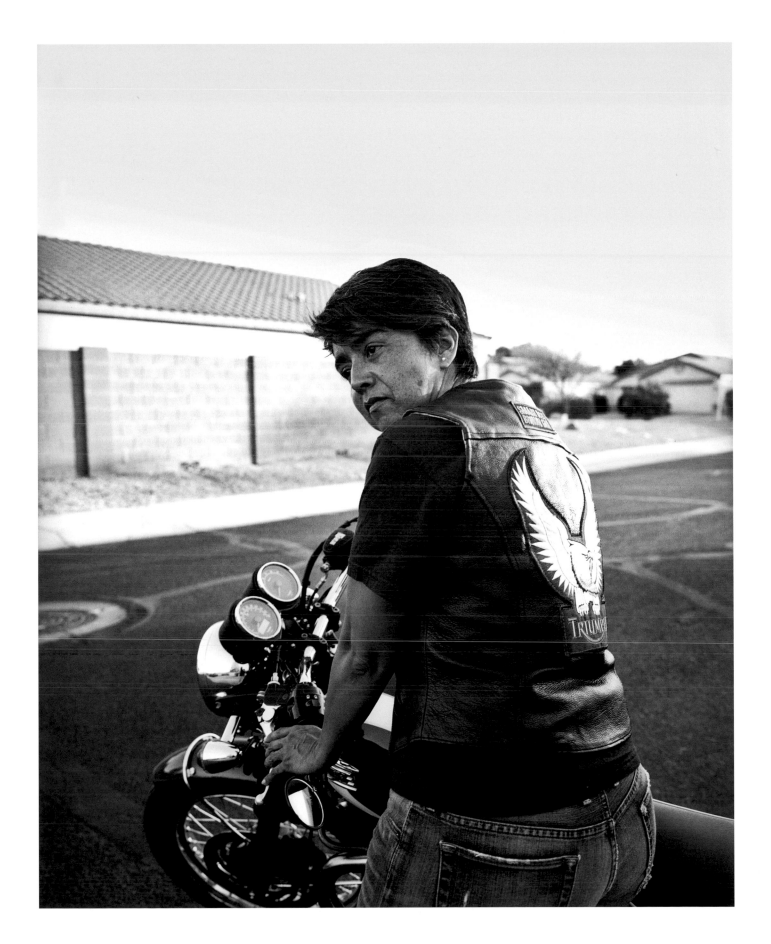

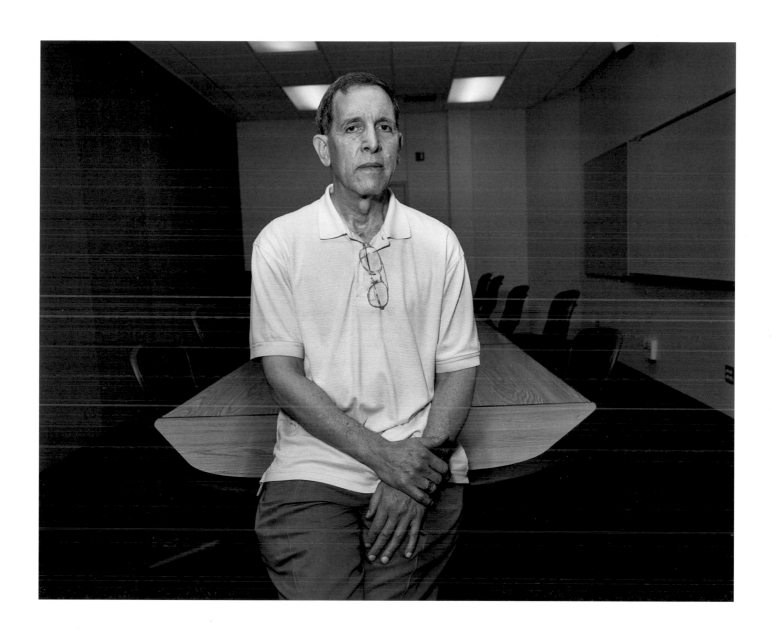

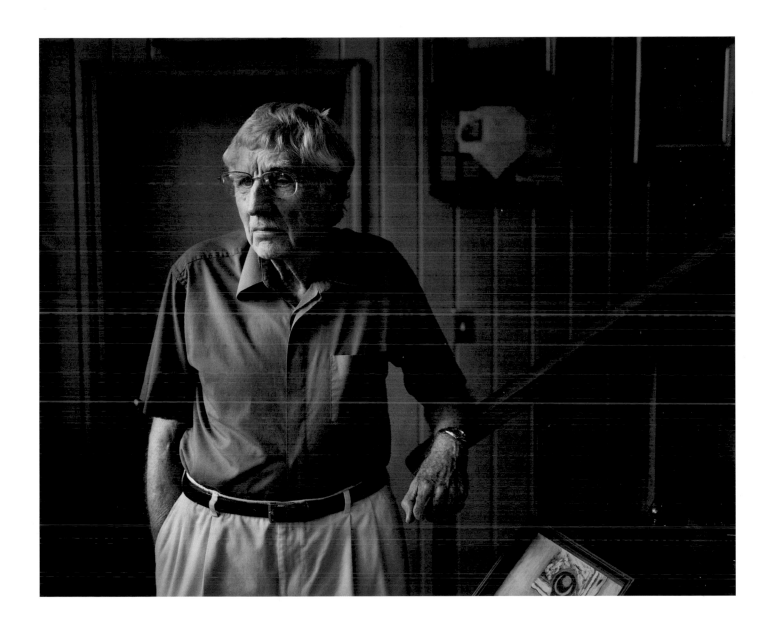

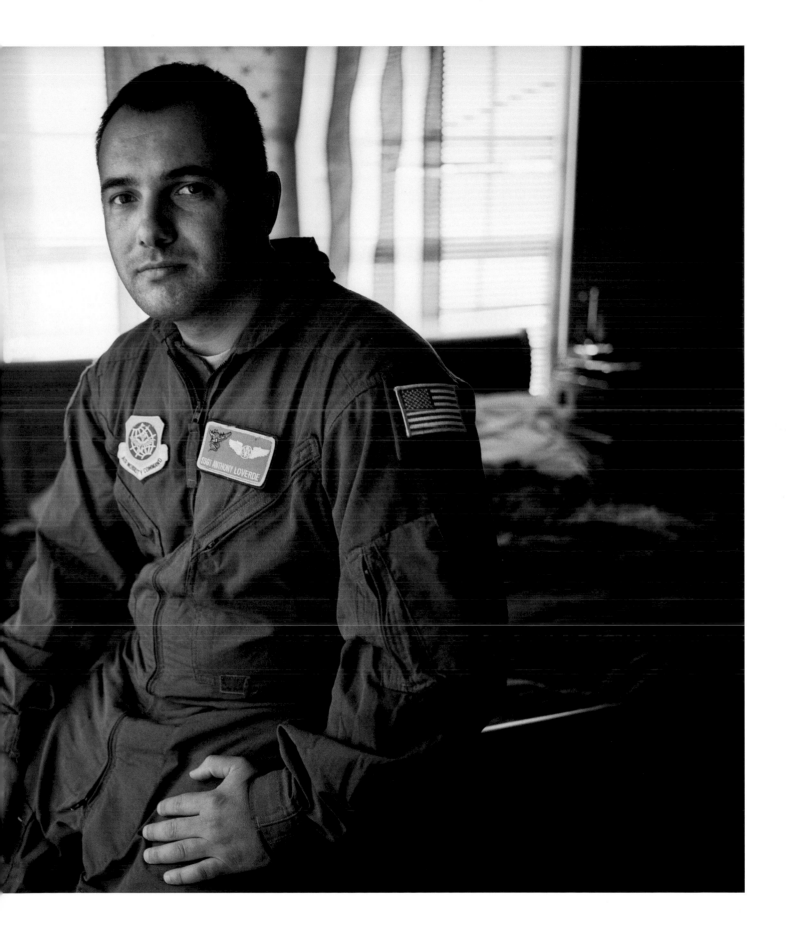

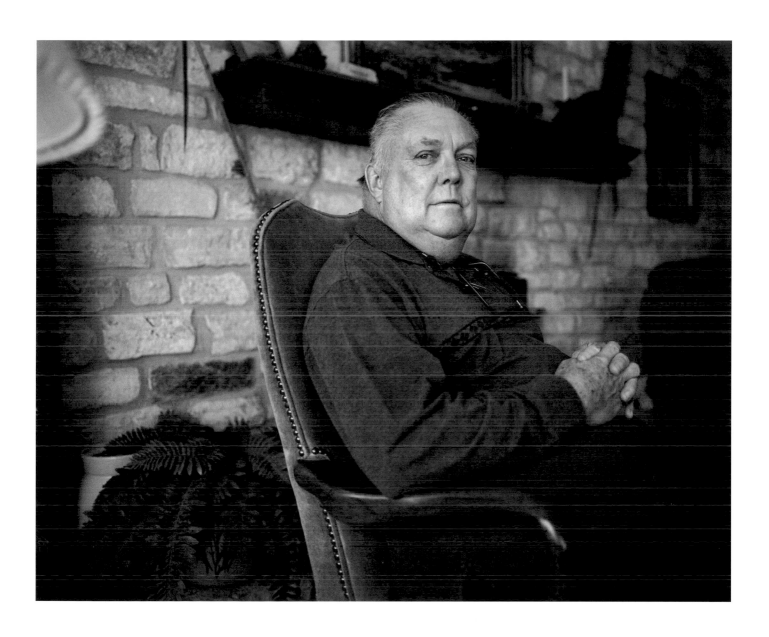

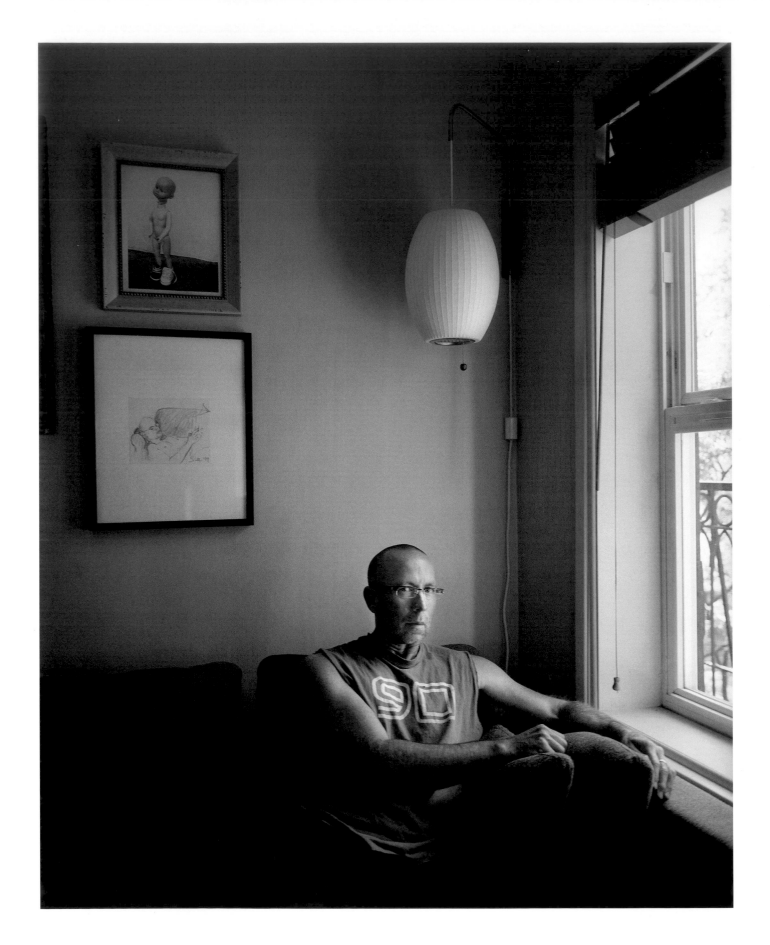

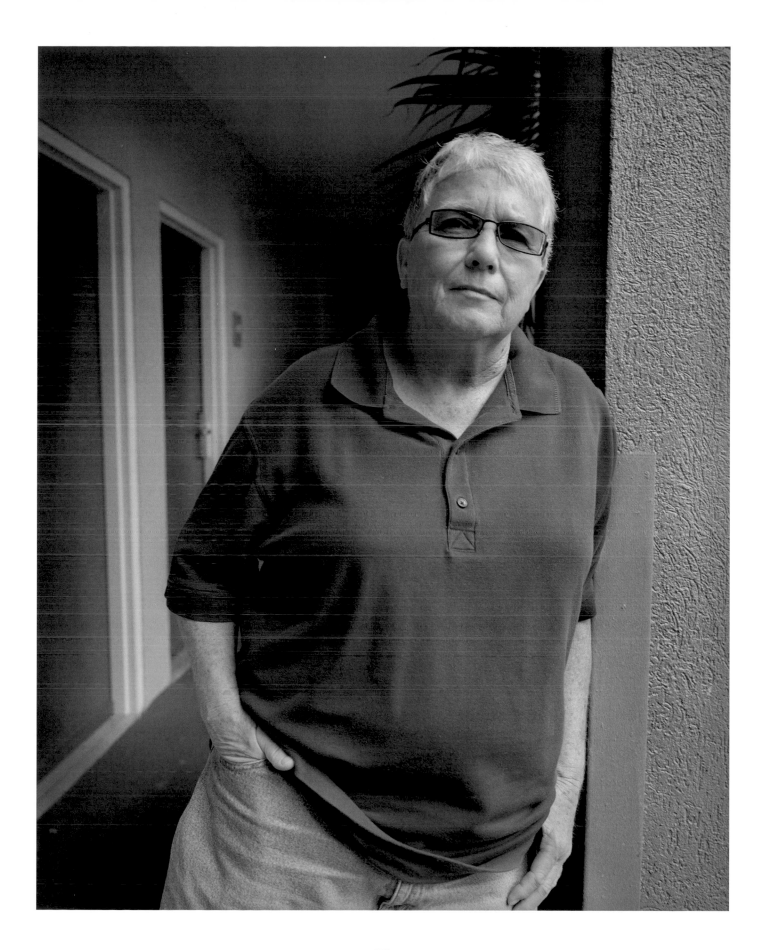

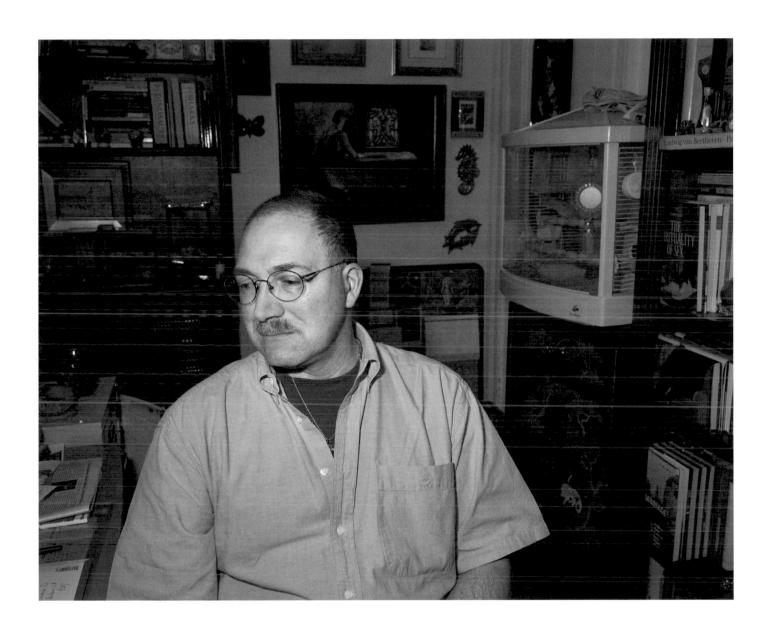

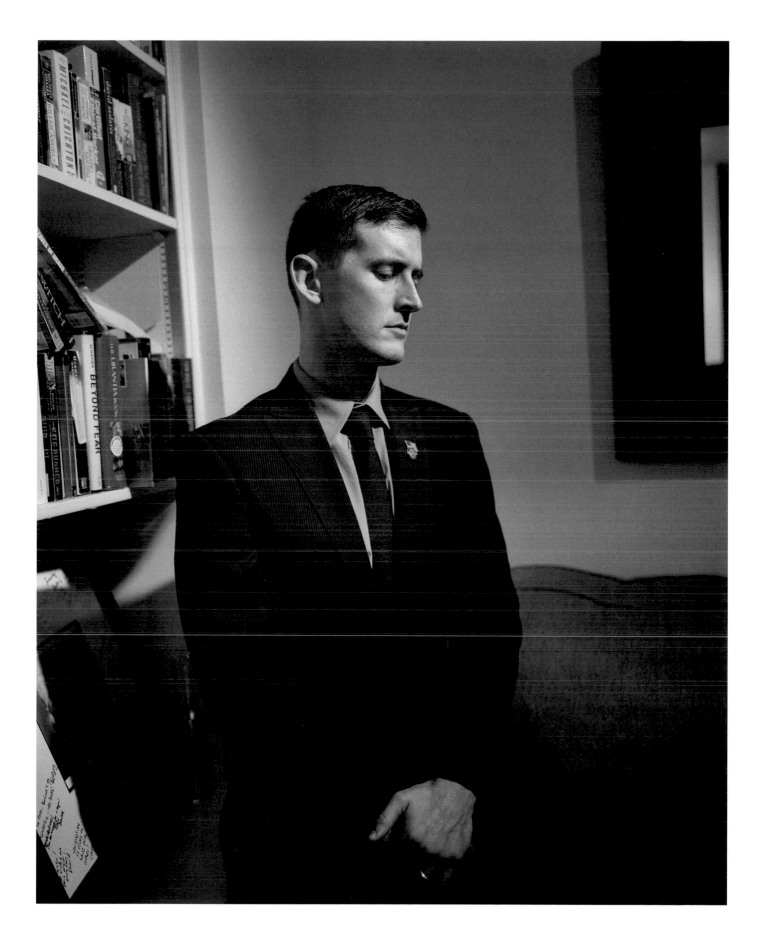

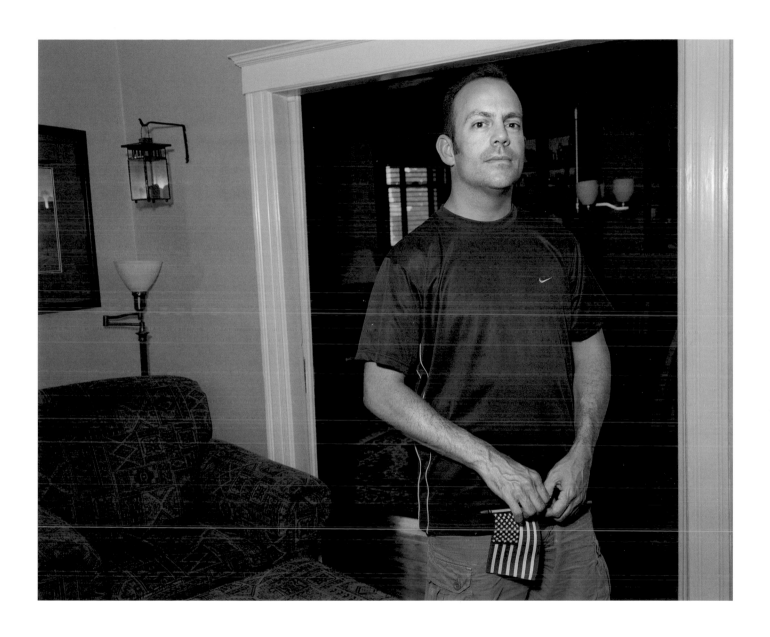

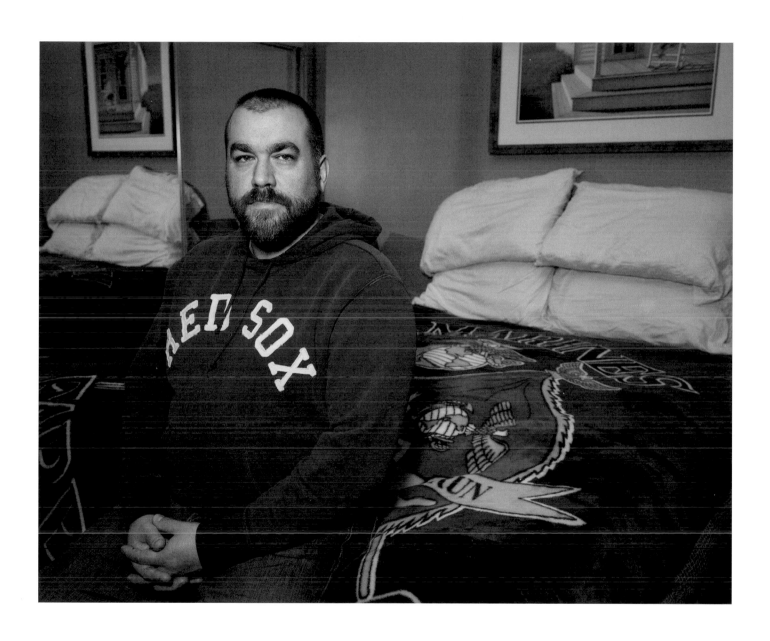

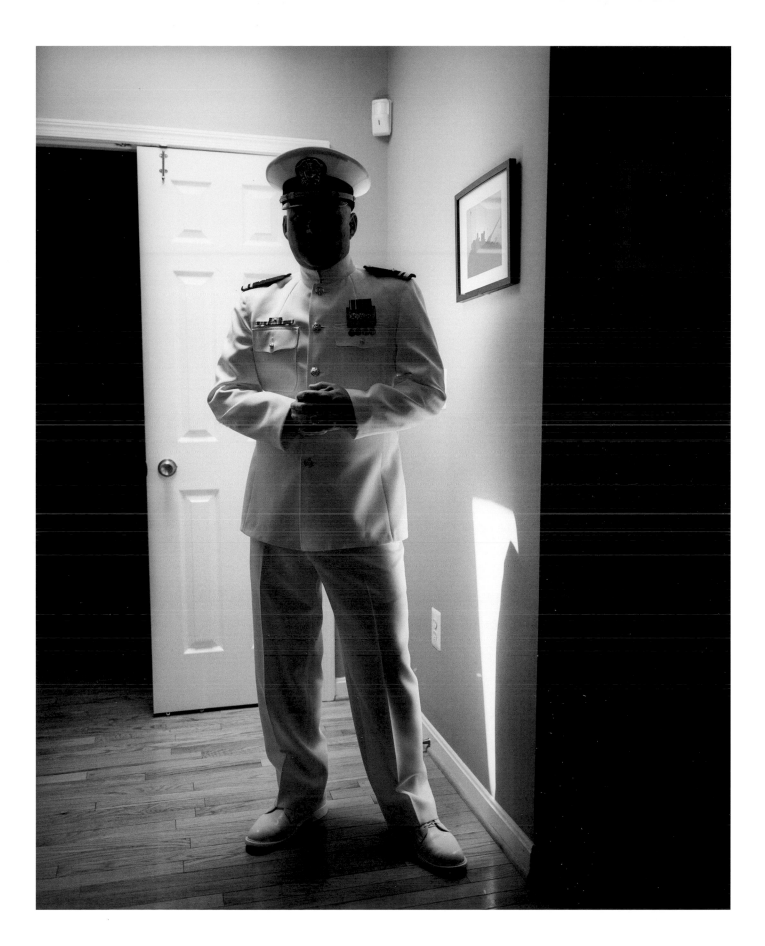

INTERVIEWS

PAUL GOERCKE, SAN FRANCISCO, CA, 2012
MESSMAN/STAFF OFFICER, U.S. MERCHANT MARINES, 1944–1945

World War II Veteran. Served in Okinawa, Ie-Shima Island,
Hawaii, and Saipan

I was born October 27, 1926, four days from Halloween! I did not follow patterns
of everybody else in terms of maturing and the usual things of childhood. I became
pianist of the church when I was ten. I wrote arrangements and picked up
evangelistic-style playing There was no evidence about gay life; nobody ever
talked about it in the family, which was very typical. We were very "churched" and
we read the Bible, so we must have come across Deuteronomy and other places that
take up this subject.

When I became eighteen I would've been drafted, so I chose the Merchant Marines.
During the war, we landed the Marines in the Ie-Shima invasion [off the coast of Okinawa],
it was a magnificent sight of flares and planes, and all in the air, and some in flames. It
was a horrible thing, fireworks in real life rather than something seen on July the
Fourth. I don't understand why the captain didn't bring a chaplain; with 1,500 guys,
you're bound to have at least one chaplain there, if not a dozen or so. Anyway, I knew
I was attracted to guys in a way, but I didn't put the dots together and figure it out.

All during the time in the service, I was on two troopships; they were both
Liberty ships, and one of them was the *James King*, and on that one, we went from
San Francisco up to Humboldt County and picked up a load of lumber. This was now
1945. In April, we were back in Okinawa, but this time not fighting a battle; the
war was just about over. We ended up in Tokyo Bay three weeks after the signing
of the surrender. We went up to Hokkaido and dropped all the lumber off there so
[the Japanese] could rebuild. Then we came back to Tokyo Bay, and during that time
I courted with GI Gospel Hour. I was twenty-two when I was out of the service.

I went back to Japan in '49 and worked there three years with ex-GIs. It was
during that time that I was getting involved in various things because of
all those GIs! I played for the Youth for Christ for all of Asia. They had a
truck to travel on. We held rallies in big auditoriums and these mass outdoor
rallies, because so many Japanese lived outside. All the places were so bombed.
But the thing that was so shocking was there were these two couples; they were
Baptist missionaries. One of the wives played the piano, and I played the organ,
a Hammond organ of all things. Anyway, I was moving on, looking at this and that,
and I discovered that in the Emperor's Palace area, there was this national
park. And there was a men's room. I went in there once or twice to look around,
and all these GIs were in there carrying on! And the two male missionaries
were there! Now it's a fusion of sex and religion! You had to realize that the
Roman Catholics are loaded with gays, especially the ones that go off into these
retreats and live on the sands or something.

<div align="right">

———————
PAGES 40–41

</div>

NATHANAEL BODON, MARLBORO, NY, 2009
SPECIALIST E-4, U.S. ARMY RESERVE, 2007–2009

Motor Transport Operator. Honorable discharge under
Don't Ask, Don't Tell

I joined the military September 11, 2007, went to Iraq in July 2009, and just returned after being "chaptered out" by the Don't Ask, Don't Tell policy. My goal for joining the military was my future. When I first went in, I went back into the closet because I was terrified. I had heard horror stories about hazing and people getting killed. I got to my unit in February of '08 and we were put on alert in June. I left for training for deployment, so it was about a year that I was drilling before I actually went on orders. My unit was stationed in Baghdad, but they tasked me out at Al Asad Airbase. My job description was container and TMR [Transportation Movement Release] manager, so I took care of packaging all construction materials and sending them out everywhere. I was responsible for $12 million worth of equipment. That was my job and I was doing it really well. I had my own office; I had my own truck.

In October, I started hearing from one of my friends who was in Baghdad, "Watch what you're putting online." So I started doing a little digging. It turns out that on my blog I had put my address [in Iraq] and a list of creature comforts that people could send in care packages. My unit name was in the address and I found out that if you Google the unit, 445th Transportation Company, then my blog would pop up. It was the fourth entry. Right after I found out that information, I get an email from my platoon sergeant and she said that the commander wanted me back in Baghdad as soon as possible. I was in the dark about a week before he finally let me know that someone turned in my blog because there are pictures of me kissing my boyfriend. Then he let me know that I'd be getting chaptered out. He said he was going to try to get me a general discharge and that I could challenge it later and try to get it switched to honorable. I wasn't going to sign anything unless it said honorable on it. It's the soldier's responsibility to prove that they are not gay. What does that entail? How do you prove your sexuality? In order to fight the discharge, I'd have to prove that I'm not gay.

It hurt that somebody screwed me over to that extent. I kept digging for information, and the signs kept pointing back to my home unit. When I left for the deployment I became really close to all those guys. They all said they had my back. One of them lied to me and betrayed me. That's really why it's important for me to know. Just for my own personal peace of mind I'd like to find out, but I don't know if I'll ever find out. Through this experience, I've become a stronger person; I've become a better person; I've matured a lot. It put me in a place where I wasn't before. I was able to get my life together and take some direction in life. Do I regret it? Would I have done it differently? No. Because you know what? There is nothing wrong with who I am. And for me to want to do something differently or hide who I am would mean that I am ashamed of who I am—and I'm not. And it would mean that I'm admitting that I did something wrong—and there's nothing wrong. I have the same rights as other people.

PAGE 43

BRUCE SIMPSON, WILKES BARRE, PA, 2009
SEAMAN, U.S. NAVAL RESERVE, 1970–1971
SERGEANT E-4, U.S. AIR FORCE, 1971–1974
Base Police Desk Sergeant, Airborne Strike Team. Honorable discharge, admission of homosexuality

I knew at six years old that I liked boys and that never changed one bit. I never suffered what many guys do, not being able to accept themselves or wanting to be converted. I just knew from an early age that this is the way I was born, this is what I was meant to be—for whatever the greater purpose is—and I'm fine with it. Personally I think it's a natural birth control method for the human race to prevent overpopulation on the planet.

All of my friends were burning their draft cards and smoking pot. I was going the opposite way; I wanted to get into the military. It was a way of getting away from home, of becoming an adult. I wanted the training and I also wanted to serve my country. I was a patriotic kid for some reason. I joined the Naval Reserve at seventeen, and in my senior year in high school, I was in boot camp at Great Lakes, Illinois. Came back to finish high school, and that summer I did a two-week training cruise and determined that the Navy was not for me. I was discharged honorably on the condition of enlisting immediately in the Air Force; I had a friend on Capitol Hill who arranged it. I was sent to Lackland AFB for basic and stayed there for tech school, Security Police Officers Training.

I had my first base assignment in F.E. Warren Air Force Base, Cheyenne, Wyoming. I wore the uniform with pride. I never had to be reminded of a shoeshine. No disciplinary actions at all. I definitely saw the possibility of spending twenty or thirty years in the Air Force. I came to love it that much. I was very good at what I did. I served as a base policeman, was trained to put on fatigues to go into the missile fields with an M16, and was part of an airborne strike team for alarm responds to our ICBMs [intercontinental ballistic missiles]. I was nominated to become a bodyguard for the commanding general of the Strategic Air Command headquarters, which was a very high honor for me.

In the midst of all this, OSI [Office of Special Investigations] put witch-hunt procedures into effect. I got called in and formally placed under investigation. One of the guys went to OSI and said, "He's gay." I blew up during the interview and basically told OSI to go fuck themselves. I got up and moved quickly to open the door and exit the office the way I came in. They tried to stop me; they wanted me to go out the back door because there was a Billy Martin sitting in the anteroom to be interviewed next. But it was the wrong Billy Martin. There just happened to be two guys with the same name. The one sitting in the next room knew nothing; there was nothing for him to know. Basically they launched a fishing expedition based on a rumor.

They jerked me back into the room, closed the door, and shoved me out the back door. I was sent from there to the squadron administrative officer where I was

served papers saying I was going to be discharged for being a homosexual. I was not dealing with that too well because if I had stayed in the Air Force, my lifelong dream was to be a cop. In the early '70s you could forget about being a cop if you were discharged from the military for being gay.

I would have been relieved of all my duties, and I should have been assigned to the goon squad—the drug addicts, the disciplinary problems—and what they did was spend all day cleaning the barracks. The commanding officer of my squadron found out about it and transferred me to his office for the remainder of the investigation. I had an envelope come in for the captain and I opened it; it was from OSI. It was a confidential report to the commanding officer on Billy Martin, who had been arrested downtown for exposing himself to an eighty-nine-year-old woman. And this was the correct Billy Martin. Here I am, knowing that my accuser has been arrested by the civilian police. I put it back in the envelope, sealed it up, and took it in. It didn't fool the captain; he knew that I had seen it and he just smiled at me.

During the investigation, they searched my off-base quarters. They went through the freezer, they went through everything and found nothing. We forced the Air Force to prove what they were saying. I knew there could be no proof; they didn't even have the right Billy Martin to start with. I went in there with my attorney; the judge advocate general turned the file over to him and my attorney reviewed the entire file; he handed it back and said, "We demand a court martial," and the judge advocate general said, "I don't blame you, it's the weakest case I've ever seen for accusing somebody for being gay." The next day the case was dropped. I was the first airman on that base to beat an active investigation for being gay. I was restored to duty, given my security clearances back, my weapons cards.

My CO [commanding officer] came to me and said, "I feel the Air Force owes you something. You can have your pick of any base in the world you want to go to and I'll make sure it's done." As a matter of fact, my CO wrote a letter of recommendation to my next CO, which just wasn't done in the military. I chose England and was sent to RAF Woodbridge, which was a fighter base with nukes, and once again served in base police. That's where things began to change for me personally.

I arrived on assignment and developed a pilonidal cyst. It's very painful and you have to have an operation to get rid of the damn thing. I had a male nurse. Once I started to get better, he said, "You're getting pretty good, you can get around. Do you want to come over to the barracks tonight; we'll have a beer or something." I said, "Sure. It'd be good to get out of here." I got into the room with him and we were talking and one thing led to another. I remember I put my head on his chest, and he said, "You know, Bruce, all you really need is somebody to love." And that is what really struck me. It was the catalyst. I knew that he was right; I did need that. And I wasn't going to be able to find it in the Air Force because of the anti-gay policy.

So when I returned to duty after about a month, I went to the major and told him I was bisexual. That was my only cop-out. I said I was bi because I figured it would be easier for them to deal with. He said, "I know." And I said, "Well, you know I was also under investigation on my last base." He said, "I know. I want you to turn around and walk out of here and believe that this conversation never happened." He

did not want me to leave the Air Force; he did not want me to leave the squadron. But I insisted on it, and once I insisted on it, he had no choice but to go ahead and start the process.

It was the procedure to code the reason the person was being discharged, and an employer would have a list of the codes and see what you were being discharged for. That had been the procedure up until April 19, 1974. On that day, I had gotten a call from my friend on Capitol Hill: "It's now in effect as of 12:00 today, make your move." And that's when I called the major and said let's do it today. I basically chose the day of my discharge. I was getting a lot of shit from one of the clerks in the area that processes it, and his sergeant turned around and reamed him and said, "You don't say a word to this man about anything to do with his personal life, you just process the paperwork and shut up."

And so, in April of 1974 I left the Air Force. I became the first one to go out honorably without the code. I can't say that I was disrespected in any way.

PAGE 45

VONDA TODD, AUSTIN, TX, 2012
SECOND LIEUTENANT, SOUTH CAROLINA NATIONAL
GUARD, 1983–1988
MAJOR, U.S. ARMY RESERVE, 1998–2012
Quartermaster, Fort Sam Houston, Texas. Retired

MARY HARRIS, AUSTIN, TX, 2012
MAJOR, U.S. ARMY, 1982–1987, AND U.S. ARMY RESERVE, 1988–2002
Adjutant Generals Corps, Fort Sam Houston, Texas. Retired

Both came under scrutiny and underwent questioning in an
investigation based on their health insurance beneficiary forms
and shared home address

VONDA: I was born in 1965 and grew up in Easley, South Carolina. I graduated high
school in 1983. I began to realize I had feelings for females probably when I was
in the ninth grade and actually had a girlfriend through high school. I joined
the National Guard when I was a senior. I remember having to fill out paperwork
and that question being on there. "Are you gay?" I said no. I wanted to join the
military and planned to have a career in the military. If I wanted that to happen,
it's what I needed to do. Was it right? Probably not, but I had a goal in mind.

We were a religious family. When I realized that I had feelings for females, my
mom was the first who knew. She loved me. She supported me. But we didn't talk about
it. I had moved away from home and my dad was diagnosed with cancer. He asked me
to come home. He said, "I don't care about what you're doing. It doesn't matter."
It was real vague. So, that was his way of saying I just want you to come home.

MARY: My father was career military, a mess hall sergeant. My parents were raised
in the South during segregation. As soon as they could get up north they did. I
was born on Fort Dix, New Jersey, in 1960 and raised there, the youngest of seven
kids. We went to Okinawa for a couple years—I was about five—and then we went back
to Fort Dix.

I went off to the University of Dayton and joined ROTC the beginning of my junior
year. At the time I wasn't gay, or didn't think I was. So, it was easy for me to
answer that question. I answered it truthfully at the time. I was commissioned when
I graduated. During my Officer Basic Course, I came out. I was pretty young when this
happened. I met a woman that I was very attracted to; she was ten years older than
me. I had a boyfriend and I broke up with him. I wrestled with the changes that

were going on in my life after I had this short relationship with a woman, but I didn't have any issues with juggling my homosexuality in the military. Things just fell into place for me. It didn't get difficult till I met Vonda.

I lived in Augusta, Georgia. And Vonda lived in Aiken, South Carolina, right across the river. We were both invited to dinner with this mutual friend of ours. I had gotten there early and got up to go to the restroom. Vonda and her partner were walking in and I walked right past Vonda. I got back to the table and she was sitting there with her partner. My friend introduced us. Vonda had just finished college and was looking for a job. I was talking to her about where I worked. A few days later, we started talking. One thing led to another over the course of a few months.

VONDA: That was our "wow" moment. It was hard because I was in a relationship. The worst part about that was I hurt her really bad. She didn't deserve it. She didn't do anything. It's just where my heart was.

MARY: We started dating in July of '07. I was a major working for a company and I put in for a job. I found a command in a public affairs broadcasting unit in the Reserves. I remember asking her, "If I get this job, would you move to Texas with me?" Neither of us knew anything about Austin. And Vonda had never lived out of South Carolina. Vonda's very religious. Sunday mornings we'd have donuts at Krispy Kreme and then go our separate ways. Vonda would go to church and I would do the laundry. She was looking at me and crying and said, "As long as we find a church and we go to church together, I'll move with you." We were with each other less then a year when we moved.

VONDA: I was raised with a spiritual foundation. I attended church. I grew up like that and just maintained the faith.

MARY: This other opportunity came up in San Antonio and I was offered that command. It had a lot of problems. There were three captain's positions and none were filled. I needed good officers, so [Vonda] joined the unit. Everything was fine and they liked her, but there were some changes that needed to be made. You have to come in and be a hard ass is what it came down to. People don't like change. The unit administrator ran things, but she just wasn't good at what she was doing. She and I bumped heads. The first sergeant and I bumped heads. All of a sudden, the Inspector General (IG) called and said, " I'm going to be pulling some of your soldiers out tomorrow to ask some questions about an investigation. There seems to be two people in your unit who share the same address, you and Captain Todd." The way he did it was weird to me. My colonel said, "You don't have anything to worry about. You're doing a great job. You're a fantastic officer. Just go answer your questions and you'll be fine."

They interviewed me and Vonda. We never admitted we were in a relationship and they never asked. They knew they couldn't. They questioned our service members' life insurance; we had each other as benefactors. He questioned why we lived together and I said, "Have you seen the cost of living in Austin?" A week later, [my colonel] was in Austin and I went to see him. I go in and he says, "We're going to have to take Captain Todd out of the unit because she's nondeployable." Vonda had some health issues. They offered her a command and never said anything else. We never knew what happened with the IG investigation.

VONDA: When a soldier has a complaint and they go to the IG, they have to turn it into a formal investigation. We don't know what the initial complaint was. But, I'm sure it was the unit administrator because she is the only one who has access to those records. We could have turned around and filed a complaint for privacy issues.

A few years later I had to get my civilian medical records for the military. I had gone to my gynecologist and she had written that I was high risk for HIV because I was gay. I had them transferred [to my command] without going through them.

MARY: Her unit administrator knew Vonda was a good officer. She handed her the records, walked out of the room and said, "Do what you need to do." Vonda just took that piece of paper out. Not everybody has those kinds of stories. It comes down to how one person feels about you. You look at somebody crossways and your career is gone.

VONDA: My retirement ceremony was in February 2012. It was time for me to leave. I had done my time and [I had] medical issues. The latter part of my career did get hard because our daughter, Danielle, was getting older and it's hard being a single parent, even if it is just for a weekend. When I spoke [at the ceremony], I introduced Mary as my partner and Danielle as our daughter and thanked them for their support.

MARY: She didn't want to do it because she was sick of the military. I said, "We need to do it. Don't Ask, Don't Tell didn't stop people from asking questions." They go after you for the wrong reasons. If Vonda was to deploy and something happened to her, I wouldn't be the one to get the call. The military can say, "Well, you're nothing." When we were younger and just us, I don't think we thought about it as much. But when a child comes into the mix, it changes everything. We didn't want to put Danielle in that position.

It was neat to be able to go to her retirement and for her to be able to recognize her family there, despite their discomfort. They're going to have to get comfortable with it. Vonda's not going to be the last one. The soldiers that worked for her came up and shook my hand and talked to me, and talked to Danielle. You could tell that they just weren't fazed by anything. But of course, they're younger. They're more open to things. It's totally changed now. It's a whole different military, a whole different mission.

PAGE 47

138

MARQUELL SMITH, CHICAGO, IL, 2010

SERGEANT, U.S. MARINE CORPS, 2000–2006

**General discharge under honorable conditions; command made
assumption about sexual orientation and having AIDS**

I had been in the Marine Corps two years, through two duty stations. My commanding officer respected me and he valued what I had to say. I received the highest performance evaluation that this major had ever given any Marine sergeant. He made me want to be an officer. I applied for the Enlisted Commissioning Program and got selected in October 2005.

I was dating a Marine but we had broken up. I got a call from the person that he was currently dating to tell me my ex was HIV positive. I called my ex and asked him, "What's wrong with you?" He says, "I'm positive." I said, "May God have mercy on your soul" and I hung up the phone. I felt incredibly hurt and I certainly believed that I was HIV positive because we were not using protection. There was no reason not to think so. I went on base to go get an HIV test. It took two weeks to get a response back. I was anxious and didn't know where to go off-base to talk to someone about what was going on and in a moment of weakness, I walked into the first sergeant's office. I didn't know anything because of the Don't Ask, Don't Tell policy. I was almost in tears.

When I walked out of his office, he said he was going to help me and I believed him. My ex had told me that my command called his command, and they were out to get me. I remember getting a call from the first sergeant: "The major said they don't want this in the officer corps. He said you could stay enlisted, but you can't be an officer." I said, "Well, you tell the major he's going to have to prove it." They were unwilling to do any investigation. The first sergeant provided a statement that said I was gay and I had sex with both men and women. We never had any conversation about who I was having sex with. He made three different statements, all of them inconsistent. My attorney did everything to fight this, but despite that, they still decided to discharge me.

I asked to be removed from the command because I was concerned about my safety. It got to a point where I was walking around with a recording device. I had a number of conversations recorded that indicated that something funny was going on. The first sergeant had inappropriate conversations with me; I could prove the major was coercing him. I don't have those recordings because from a legal standpoint, should I have brought those up, I would've been in trouble for wiretapping. I was very worried. No one would protect me and so I ended up not saying anything at my board hearing. I ended up writing a statement indicating that I had made no affirming statements to the first sergeant regarding my sexual orientation.

I was discharged on July 17, 2006: general discharge under honorable conditions— for one reason only, because I fought. I felt I had served impeccably my entire career and the outcome should be no different. When I walked off of that base, I

cried. I cried not because I was sad; I cried because I finally felt what freedom was like.

My ex is still serving. He was never discharged or investigated. His command determined it was hearsay. My command determined it was sufficient evidence. Here's the irony in all of that. My first sergeant and my commanding officer were both African American. I absolutely understand what it took for both of them to be where they are. I remember the first sergeant discouraging me from the commission because he said that there was no room for us there. I can understand that homophobia in the African American community is so deeply entrenched and had huge implications as to why they did this. I think the last thing that anyone wanted to see was that I be commissioned as this gay African American officer.

I always wanted to be an officer. I think being African American had everything to do with why I fought. I felt that so many people told me what I couldn't do and I wanted to show everyone what I could do. I had family members that told me I wouldn't make it. Did I do it to prove people wrong? Maybe. Did I have days where I wanted to walk away? Absolutely. At some point, something happened. I came under some great leaders, and something happened where I literally wanted to be the best that I could be. I wanted to be Marine Corps.

I felt that in my darkest hours, the Marine Corps turned their back on me. After I got out, I wouldn't even discuss having been a Marine. I needed to grieve; acknowledging I was a Marine was difficult. I talked to some of the greatest leaders after I got out. The same gunnery that asked me to come work for the sergeant major in the Marine Corps said to me, "It's not everyone in the Marine Corps, it's just individuals. Always remember that." And she was right, it's just individuals.

PAGE 49

YVONNE BISBEE, ATASCOSA, TX, 2012
TECHNICAL SERGEANT, U.S. AIR FORCE, 1979–1999

SIGINT Analyst, Intelligence Analyst. Retired; repeatedly
threatened with being outed throughout military career; suffers
anxiety and panic attacks

I lived just outside of Erie, Pennsylvania. I knew I was different. My mother was
physically, verbally, and mentally abusive. I fought tooth and nail every step of
the way, but I learned at a very young age that it wasn't me who was the problem.
That protected me. I've always been strong-willed. I don't think she liked the
defiance she saw in me. My stepdad was the buffer between us, but when I came out
to him, he would have nothing to do with me.

I did not want to be stuck in a small town for the rest of my life. I had a
partial scholarship to a local school to play volleyball and I talked to my
mother about it. They couldn't afford to send me to college, so she took me to the
Air Force Recruiting office: "My daughter wants to enlist—sign her up!" I enlisted
with delayed entry in December of '78. I was pissed at my mother, but it turned
out to be one of the best things she ever did. It opened the world to me.

I was seventeen, barely out of high school, and I fell in love for the first time
with a woman. I met her in tech school and it was an instant attraction for both
of us. My stomach was in knots when she would come around. She made me realize
that is how I want to live the rest of my life, but I knew enough not to show it,
because my career was important to me and I wasn't going to jeopardize what I
could become for who I was out of uniform.

My older sister and I were never close; there was always a mutual dislike. She
entered the Air Force in 1978, a year before I did. My first job was a Morse
systems operator. That was also her career field. The intel world is small and her
presence in it haunted me my entire career. I cross-trained and became a SIGINT
[signals intelligence] analyst before being sent to RAF Chicksands, England, where
she was already stationed. A few days after I arrived, we were driving onto base
and she pointed out the female security police on duty and told me to stay away
from Mr. Man—she referred to lesbians as Mr. Man.

I never told my sister I was gay; we never discussed my personal life. I'm not
sure when she actually found out, but with that knowledge came power over me. At
first it was comments like, "Are you seeing Mr. Man?" Then it was not being invited
to my nephew's school events, to not being invited to birthdays and holidays. If
I pushed her about it, she would say, "You know I could end your career with one
phone call" or "I'm sure OSI would love to know you're gay."

I never doubted for a minute that she would make that phone call. It got to the
point where I quit trying to be a member of my own family. I was afraid she'd go
through with her threats and my career would be over. I was more afraid of

the fallout to my friends. The Air Force loved getting other gays simply through guilt by association. It was one thing if I lost my career, but I wasn't about to see it happen to my friends. I finally quit being afraid of losing my career on the 21st of May 1999, the day I retired.

My anxiety/panic attacks began in the mid '80s as a result of living two lies, or lives: I couldn't talk about my job at home and I sure as hell couldn't talk about my personal life at work. I started to feel invisible. At first the attacks were minor. They would come out of nowhere. Large crowds of people would cause them; movies at the theater became a thing of the past. Knowing I had to be outside in formation would guarantee one. Trying to explain to someone what was going on made others look at me like I was crazy, so I quit explaining and suffered through them. I drank to avoid the attacks and mask the symptoms.

My first major attack landed me at the ER in the summer of 1998. I thought I was having a heart attack. After hours of tests the doctor came in and told me I had a severe anxiety attack. There were many contributing stressors: caring for my mother after she was diagnosed with a brain tumor, I was about to have major surgery myself, and looking at less than a year left until retirement and not knowing what I wanted to do with the rest of my life, plus the fact that I was still invisible. It took a while, but I quit drinking and now take medication to mask the symptoms.

For thirty years I lied about who I was; twenty years in the Air Force and ten years in the corporate world. Gays didn't fit into the grand scheme of how things should be. Some of the best analysts and linguists I've ever worked with are gay. We have gone places. We have done things. And we have done it twice as well, because we're dedicated to the job and mission. We had to prove to our straight counterparts that we were just as good as, if not better than, they were. It's always been a challenge. Lesbians and gays in the military have always been more motivated to doing a better job. I don't know if it's just a sense of pride in ourselves, or if we're just overachievers.

PAGE 50

JAMES HALLORAN, SAN ANTONIO, TX, 2012
SERGEANT E-5, U.S. ARMY, 1974-1978

Russian Linguist Voice Intercept Operator. Honorable discharge

I was born 1954 in Scranton, Pennsylvania. Roman Catholic identity was a large part of growing up. Neighborhoods were defined by which parish you belonged to, which was a surrogate for, "What is your ethnic heritage?" The highest political office (although it wasn't elected) was the bishop, because that was the ultimate authority. The rules of the road were not voted on, they were handed down. And the value was on submission rather than on what we would call one's individual process. That environment does a very good job of creating the appearance of living by those rules and believing those rules!

That was the '70s, the era of great promise, the Age of Aquarius. The staff of life was beer! Smoking dope and popping speed was just how the world was. I went to university in Philadelphia. Being in the bigger city presented opportunities that did not happen at home and I remember having sex with somebody, though I don't even remember exactly how it happened. Still no sense of declaring myself to myself as a gay man, and a common rationalization [I used] was, "OK, if I do this, I'm not going to get sent to Vietnam," because my concept of the military—"the Army" we used generically to mean military service—was just part of the fabric of our life.

Perceptions of the Army had changed and the draft and war in Vietnam was about over. So that wasn't going to happen to me if I went and talked to these guys. The attraction for me was quite practical, actually. I heard that the Army had these tests they can give you to tell you what to do. And my recruiter, Sergeant Doll, made it sound like finishing school. He painted it up wonderfully. And that was where it started. After boot camp, I was stationed for a year close to San Francisco. Language school seemed to have a good number of gay men. Many were training to work in intelligence or security fields and there was a generalized paranoia, much like in the civilian world. Lots of speculation and nothing said out loud, but recognition of a shared attribute and an emergence of social networks, but little if any sexual activity in the barracks.

One weekend our classmates went to Disneyland. Ben, like me, remained behind. He let me know he had a friend who lived in San Francisco, the epicenter of the emerging gay movement in the 1970s. Ben was urban Detroit to my suburban Scranton, black to my white, Protestant to my Catholic, musical to my tone deaf, savvy to my naive. We were young, buffed up from boot camp, and new on the gay block in the Castro. I had my first date with a guy, Rick, who lived there and we saw each other whenever I could get to San Francisco. It was the classic summer romance, Memorial Day to Labor Day.

After language school, I spent a couple months in West Texas at a small air force base where the commander was a not very secretly gay woman who earned respect from all. Despite being a security base, there was a fair bit of interaction with

local civilians. My roommate in the barracks was also gay and we wound up dating two local civilians who were friends. Then duty assignment to D.C. meant immersion in another kind of fantasyland where things were not as apparent as in San Francisco.

Several years later, I wind up working with HIV-infected active-duty service members. People have no clue how important the Department of Defense was in HIV research. They link HIV with gay men but do not link gay men with military service, choosing not to inform officially unacknowledged active-duty gay men of the need to understand and address the threat of this disease within the uniformed services. The contributions of those brave men and women will likely go unsung in the history of the pandemic, just as the sacrifice of today's service members gets yellow-ribbon bumper stickers or priority boarding at the airport, but not a lot of substantive understanding or ongoing support.

PAGE 51

MIKE ALMY, WASHINGTON, D.C., 2010

MAJOR, U.S. AIR FORCE, 1993–2006

Air Control Systems Manager. Deployed to the Middle East four times; discharged under Don't Ask, Don't Tell; pursuing reinstatement

In my early thirties, I was trying to fully understand who I was as well as the implications of Don't Ask, Don't Tell. I had been in the military ten-plus years. I had every intention of staying twenty years to retirement and make a full career out of it. I realized it was a sacrifice I would have to make, keeping my private life separate from my professional life and in all likelihood never having a significant relationship.

When I was in Iraq, the Air Force restricted all private email accounts; we had to use government email on the government network. We used that primarily for work purposes but also for personal use. I used my email writing to family and friends. My unit rotated out of Iraq and the new unit came in and someone, somehow, stumbled upon my private emails. Instead of just deleting them, [he] proceeded to read them, found a couple emails that peeked his interest and raised them up to his squadron commander. They ordered a search of my emails—over 500—and pulled out maybe a dozen or so that were damaging to myself as far as DADT. So in the middle of the Iraq War, during the height of the insurgency, they were searching private emails to see if someone's violated DADT. They conducted the search without ever getting a lawyer involved. They forwarded those to my commander back in Germany.

About six weeks after we had been back in Germany, my commander called me into his office and the first thing he does is read me the duty policy on homosexuality. I'm sure I must have turned ghost-white because I had no idea that any of this was occurring or had taken place. Then he hands me the stack of emails. I look at them and I recognize them as ones that I had written. But in the back of my mind I'm thinking, "How the heck did you get ahold of these?"

He asked me to explain the emails. I said, "I'm not going to make a statement until I talk to a lawyer first." We went around and around for about twenty minutes and he realized that he wasn't going to get anything out of me. He relieved me of my duties right there on the spot. It had a horrible disruption to the unit. A few months later they suspended my security clearance, took away part of my pay, and the whole thing dragged on for about sixteen months before I was finally thrown out of the military. On my last day I was actually given a police escort off the base like I was a common criminal or a threat to security.

Initially I was suicidal because I was devastated. I couldn't compose myself; I didn't want to get out of the house, I just wanted the entire thing to go away. That lasted for probably a month or so, and it was really only through a few very close friends that really gave me strength because I had none of my own at that point. They're the ones that pulled me out of that initial phase. I'm sure I was depressed for two or three years afterwards.

I knew the rules as far as DADT. I never told. The Air Force in essence asked
by searching private emails. I refused to answer the question. And yet I was
still thrown out. I maintain to this day that the Air Force violated DADT by
searching the emails. And yet no one else was held accountable for that. No one
else was punished.

I didn't realize it at the time, but looking back on it, I realize you can never
be fully honest or open with people that were close to you, with people that
loved you or people that you worked with every day. There is this constant
barrier around your private life. It takes its toll after a while. You become so
compartmentalized and so internalized that you don't even realize it.

PAGE 53

ZACHARY WERTH, BOISE, ID, 2011

SPECIALIST, IDAHO ARMY NATIONAL GUARD, 2007–2010

Medic. General discharge under honorable conditions, erroneous enlistment; used as a smokescreen for homosexuality

DUSTIN HIERSEKORN, BOISE, ID, 2011

PRIVATE, U.S. MARINE CORPS RESERVE, 2010

Discharged for medical reasons two weeks after basic training

ZACH: I was born April 9, 1987, in Challis, Idaho. My mom had me at a very young age. My father was out of the picture when I was two. Mom dated a lot of older guys in the military. My grandpa was a lieutenant colonel, Green Beret. He would make me fold my bed with hospital corners before I got any presents at Christmas. It was, "Yes, Sir" not "Thanks, Grandpa." So it was always pushed on me to join the military.

Towards the end of high school, my mom kicked me out of the house. I graduated and came down to Boise State University. My brother was having problems, so I put college on hold. My mom became dependent on pharmaceutical drugs; she had credit cards in my name and ruined my credit. At that time they were offering a $20,000 enlistment bonus. It was a chance to pay off my debt and go back to school with the GI Bill. I wanted to help people, so I chose to be a medic. I swore in on November 1, 2007. The day I graduated from basic training, I shipped off to San Antonio where I started medical training.

San Antonio is much bigger than Boise, so I got to go to my first gay bar. Somebody poured a date-rape drug in my drink. I was going to pass out, so I ran out and fell into a cab. I had my dog tags on, so the cab driver knew where to take me. I ended up waking up in the hospital because I was dehydrated. They did a toxicology report and my platoon sergeant had to do a report on what had happened. They asked where I had been and I had to tell them what bar it was. I used the excuse that I didn't know it was a gay bar. I didn't go out for quite a while. I'd spend my weekends on base. I was still scared about being open. Everything was smooth until I got home.

I was stationed with a CAB Scout unit in the medical platoon. I had MySpace, but I didn't have my profile set to private. Somebody looked me up before I got home and told other members of my platoon that I was gay. People ask me on my first drill if I was gay; they told me it was talked about among some NCOs [noncommissioned officers]. One of them was extremely homophobic and he went to his team leader, a staff sergeant. He was not my team leader, he was not my squad leader, he was not my platoon leader. He was nobody I had to take orders from, but he took time to call my house one night and tell me, "What you do in your personal life had better stay that way. I don't want to hear about it, I don't want to see it, and

I don't want to hear any complaints or I'll go to the commander with this." He went out of his way to find my number and threaten me, so I figured if he could do that, how far would he be willing to go to find something incriminating against me.

I was seeing Dustin and I was scared because I was our provider. That's my job. It's something I'd worked hard to achieve—my rank, my medals. I was terrified that he'd tell, no matter what I did. Whether I played their game or not, they'd turn me in anyway. I turned to my commander. I was very cautious about what I said, but at the same time I'd gone in there unplanned. I'm tiptoeing around the issue, trying not to out myself and trying to let him know what has been going on. I was scrambling for any outlet to get away from them, to not be outed anymore than I already was. I looked at getting transferred to a different unit. I didn't care if it was ridiculous bullshit training that had nothing to do with my job. I'd go to pre-ranger school if I had to just to get away and not have my livelihood threatened.

When I went in to talk to my commander about the harassment the second time, he said, "Let me set up a meeting between you and me and the squadron commander." A week later, my unit commander stood behind my squadron commander and didn't say a thing. The squadron commander said that he'd been informed of the harassment, he'd been informed of my complaints, and one of the first things he said to me was "I have no doubt that eventually Don't Ask, Don't Tell will go away. I understand that we've been having some problems, however Don't Ask, Don't Tell isn't gone." That's all he said to me. And then we got the order that our unit was being deployed to Iraq and we started training.

I was seeing a cardiologist. I had a condition that would not have allowed me to join without written approval from a doctor. And that's what they used. So in the midst of a deployment, I was discharged—general under honorable conditions—for erroneous enlistment. I lost my insurance and my job. I was told by one of the officers who signed my paperwork, it would be as if I never joined, and my service didn't mean anything. After three years, they decided to look at my medical records. They were looking to get me out without Don't Ask, Don't Tell. I lost everything I'd worked hard for.

Shortly after I lost my job, I lost my apartment. Medical bills racked up from seeing a cardiologist. I had a hard time finding work for a long time. I went from the military to a seasonal position. I still have all of my medical certifications, but right now, EMTs are not in high demand. My goal is to save up money so I can get back in the medical field.

I hate them for what they did. I don't understand how people could do that to someone. I keep all of my medical and military documents, all of my certifications, awards, medals. Sometimes I think about framing them because I'm proud of them. I'm proud of what I did. But at the same time, I feel like I'm justifying my service to myself, that I did serve. I would hope that my service mattered to someone.

DUSTIN: I was born December 16, 1985, in California. We moved to Colorado when I was twelve. My dad got laid off from his trucking job, lost everything, so we lived in our motor home for a couple of months and then stayed in Canon City for a year and a half. My parents split up, so me and my dad left for Sterling,

Colorado. I wanted to get into law enforcement and one of the things that they look for is military background. I thought that would make my dad proud 'cause he was in the Navy. I was skeptical with my vision; I thought that was going to hold me back, so I lost interest.

My parents had gotten together again and I was dealing with coming out. I tried hiding it. My parents didn't accept it and to this day I'm really not out about it. Family life went to crap and my parents threw me out of the house and took away my truck. I ended up moving my stuff in with a good friend of mine. He was straight and only had a little one-bedroom apartment. That's what got me through a lot of it, plus a lot of beer.

My parents retired from the Department of Corrections and they moved up here. I stayed back; I had a good job doing insurance and was licensed. Then that company fell apart. Everybody got laid off. I had nothing and my one roommate wasn't paying his part of the rent so we were falling behind and my dad's like, "We'll come get you." He brought a truck and we towed my second car and put everything I owned in two cars and a pickup.

[Zach and I] started talking. I finally asked him out and would drive into Boise all the time to see him. I loved him right away. We got an apartment together 'cause we both were in bad housing situations. We started making our home together and then it was time for him to go on deployment. I've always been proud of him, but it was rough on me. I didn't know if he was going to come back. I was scared. Part of me was grateful for him getting discharged, so I didn't have to worry about him—he would be with me.

I wanted to be as strong as he was. He's helped me so much financially, now it was my opportunity to do the same for him. He was the one that gave me the courage and support to do it. I've always had an interest in the Marines. I thought they were the most respected. I wanted to be the best of the best. So I sat down with a recruiter. He told me, "Don't Ask, Don't Tell is going away, but here at the Marines we don't accept it. If that's who you are, you need to find another branch." I had to sign papers about not being gay.

When I was at the Military Entrance Processing Station [MEPS], they had me do the standard eye test, 'cause they said I was color blind. They pulled me out of the screenings and sent me to a downtown eye doctor in Boise and did a full eye exam there. According to them, I'm not color blind or as bad as what MEPS was saying. And so they signed off on it and they passed me through. I swore in and when I did, that was honestly one of my proudest moments of my life. I was in tears as I took my oath. I was happy that I was going to be there like Zach and make him proud of me.

I had to wait for my deployment. I ended up talking to my recruiter; I just wanted to go and get it over with so he bumped me up. It was originally targeted for March and they ended up bumping it up to January. My day came, and I left. Day four on base, they went to do my vision screening. They said I had myopia and that my astigmatism was more severe than what they had thought it was. My corrected vision was their baseline of what their noncorrective vision is allowed, so it was pretty much three strikes right there.

ZACH: The whole plan was [Dustin] was going to go in. I actually moved in here with my friends as their roommate while he was gone. We sold a lot of our stuff—our dog, our thousand-dollar couch, everything—just to prepare for him to leave. I was happy doing it, 'cause that was a big step for him to take. Within two weeks everything that we planned is just thrown out the window again. He was coming home to no job. I was only doing temp work, so money's not exactly steadily coming in. It was supposed to be me here with my roommates and all of a sudden it's either they have to let him stay or we have to find another place to live. We didn't know where we were going to go from there.

DUSTIN: I felt like I failed. I know in my heart that it's not my fault. I was afraid of what we were going to do and where we were going to go. I didn't know how things were going to be. And it turned out after being here for a little bit it just never felt like home. It felt like we existed in that back room. We had to deal with car repossession; it was tough. We struggled financially for quite a while after me coming back and here it is now, six months after me getting home, and we're just now starting to get back on top of things.

PAGES 54-55, 248

CHARLES CHRISTOPHER BYRNE, PLATTSBURGH, NY, 2011
OPERATIONS SPECIALIST SECOND CLASS, U.S. NAVY, 1989–1999
SPECIALIST E-2, U.S. COAST GUARD, 1999–PRESENT

Chief of Operations. Appellate leave; special court martial;
awaiting discharge results

I was born in the Philippines in 1969 and was adopted by my aunt because she
was not able to have kids. She adopted a girl from her older sister, got married
to an American sailor and moved to San Diego. I never knew my real father. He
was also a sailor.

I decided to join the U.S. Navy in the delayed entry program because they offered
money to go to school. I went to boot camp, expected to only do one term, then
go to college. But the Gulf War started. I was an operations specialist with
Intelligence, so I kept being sent out. I was married at the time, and my wife got
pregnant—we had our son in '91. She couldn't deal with me being gone so much and
wanted a divorce. My concern was my son, so we stayed on good terms.

My first encounter [with a man] was on board ship. The individual was a good
friend of mine. He was married. We were drunk. Out of the blue he made a move
on me, and I did not resist. We were hanging out more and I think it became
obvious. It was reported and the Naval Investigative Service [NIS] got involved.
Next thing you know, we're at the NIS station at the base in Bremerton being
interrogated. I didn't know what was going on, but I was denying everything. They
had no evidence. Three days of interrogation, and then on the third day, out of
the blue, in the middle of interrogation, a guy came in and said this interview
was over. The investigators left the room, and then this guy came back in and
he apologized, "The charges have been dropped. If you want to, you could file a
complaint." I didn't. I just wanted this done and over with.

I put ten years into the Navy [and was honorably discharged]. When I signed up with the
Coast Guard through MEPS, it became a smooth transition. I didn't lose rank, I didn't
lose time, I didn't lose pay. I just changed uniforms. I was a radar man working
for Vessel Traffic Services [VTS]. Then I met my partner. At the time he was fifty.
He was HIV positive and had been since the '80s. He started having difficulties and
I was having a hard time at work, because I was taking a lot of time off trying to
be there for him.

I started getting counseled for it and was put on probation for six months. When I
left VTS, I figured this would be my last tour before I retire. We didn't have a
ship, so we were sent to Coast Guard Island in Alameda until the ship was ready
for delivery. By that time, I had made chief in the Coast Guard. When I went to my
new command, they were aware of my situation. It continued because my partner was
getting worse. I was trying to come up with excuses so I could get time off to
see him.

The command decided to do a urine analysis for everybody. I was called into our XO's [executive officer's] office and was presented with the result saying that mine [tested] positive with cocaine. I don't do any drugs; only thing I do is drink alcohol. "You're under investigation. Here's the number for legal in San Diego." I got a legal representative and came out to them. "Here's the whole story. I'm gay; I'm being targeted. I have a partner and I handle his meds. He's on morphine patches." They explained to me, "It's not like you had a huge amount in your system, only 276 nanograms. They allow 100."

They took me out from my command. Nobody could talk to me until the court martial. They sent me to work for three senior chiefs and they treated me like I was in boot camp. I did everything that they wanted. After three months doing all the shitty jobs and digging trenches, I was working with other kids in trouble counseling them.

Before the trial started, my attorneys gave me a request for a Bad Conduct Discharge [BCD] to get an automatic appeal because the Coast Guard is the only [branch] that, even though you can be found not guilty, they can put you through administrative discharge process immediately. The verdict came back guilty and [my lawyer] said, "I think we'd better submit the BCD." So I fill it out and she went in the judge's chambers with the prosecution. The judge came out; he was shocked that I submitted this. I was reduced to E-2 and that was the last day I was on Coast Guard Island.

They said the appeal could be anywhere from three to eighteen months. They're not sending me my DD-214 [discharge papers] and they're not releasing me. This is since 2009; it's 2011 and my appeal is still going. I'm not going to give in. My appeal attorneys say, "Your attorneys misled you. You probably would've gotten a punishment and retired as a first class."

PAGE 56

152

NANCY RUSSELL, SAN ANTONIO, TX, 2010
LIEUTENANT COLONEL, U.S. ARMY, 1962-1982

Battalion Commander. Retired; testified to the House Armed
Services Subcommittee on Oversight and Investigations about
Don't Ask, Don't Tell in 1993

[Sexuality] was something that you really weren't much aware of. It wasn't talked about much like it is today. All I knew was that I was not comfortable in the dating situations. I didn't feel right and it was only in college that I had been attracted to women. But as far as actually getting into a real gay relationship, that didn't come until the military. In the Officer Basic Course there was an attraction between me and another woman but it never became a whole lot; the circumstances were not right. When I was at Fort McClellan was really when I started acting on my sexuality. When I left McClellan, I went to Fort Ritchie and had a relationship with the company commander. I was the executive officer. We had a relationship only until she was reassigned, probably something less than a year. That was the hard part, the separations. You never did get to choose in the military.

When I went to Germany I was in a relationship with an Army nurse. Ultimately, after something like a year she was transferred back to the States. I came back to the States and went to Fort Mead and was in a relationship there, and that one lasted quite a while and then she was sent to Europe. Time away makes it very, very hard on relationships. And that's the way it went for my entire military career. One day you would be with somebody and the next thing you know you were going your separate ways.

I don't think I dwelled on it. I don't think most of us did because we knew the circumstances. We knew this is the way it is, take it or leave it. You could get out if you didn't like it. So, there was a choice there. If you wanted to stay in the military and you wanted to complete a twenty-year career, then that was one of the circumstances you had to accept.

I remember there was always this underlying current that there were certain things you didn't do because you might be suspected of being gay. You had to be so very careful even about things that were perfectly innocent because they could be taken the wrong way. What I can tell you is that it creates this very, very big ache inside. There's always this being so careful about the impression you are leaving, or what people are going to think, or selecting your words. So when I finally was out of the military I saw a psychiatrist, and the reason is that you are constantly keeping up this dual identity and it tears at your soul. It makes a difference in your overall confidence and it creates a definite post-traumatic stress, not of battle but of this awful cloud that's constantly hanging over your head as to how you have to act or who might think something. You can't spend twenty years in active duty without someone thinking something.

I had relationships but again they didn't seem to last more than six months. I don't think I'm the easiest person to live with. I think once you've been in the military and establish relationships with women who haven't been in the military, there's difficulty truly understanding one another. Women find me intimidating. I realize it would be easier to be in a relationship with a woman who was in the military because you have a similar background and basis for getting along.

The people who join the military go into the military not because they want to make war. Most of them go in to keep the peace. They are patriotic, they love their country; they want to serve their country. It is a shame that you have a perfectly willing gay man or woman very qualified, well educated, well behaved and they can't serve, while the military is cutting their standards in order to fill the ranks. It's not justice for us and it's not justice for the military.

PAGE 57

154

WILL CHANDLEE, PHILADELPHIA, PA, 2010

FIRST LIEUTENANT, U.S. MARINE CORPS, 1945-1954

World War II Veteran

My name is William H. Chandlee the third. My middle name is Herbert. My father was Big Herb. When my mother would answer the telephone, somebody would say, "Could I speak to Herb?" And she'd say, "Do you want Big Herb, or Little Herbie?" I don't think that necessarily made me homosexual but it certainly didn't do anything to thwart it.

Actually, growing up knowing I was gay, I was waiting for time to pass until I could segue into it easily. I never felt ashamed. It never really bothered me. It didn't torture me. I just knew that in time it would be quite OK. I didn't suffer. I was lucky, I really was.

I desperately wanted to travel. When I graduated from high school, I could have easily been drafted. My parents didn't have money to spare for a college education. I knew if I went in [the armed forces] for two years, I could get two years on the GI bill. I somehow favored the Marines. Maybe I was sixteen when I applied; my father wouldn't sign for anything, but he did sign for the Marines. When you go through the medical examination, the psychiatrist asks you a few questions. I wasn't prepared for it but I knew exactly what the hell it was about. "Do you have a girlfriend? I said, "Yeah." "Do you like to dance?" "When I'm with her, sure I like to dance." "OK, you're finished." I knew that if you told the recruiting people that you were homosexual, they didn't want you.

After I finished basic training, I came home, had a nice Christmas holiday, and then went back to Parris Island. We were all put on a train to Camp Pendleton in San Diego. There were some maneuvers and then we were all put on a big boat called the Breckenridge and about four or five days later, we pulled into Honolulu Harbor. As you approach, the smell of flowers just floats out across the waves, and Oh! I thought, my God, I wanted to stay there. There were hula girls on the dock waiting for us, and a little orchestra [sings] and those wonderful songs. We drove out to the country past Pearl Harbor to a deserted beach. We all took off our clothes, and went in for a swim and spent the day disporting ourselves on this sandy beach. It was paradise. I was consciously controlling myself. I was going to keep my mouth shut and behave myself.

[After two years] I went to school at the Philadelphia Museum School of Industrial Art. I studied drawing, oil painting, and illustration. It was during that period that I came out with a bang; I couldn't get enough sex. There was a whole crowd of us and we didn't hide it at all. I got put in the slammer one night. I'd been to a party, beautifully dressed in a white linen jacket and proper trousers and shoes and a necktie. I thought I'd stop in the Allegro, a popular gay bar. Two minutes after I got a beer, all the lights went on and we were unceremoniously taken away in the police van to jail, where I spent the night. I feel a little odd talking about these

things, but memory is nice especially the older you get. I'm eighty-one. Every year, there are fewer people to remember with. And that's sad.

I got called back because the Korean War was on. I was sent to Camp Lejeune in North Carolina for training and Officer's Candidate School at Quantico, Virginia. Somebody always had a car and was going north. You pay twenty dollars to go along and be let off in New York. I remember coming back it was bitter cold. It must have been around 1950 because the car radio was on and every hour "Tennessee Waltz" came in. There were five Marines in the car, two guys in front and three in back. I was Lucky Pierre in the middle. The car heater wasn't working. The two guys in front were talking. We had our heavy Marine winter overcoats on our laps. The guy to my left was snoring in his sleep. I was trying to sleep when suddenly I felt a pressure against my right leg from the fellow to my right. I responded in time and I tell you, every time I hear the song "Tennessee Waltz" I think of it. As the miles piled up, we were just sort of sprawled… We were just totally covered.

They weren't sending any more Marine officers to Korea and so I just finished up my hitch at Quantico. During those two years, I experienced one major relationship with a Navy lieutenant, a dentist from Little Rock, Arkansas. He was very good looking and charming and had a wonderful speaking voice. And he had a car. For eight months we would go to the theater in Washington, take drives into the country and go swimming or fishing. He was very good in the bed department. I took him home to meet my parents. One time he was staying with us in the country and he told me he was getting married; it was a girl he had known all his life and hoped I would be a part of the wedding. It upset me; it came so unexpected. We'd been so happy together.

I thought maybe somewhere, sometime taking the ferry to Fire Island, I might run into him some day. I've thought about it with other people, listening for their voices. Occasionally I look at someone, "God he's a dead ringer for…" And then I think, he's only about half the age that the chap I'm thinking about would have been.

I was a better person when I left the Marine Corps. I was less of an asshole. I learned to listen and I learned to keep my mouth shut. Be a better buddy. Be a better friend. It's a bonding situation. The training was hard, but it was certainly bearable. We were all better physically. So much water has gone under the bridge, so much time has passed. Shadows are lengthening and life is full. I think about them and wonder what they're doing. Over the years, when I had an antique shop, my name was out front, and half a dozen times, some fellows from the Marines stopped in just because they saw my name. It was nice to see them. The last one bought a barn in Bucks County and was breeding canaries. You never know how people are going to end up. It was interesting. It was. Yes, it was.

PAGE 59

ERIC ALVA, SAN ANTONIO, TX, 2011
STAFF SERGEANT E-5, U.S. MARINE CORPS, 1991–2004

Retired. Honorable discharge; first U.S. military casualty in
Operation Iraqi Freedom; Purple Heart recipient; Presidential
Unit Citation; advocate for equal rights

My grandfather was in the Army and served in World War ll and Korea. My father, a
Vietnam veteran, was drafted in 1967 and survived the Tet Offensive. I also wanted
to follow in family tradition. I was eighteen when I joined the United States Marine
Corps in 1989. Because it was pre-Don't Ask, Don't Tell, the questions were asked
about sexual orientation. I already knew I was gay, but I was consciously trying to
suppress it.

It's 1999 and I'm coming on my ten-year anniversary. I knew that I was going to
make the Marine Corps a career, and I thought maybe I could find someone who was
also military and we could both have careers even if we were on different sides
of the world. I never thought about meeting a civilian. Then in the spring of 2002,
rumors had started that there was a possibility of going into the Middle East. We
were being deployed to Kuwait and we knew there was a possibility of an invasion.
I was getting ready for war and that became my main priority, to make sure that my
Marines were taken care of.

I got there January 17, 2003, ahead of thousands of U.S. troops, and for two months we
stayed in Kuwait and waited. When [the invasion] did happen, the night before I was
doing night ops with Sgt. Peterson. I came back in at four in the morning; I had been up
the whole day. I barely took off my boots and uniform and wasn't asleep for twenty-
five minutes when the colonel said tear down the tents, wake up the Marines and meet
at the supply tent. That next morning, I didn't eat breakfast; I didn't stop to eat
lunch; I didn't eat dinner. We loaded up the vehicles and were moving. We stopped on
the Kuwaiti side, shy of the Iraqi border and that's when you heard the bombs.

We moved in the next morning, on the twenty-first, about 9 a.m. We were the first ones
to secure the city of Basra; we stopped to regroup at this huge area of open sand.
The other vehicles ahead of me were spread out. People were walking around. Iraqi
kids were playing on a big sand hill in an old Iraqi tank. A lot of us began to
recognize that the ground didn't look as stable as it should have; there were things
protruding through that looked suspicious. I had already gotten off my vehicle. The
Iraqi kids were trying to get near the convoy and some of the Marines already had
formed a perimeter to keep them away. I think back on it now and I think they might
have been trying to warn us.

I remember walking back to my vehicle. It was really dusty. I wasn't hungry, but I
knew I better eat to keep my strength up. I decided to eat my MRE [Meal, Ready-
to-Eat] on the hood of my Humvee, so I left the canvas door open, walked around,
and opened the MRE. I was walking back to the passenger side of my Humvee to get

something out of my seat. As I was going back to my vehicle, the explosion went off. It was unbelievable. I remember getting knocked feet away, landing in the sand holding my arm. My index finger was gone. I could see the whole hand was caked in blood—it looked like maple syrup. I could see the bone. My hearing was gone. I remember looking back at Sgt. Peterson looking out of the Humvee through the canvas. I just went like that—like get back in—I think he knew I didn't want him to see me like that. People were running and helping me. They were cutting off my uniform. They took my 9mm pistol and took off my flak jacket. I was in a lot of pain, grinding the shit out of my teeth.

I was trying to sit up but I couldn't move. I'm screaming, crying, thinking I'm paralyzed. I couldn't feel anything. The Navy Corpsmen combat medics are helping. The chaplain's holding my head, "Look at me. Look at me." He wouldn't let me move; he was holding me pretty tight because I was hysterical. I kept asking him, "What's going on? I don't wanna die." He said, "You're not going to die. Stay with me, staff sergeant, stay with me." I could see overcast clouds and was thinking, "Oh, my God, I'm gonna die. My mom is going to be mad. Please don't let me die. I didn't even get to say good-bye." I thought about my two sisters, and I thought about my mom and dad and my grandmother.

There was a second explosion and that's when one of the corpsman bringing the trauma kit to help the other medics stepped on the second land mine. By this time, there was massive chaos, you could see people running, you could hear people yelling, people were jumping on vehicles to get off the sand. We were in a minefield. Lots of screaming and yelling and cursing. It was such a nightmare. I didn't even know who got hurt.

Then I felt them lift the left leg. I actually felt them pull the boot off. I looked at Chaplain Stennet, yelling, "What's wrong with my leg. Fuckin' tell me." I didn't feel the right boot come off. I didn't feel my right leg; I think the foot was gone. It felt like an eternity and I thought, "I'm going to die here." There are no hospitals in Iraq. We have to go back to Kuwait and so I'm thinking, "Where the hell is the helicopter?" I didn't hear anything. They finally bring ambulances-they put us on and they close the back doors. Now it's hot. I'm completely naked. The only thing I have on is a poncho covering me and we're going down this bumpy road—it's not paved or anything—and it hurt.

I finally start hearing that sound, little by little and it gets louder and louder, the sound of the blades of a helicopter, tluk, tluk, tluk. It got really loud, like we were underneath. I was still grinding my teeth. Bandages everywhere. "Hurry, hurry, hurry." Staff Sergeant Cucci put me and other wounded people on. I was holding his hand and wouldn't let go. I was crying, telling him I didn't want to die. I could see it lifting off and then all I could see was the sky. When we landed, people rushed in and were carrying me into the tent and next thing I know I was put under anesthesia and I was out.

I lost all track of time. I lost all sense of where I was until waking up. I was dazed, like I was inebriated and everything was slow motion, like you're drugged. I remember looking down and I saw that the whole right side of my sheet was flat, literally just flat and I started crying, "It's gonna be OK; they're going to put it back on; they'll put it back on; they're going to put it back on." My whole left leg

was bandaged up, literally almost in a cast. My right arm was broken, my left leg was broken and my right leg was gone. There was no saving the leg; it was too shattered, probably mangled. I believe part of it was already gone before I got to Kuwait, and all they did was do the amputation and clean up. After I got to Bethesda, ten days after being in Germany, they amputated my knee.

I needed to talk to someone and I needed to get medication for the sadness that I was dealing with. It took me a long while to admit that I have PTSD. To this day, almost eight and a half years later, I miss the Marine Corps. This would have been my twenty-year anniversary. I miss my leg every day; I miss my career. I don't do what-ifs anymore in my life—at least I try not to. What if I never got off the vehicle? What if I had just taken a nap? I was killing myself with that thought process; it wasn't going to bring back my leg. My life changed forever. I started to learn the life of someone who was disabled.

I actually thought, "Who's going to love me now? I'm thirty-three years old and who's going to want to be with me? I'm deformed." I was looking for male companionship, so I started to get online and put my profile out there. I started talking to someone whose name was Luke, like Luke Skywalker. It was Daryl Parsons, who eventually became my partner. He introduced me to the Human Rights Campaign [HRC]. I looked at the Web site and emailed Brad Luna about my story and said if there's anything I can do, let me know. I get a phone call: David Smith, the vice president of programs, flies me to Washington, D.C.: "Congressman Meehan introduced a bill to repeal Don't Ask, Don't Tell. We want to have you help by telling your story." I forgot after all these years I was serving under that law. I had been retired for two years and I hadn't even uttered the words DADT.

Good Morning America interviewed me. Jay Tappet, *NPR*, Anderson Cooper, Paula Zahn, the *Washington Post*, the *LA Times*, the *New York Times* were going to do an interview. That was it. I was out. People were seeing it on CNN sitting in restaurants, in airports. I came home and things did change. Neighbors stopped waving, but eventually they came around. Everybody was so huge on support. I tell people why I decided to come forward. I served honorably, I sacrificed for this country and I believe all people deserve to be equal. I will do everything in my power to speak out for equal rights and the respect for human beings.

I would never change anything in my life. I'm right where I'm supposed to be in this second life. It doesn't mean I'm a perfect person. The reality is things are still good for me. My leg will never come back, but I have a new life. I now have a voice.

PAGE 61

DEBRA FOWLER, LOWELL, MA, 2013
SPECIALIST, U.S. ARMY, 1986-1988

Korean Linguist. Defense Language Institute Soldier's Award;
dishonorable discharge, fraudulent entry; outed when being
investigated for top-secret security clearance

I was born in 1965, adopted when I was a few months old and moved to Pittsford,
a suburb of Rochester, around the age of nine. I remember sitting in my classroom
looking across at a student, and the way she was sitting at her desk was like a
punch in the gut. I would not allow myself to think about it. When we moved to
Export, a coal-mining suburb of Pittsburgh, I became friends with another gal who
looked very much like the one in Pittsford. I wanted to think about kissing her,
but I tried very desperately to force it out of my mind. I became obsessive about
running and dieting; the more I exhausted my body, the less energy I would have to
think about that. I was probably a junior in high school when I decided I couldn't
shut it out anymore. Just thinking about her, thinking about being close to her and
kissing her, or holding her hand felt luxurious to me.

I graduated, got to college and went to Ocean City, Maryland, for the summer of '86.
I met a woman—a police officer in Lewes, Delaware—and we started a relationship. I was
so terrified of what my parents would think that I didn't go back to school. I didn't
contact them for several months. She got a job for me working in central supply for the
Beebe Medical Center and working at the University of Delaware communicating weather
forecasts back and forth for the fishermen in the boats off the coast. I came home one
day after just a few months of being together, and she had packed all of my stuff, put
it outside, and said, "You no longer have a job at Beebe, you no longer have a job at the
University of Delaware, and you need to go." She was not a stable person.

For about a month, I was homeless. I heard that if you went to the recruiting
center, they would take you to a hotel, feed you dinner, and you would have a bed
to sleep in. You would get breakfast; then they would start the paperwork for in-
processing. I slept in the bed, had breakfast, and told them I didn't have any
identification so that I would be able to come back the next day and do the same
thing. I was desperate for a bed and a meal. That was the point when I reached out
to my parents again, and told them where I was, and what had happened, and that I had
joined the military. They came down to retrieve me; I had to transfer to a different
recruiter in Pittsburgh. I was fortunate to get into the Defense Language Institute
after basic training and received orders to go to the Presidio [military base] to
study Korean. Two weeks away from graduation, my company commander called me out of
class to his office. He handed me this folder and said, "I want to give you something
to read, and then I want you to respond to it." I needed a top-secret security
clearance. When they investigated my background, they spoke with this person that I
lived with in Lewis, Delaware. She gave a statement that not only was I a homosexual,
but that I dealt cocaine, and that I was an alcoholic. I had never even seen cocaine.
I certainly was not an alcoholic. I said, "None of this is true." He said, "Well if

it's just the drugs and alcohol, we could let you stay in. Are you telling me that you are not a homosexual?" I said, "I am not." Two days later, I was pulled out of class again and put in a van. I was taken to one of the main administrative offices into this huge room where there was a table with a lie detector test, a small couch, and a straight-back chair next to the lie detector. This guy in civvies hooked me up, asked some questions, took the results into another room to consult with someone, came back and said that I wasn't telling the truth.

They asked, "Where are you from?" "What's your name?" "Are you a homosexual?" I said, "It was just one time, I'm not a homosexual." I was desperate because I loved the military. I loved everything about it—the esprit de corps, the rigor, the experience with language! I was clawing to stay in. He said, "Why don't you give us a written statement describing this experience." He told me that whatever I wrote would be confidential between him and the analyst.

I wrote about a paragraph of some crap that I made up and handed it to him. He left, came back, "We need some more detail." He took it, left, came back, and said, "No, our analysts need to know where your mouth was, where her hand was. They need to know specific details so they can determine whether or not this was just one experience or if you really are a homosexual." I didn't know what to do; I was terrified. I wrote three pages of bullshit. I was not about to give them any details of my intimate life, so I made up everything. He left, he came back, and he leaned across until he was inches from my face—I'll never forget this—and said to me, "It's a shame men don't turn you on the same way women do." I wanted to punch him in the face. From that moment, I don't remember anything. I don't remember leaving the room, I don't remember being driven back. I don't remember anything, just him saying that to me.

I was called back to the company commander's office. He told me I was going to be allowed to graduate and receive my diploma because I was being given two out of three awards that they bestow to each graduating class. My classmates had orders to go to Texas for top-secret training. They left the next morning and I proceeded to clean toilets for three weeks. I was with others who had gotten into trouble. One soldier had been convicted of dealing drugs. He was not being discharged. Here I am working side-by-side, cleaning bathrooms and floors with a drug dealer, and they found a way to keep him, but I was unfit to serve. Being gay was worse than being a drug dealer.

I thought I was useless. I had quit school, I joined the military, and then I was kicked out. I didn't understand how I was going to find a place in the world. I felt ashamed of who I was. It was just like a slap in the face. The connections of being in service, being of use, finding what I thought was really my calling…stripped away. [On] my DD-214, I'm discharged under fraudulent entry. I was allowed to keep a couple of things, but not the dog tags. The guy yanked them out of my hands.

No entity, no individual is infallible, or completely comprehensible; that's how I wrapped my brain around it in order to salvage some self-respect. If I had a chance to re-up, I would. I love the military. Part of me was absolutely raging. It was incomprehensible to me how she could do that. Part of me wanted to believe that if she didn't hear from me, that maybe she would think that her comments didn't affect my life. I couldn't see the point of engaging with her. I didn't want to give her any satisfaction. It's so irrational and evil! I think I'll always be pissed.

PAGE 63

161

Honorable discharge with pattern of misconduct;
being treated for PTSD

I was born in Virginia Beach in 1981 and spent most of my life on Long Island. My stepfather didn't recognize me as one of his own. He wanted his youngest son to be a cop or a military person but he told me, "I don't think you could handle that." When I was seventeen, the ROTC program medically discharged me; I had asthma and hypoglycemia. I was never going to survive. I couldn't do it.

I graduated high school and was studying full-time to be a special education teacher. Then 9/11 happened. I was in the city for an interview, in the building right behind the World Trade Center. I didn't know what happened; I didn't even know that it was the World Trade Center. Everyone was evacuating. It was so smoky that you couldn't see your hand in front of your face. It was chaotic and was getting hard to breathe. I started crawling on the floor. People were running everywhere, stepping on me. It was a mess. Then I heard screaming and yelling. I was following the voices and the next thing I know a military person picked me up, "Are you all right, son? You're crawling on the floor." I was like, "I can't breathe." That's when he asked me, "Do you want to do this? Do you want to do that?" I started helping right away.

I joined the Navy in 2005. I did basic at Great Lakes, Chicago. And right after that they sent me to Pensacola, Florida, for more training. They were still looking for people in New Orleans [after Katrina]. They knew that I'd helped with the World Trade Center and they asked if I have any medical experience. "I do volunteer work for the fire department and I know CPR. I'm already certified." I was going forward with my EMT, but I didn't have my qualifications. I went with them and helped pick up bodies and find people for about a month and a half.

I went to Afghanistan and then Iraq, a little south of Baghdad. It was supposed to be a six-month to eight-month tour. They needed people, so I stayed behind with people I considered family; I didn't want to come home. I worked with the Navy, the Air Force, and the Marines, guarding detainees. I was so fascinated with how we call these people our enemies and we're at war with them, but they're just like us. I was tryin' to get familiarized with the people so that it wasn't like a prison. But most of the time, you don't know who's good and who's not.

I was hanging out with one of the guys that was very feminine. Some people stand out; they're just different. The individual wanted to have sex with me and I told him that's not going to happen. Then someone left shit in the guard tower and wrote my name on a note that said, "Toxic, you're probably fudge-packing him." I never had sex with that guy. I knew he was feminine, but I didn't care what people said. I admired his bravery and his courage and his commitment to himself as well as to his unit. My captains didn't do anything about it. Once they thought I was that way, I had people say "Don't talk to Toxic, he's a faggot now." I never distinguished

myself as anything to that nature. But they picked on me; they picked on a lot of people that I knew.

I can't discuss the shooting; I can't discuss the four-year-old boy; and I can't discuss the kid who was six to eight years old. I'm not authorized to speak about that. But one evening on my shift on the compound, some guards did the normal walks. Other guards were all inside the building. I saw [the detainees] were dragging somebody. I ran inside, "I think they're bringing me a body." And they were like, "Toxic, are you on a suicide mission? You didn't bring any ammo." I didn't think. I had my sacky plates on. "They're people. Let's find out what's going on." The kid was sixteen years old from what I could make out, what they were translating. (You don't know what their ages are because there are no IDs, so you have to go with what they say.) He was raped for their pleasure. I took off my coat and covered him up because he was half naked. The next thing I know, the guards are coming because the detainees are screaming. I don't know what I'm going to do. I have keys in one hand. I have a rubber shot gun in the other; we don't have live ammunitions. The guards were thinking it was going to be a riot. About thirty-two guards are in the compound ready to shoot and I'm still in the compound with my Kevlar vest off taking on this kid.

I start the next day by getting yelled at by my supervisors. The detainees called me savior. "You're like us now." I said, "I did it hoping if you saw one of our guys, you would do the same thing." I made a bridge between us. If you do something bad to them, they won't attack you, they're gonna attack your friends, your families, because those are things that makes you feel joy. If they take them away, they feel they completed their mission. When they killed everybody you know and take everything that makes you happy, maybe they'll take you away from your suffering.

I came back January 18 of '08. My time was due. Not only was I known as a baby killer and had stuff thrown at me, but my department put me in handcuffs. Everyone else was allowed to go home and see family. I wanted to see my mom and my brothers and my friends and just relax, just de-stress. I was denied that. I had to go back to the ship and wait permission. The ship was on work-up, so I stayed on shore duty till they returned.

They were saying I have PTSD. From the very beginning I had a chip on my shoulder. I went from a person that was starting to try to change his life and be a little bit more understanding to an angry, obnoxious, rude person. I had my own barracks, but I had no one to talk to. I didn't know anybody. Everybody that I did know was on the ship. The civilians I did know are not there now, because people changed. No one's the same. Everything was gone. I was alone. I drank in my room all the time. I couldn't fall asleep. I didn't have my wife to talk to. My dad was more concerned about the war; he would ask questions but he was always repeating the same thing and he wasn't really getting it. "Why do you feel alone? Why do you feel that way? I'm talking to you on the phone."

Our lives are threatened there every day: IEDs, missiles, rockets, every day, every hour. People don't go to sleep because you hear the noise and you don't know if that's gonna land in your compound or if that's going to hit you while your sleeping. When you're bombed or rocketed every day for over a year—you hear boom, boom, boom constantly—you're so conditioned to it. But here, it sets stuff off. Boom! You see yourself as a soldier again. I'm in my cammies, my helmet, my Kevlar vest.

And then, click, I go into a mode that says, "OK, I have to defend myself; I have to protect myself."

If they can't get you on Don't Ask, Don't Tell, then they'll push you out or make your life miserable. With my own personal case, I never once admitted I was homosexual. Because I denied everything and was in Iraq for over two years in two tours, they told me I had an honorable discharge with a pattern of misconduct. They're using someone else's word against mine. I went to captain's mast once. Then I went back to captain's mast, went down another rank, and went back on restriction. I had a speeding ticket from 2001 before I entered the military that they used as a pattern of misconduct and kicked me out.

I'm still fighting it every day. I had to fight to get my benefits. I didn't have my GI Bill, which I had already paid off. I was granted a VA loan finally. They held onto my DD-214 for over eight months. I am not allowed in the reserves and I'm still going to fight that.

What I was being accused of with the individual—I never had sex with him—I can't even say what I did. I wish I could. Even with my therapist, I don't talk about that, but it's affected me to this day. I can't have a decent relationship. How they could do this to somebody and just turn their backs on them after they helped their country? Every day I'd have my uniforms all lined up and I'd look in the mirror to make sure they still fit. I'm proud of my uniform. It made me feel like, OK, I've got to get up this morning. When you put it on you feel the respect the American people give you. They don't ask, are you gay? They don't see that. They shake your hand. They welcome you into their home.

The Navy [is dedicated to] honor, courage, and commitment. For me, I don't use the word *honor* for what I do in my privacy. Will I be honored and respected the same way? No. I use the word *courage* because I can go to Iraq, but I can't even have the courage to say to myself, "This is who I am, this is how I want to live my life."

PAGE 65

MATT MCCARY, ORANGE PARK, FL, 2011
AIRMAN FIRST CLASS E-3, U.S. AIR FORCE, 1998–2000

Intelligence Specialist. Honorable discharge; put under arrest after being singled out by coworker; discharged within five days with no investigation

DAVID COCHENIC, ORANGE PARK, FL, 2011
CHIEF PETTY OFFICER E-7, U.S. NAVY, 1992–PRESENT

Field Medical Service Technician, Aerospace Medical Technician. Received Navy and Marine Corps Commendation Medal, and Navy and Marine Corps Achievement Medal

MATT: I was eighteen years old and trying to figure out what I was going to do with my life. I felt it was my duty and responsibility, so I enlisted. I don't think the sense of service to country really set in until I got to basic training and realized that I was one piece of a much bigger brotherhood, a fraternity, protecting our national security and way of life. I was given some advice by my dad before I went in. At this point he knew about my lifestyle. "There's this policy they're going to ask you about and you have to sign some papers. It is in your best interest not to mention it." And that's what I did. I didn't mention it. I thought it would be easy to hide, because I had been hiding it already. I hid for years.

I kept my lifestyle to myself all through basic and all through tech school. Didn't say anything to anybody, didn't reveal anything about my sexual orientation. I graduated and then was stationed in Germany as an intel specialist. I was lonely over there, and I lived out in the middle of nowhere. I tried to commit suicide one night because I was torn on which way my life was going. I had nobody to talk to and I got this real nasty email from my mother that really put me down. Information was released to the squadron the next day in a public announcement that I had tried to commit suicide. I had once made this off-the-cuff comment to a coworker about another male in our squadron and how he was attractive. She went to our first sergeant and said, "I think he did it because he's gay." That started the discharge paperwork. I was released from the hospital about a week later. The day I returned to work, I was taken into my commander's office, read my rights, forced to relinquish my base ID, and was required to have an escort. I was treated like a criminal, like I had broken some security law.

Active-duty friends began to avoid me, refused to talk to me, wouldn't take my phone calls, and wouldn't return emails to give me any kind of advice or assistance. When I went to base legal, they said the only option I had was to prove I was straight. If I couldn't prove I was straight, I could lose my honorable status. I remembered from another conversation with my dad that you don't want anything other than honorable

on your discharge papers. So, I'm thinking, "How do you prove to somebody that you're straight?" I had no legal defense, I had no argument, nothing to give them to prove this, and I was worried about losing that honorable status. So I said, "OK, I won't argue it." A week later—Friday, February 18, 2000—I was discharged. I was a civilian again.

I was ashamed because even after my dad gave me guidance to keep it to myself, I had said something anyway. I didn't contact [my parents] for assistance. I tried to do it on my own and it failed. I went as far as to lie to them that I was still active duty. I felt loss of pride, loss of self-worth. Where were all these people that said they were your friends? I would run myself into the ground every day.

What annoyed me most was the release of private medical information. My DD-214 said homosexual admission. I did seek out the Air Force's review of the Board for Military Correction of Records and had the narrative status changed. I made a comment that somebody was attractive. I never said, "I'm gay," "I'm bisexual," "I enjoy having sex with men." I've heard plenty of straight women say, "She's attractive!" And I've heard men say, "He's got a great physique!" Because I said someone was attractive, that was grounds for my discharge? I don't think this coworker meant ill will—because we were friends. But she thought she was doing me a favor? She wasn't! She was ruining my career.

I got a job with USAFE [U.S. Air Forces in Europe] in Germany as a civilian. I worked for six months and told my parents I was going to Illinois, where one of my friends was stationed, and make it look like I'm still active duty so that they're not let down. Finally, I told them I was discharged. They were upset; my dad had big dreams for me; "Why didn't you call me? I would've helped you. I could've supported you. I could've given you advice." It goes back to, "I didn't want to let you down. Everything that you told me not to do, I did anyway. I didn't want to have to ask for your help to fix something that you told me not to do."

DAVID: At sixteen, I signed up for the Navy, delayed entry. After graduation in May '92, I went to Great Lakes, Illinois, for boot camp and then Hospital Corps School. I met my future wife in Great Lakes; she was military also. We started seeing each other and being silly immature kids; at eighteen years old, we got pregnant. We got married in August '94 and my daughter was born the following month. Now we were dual military. Shortly after the birth, she got orders to Alameda, California, so I requested spouse collocation and got orders to Alameda as well. Her orders were to a ship. She just had Marrissa and she didn't fight the order process, which should have been delayed due to her recent birth. That really irritated me; she just let the Navy screw us. So when we got out to California, she left. I was a nineteen-year-old kid with a four-month-old child. I wanted to be married and have a child. I just didn't realize it was going to be so soon.

I did notice guys, but at the time I was very naive. I didn't know what it meant. I was introduced to the lifestyle by a fellow sailor in Alameda. He said, "This is my first time; it's new to me." It turned out he was in a relationship. He got me at a moment of weakness because I was a single parent. I fell hard. I wrote my wife sort of a Dear John letter and told her that it wasn't going to work. Writing the letter wasn't just because of this experience. I was disappointed that she didn't get her orders changed and felt we rushed into the marriage. I had a lot of anger for her, so writing the letter was very easy.

She came back when Marrissa was probably nine months old. She already had met someone of the same gender on the ship. Shortly after she got back from deployment, she moved in with me and we became roommates. We were relying on each other's income. A year later, without discussing it with me, she chose to get out of the military. I was furious! We parted ways and I was transferred to Harlingen, Texas. At that time, Marrissa was getting older—she was about to be three—and I really loved being a parent. I started thinking I didn't give the relationship with my wife a chance. I was so aggravated with her for being lazy and not doing what's right. In the back of my mind, I wanted another child and I can't very well do it on my own. So she and I started back together in Texas and my son was born in March '99.

We stayed together for a while and in 2000, while living in Louisiana, we realized we were staying together for the wrong reasons and decided to be roommates again. I never went to clubs; I was too paranoid. I met Matt online and we started talking a year before we met for the first time in person at Ruby Tuesday's in Biloxi. From the moment I saw him, there was something. I didn't know what it was, but there was something. I had lunch, he watched me eat, and then we went to a local bar, had a few drinks, and then parted ways.

MATT: I was the same way. We couldn't take our eyes off each other, even when we said goodbye, standing out in the parking just kind of looking at each other, trying to find another reason to go in and have another beer. We were doing whatever we could to find another reason to make another minute last just a little bit longer.

DAVID: Six months later I called him. It was New Year's Eve, I called to see how he was doing out of the blue. We were still chatting online. He told me that he had started seeing someone. I said, "I just wanted to call and see how you were doing, don't really know why." Later that year, he broke up with his boyfriend, and I convinced him to come to stay a weekend with me.

Whenever I met people, I looked at the potential of long-term, because I have kids. I saw this 21-year-old, and there was potential there! The chemistry's there. So, I drive him back to Biloxi, and we decide that we're going to see each other every other weekend. We did that for about a month. I really enjoyed being in his company. I felt complete and I wanted to be with him all the time. Every other week became every weekend. I brought the kids to his house, met the parents and we moved in with each other in July of '02.

We've been together for ten years. I'm always paranoid; if I lose my job—my livelihood, my kids, everything is gone. I always worried about other people because whenever we're in a room together, you pick up on it. We finish each other's conversations and just the way we look at each other. So I kept a very private life. I would alienate my work life from my private life to the point where if I saw people I worked with [in the Navy] at Walmart or at the mall, I would ignore them. We told our kids that if anyone asks, Matt's your cousin or uncle because we had to keep our guard up. There are some people who sniff that out; they're looking for a reason to meddle in somebody's business.

MATT: Ten years in our relationship and we're doing that. We're both paranoid. He's confided in a couple people at work and when he tells me, I want to choke him because

that brings back everything that I went through. I made one comment, and that's what put me out.

We live in a very conservative county. It's a big military area. How do you go outside as a family? How do you do things inside your house without having to shut the windows? We spent ten years constantly looking over our shoulders. That's not something you just stop doing in a day. You have to relearn how not to worry about being you.

PAGES 28-29, 67

KATIE MILLER, NEW HAVEN, CT, 2010

U.S. MILITARY ACADEMY, WEST POINT, 2008–2010

Resigned appointment on moral grounds

During "Beast"—our cadet basic training—we received a large-scale briefing of the [Don't Ask, Don't Tell] policy in an auditorium with all 1,300 cadets. It wasn't presented as a question-answer brief; it was straightforward: This is what the policy is, this is how it's enforced, and this is what constitutes homosexual behavior. I knew in my heart that the policy was wrong, but I was going to adhere to it because that was my job.

I didn't understand the challenges I would have to face when I went in. When we're eating the same meals, going to all the same briefings, a friendship developed, a camaraderie. I went in thinking that I could just not talk about my romantic life, but with these personal relationships and these bonds comes personal inquiries. I immediately found myself lying. I played the gender-pronoun game replacing "she" with "he." I acted out of what I thought was necessity, adapting to the policy and still maintaining my status as a cadet and not endangering that, but lying in the process.

There was a roundtable discussion we had monthly as cadets—Professional Military Ethics Education and in April of my freshmen year at the Academy we got on the topic of cultural appreciation and eventually of gays in the military. I was sitting in a room full of my company mates, who I spent a significant amount of time with; these people were my friends. There were three cadets who were very vocal in voicing their dissent against allowing gays to serve openly in the military. It's not like they went about it in a very academic or professional manner, but they started throwing around these very vulgar and derogatory terms making this a very primitive conversation. I remembered sitting there listening to them and I really wanted to say something because I was just so angry; I was really offended. More than anything I was very hurt because these were my friends that were insulting me.

It made me rethink my entire decision to come to West Point—I was part of an institution that would allow me to be violated. I started understanding how far I had come at the Academy, but also how far I had digressed as a person in completely hiding who I was. I knew that I wasn't going to be able to graduate the Academy with the policy in place. The beginning of junior year rolled around; I had to commit to the military or resign. I resigned and I made my resignation public. I told the Academy the exact reasons why I was leaving. I made a deliberate effort to separate myself from my cadet friends for fear of alienating them as being gay or lesbian. I was very much alone. I was saying good-bye to an institution that I cared about and that had done a lot for me.

Seeing my former comrades react so strong is devastating, but leaving the people that I actually cared about and were supportive of me was more devastating. I was not going to be able to have it both ways. Either I was going to be in the closet at the Academy under a repressive military law or I was going to be at Yale studying but not part of an institution that I really believed in—the U.S. military.

PAGE 69

RAY CHISM, BRONX, NY, 2010
AIRMAN SECOND CLASS, U.S AIR FORCE, 1963–1967
PRIVATE SECOND CLASS, U.S. ARMY RESERVE, 1980–1984

Aircraft Mechanic/Clerical. Other than honorable discharge, suspicion of homosexuality; prevented from reenlisting

I have been gay all my life. I realized that this was something that I held within myself. I didn't tell anybody what I was feeling. I just kept it inside all through high school and till my freshman year in college. I was confused at that time. I wrote the dean of Morehouse College a personal letter. I didn't feel that I needed to cut my hair—I felt that my hair bein' long didn't necessarily indicate that I was homosexual and that I was having feelings of being homosexual—and [asked] if he would give me enlightenment how it would affect my term in school. I didn't get any kind of response from him.

I was there from '61 to '62. The college courses proved to be much more difficult than what I was accustomed to in high school. My average was usually 90s and 100s on work that I turned in. But they fell below the average, so I couldn't go back my sophomore year. I had hopes of studying at the Sorbonne in Paris. I enlisted in the Air Force because of a old wives' tale—if you're not a man, the military service will make you a man. It was September 23rd of 1963. I was in Texas—Lackland Air Force Base—when the news came [just two months later] that the president had been shot.

I didn't answer the question [on homosexuality] correctly. I said no. I knew I would be refused entry if I answered correctly. It sort of bothered me because I was raised Southern Baptist in the church. I was a firm believer that God would punish you if you lied. But I felt that it was a means to an end and that God understood. I felt bad about it in a way.

In basic training, you had these challenges; you had to swing on these ropes. 'What? Are you a girl? You can't do this? Come on man! You can do this!' If you missed a certain challenge, you got set back and you had to do the thing all over again. I went through it without any setbacks. I was proud of myself. I was trying to come to a conclusion that this is the way I was. "This the way you gonna be until you die." It's not something that you can do—change your sexuality, change your feelings about men—by the things that you do. That was the thought I had. If I do enough masculine things, then my sexuality would probably automatically change. I would be masculine or oriented masculine.

I was at Lackland for about two years as far as I remember. Then I was transferred to the technical school for aircraft mechanics. I hated it. I wanted the clerical section, but I didn't qualify. After being trained as a mechanic and working for a while on the flight line, I spent my last year in Thailand. About eight months before I left Thailand, I cross-trained into administrative. I was filling out discharge papers for airmen that were coming out. I left the mechanical field entirely, but I was discharged under the Mechanical MOS.

I had a roommate; we understood each other. It was after we went to tech school and we were working as mechanics. I would pull a KP [kitchen patrol] for him and he would help me do the mechanical things on the aircraft that I couldn't do too well. We had strong feelings for each other. He was married on the outside and he went back to his wife and child. But we were close while we were in the military. We were very well aware that we couldn't carry out our feelings for each other any further than what we were doing there in the barracks. When I was transferred to Thailand, he went to Ohio. When losing your mate, you miss having the person around and having somebody to understand you nearby. We had planned to meet after we got out. He was from St. Louis, Missouri, and I never went to St. Louis after I got out of the service. He said, "Look me up." I never pursued it. The only thing I have left is a picture of him that I still have in my album, my photograph album.

I worked on different jobs from '67 to '75 in Georgia. I came to New York in '75. I read an article about Greenwich Village and the things that the gays were doin'. I felt I wanted to come because of that. I was going with a guy that had an old car and he drove me from Atlanta to New York. We had some excursions in that car. It broke down once. And once or twice while we were on the route. But it was enjoyable. It was a thing I'll never forget.

My uncle lived in Harlem by himself. I didn't know exactly where he lived, but I found him. I lived with him for several years. My uncle had a friend—they had been friends for a while. We were attracted to each other. I stayed with him in an apartment and then later on, I got my own apartment. We were pretty close to each other. As a matter of fact, he was married and had kids. His kids knew that he was gay and so did his wife. It was kind of a peculiar situation. We were friends until he passed away in '83.

I went in the Army Reserve in 1980 to 1984. I missed the camaraderie, being in an organization and working. I wanted the compensation for being enlisted too. I didn't have much of a job. I enjoyed the reserves while I was in, but I feel that I was wronged. They didn't allow me to reenlist because they found out that I was living with my uncle, which wasn't really a reason to indicate that I was gay. They had ways of checking up on people. Somehow they found out. They gave me a less-than-honorable discharge.

I wouldn't say that I'm angry as such. I just feel that there's a strong need for adjustment for the military. Those rules and regulations that they have are old and archaic and they should change and come up to date and accept people as people are. I have in the back of my mind, that one day I'll write a book. I haven't written anything yet, but I want to let out some of the things that I have accomplished over the years. I feel that people should know all the things that I've learned that would be of interest to other people.

PAGE 71

JOSEPH ROCHA, WASHINGTON, D.C., 2010
PETTY OFFICER THIRD CLASS, U.S. NAVY, 2004-2007

Master-at-Arms, K-9 Unit Dog Handler. Honorable discharge after coming out to his commanding officer; suffers PTSD from years of abuse, hazing, and humiliation

I wanted to join the Marine Corps, and my godfather said that if I ever wanted to join the Marine Corps I would have to do it through a commission at the Naval Academy. I didn't get into the Naval Academy. So in order to prove myself, I joined the Navy. My intentions were always to go to the Academy and commission as a Marine and get to Iraq and Afghanistan.

After boot camp, I started at Master-at-Arms School, and that's when it started to get scary. I didn't want to go out to straight bars every single night and pretend. I did want to find another gay person who was in the military. I needed a friend, but how do you approach someone? How do you know you're not outing yourself? How do you know that they're not going to out you? And then once you find someone to go out with, you're terrified of who's going to see you. I was confident that if I just never told anyone, I could be just as successful as anyone else.

I spent about six months to earn the chance to go to dog school and become a handler. Chief Petty Officer Toussaint claimed that he had a very proud and very exclusive family that he called his K-9 unit, and I wanted that really bad. There was a lot of rumors that Toussaint wasn't a good guy and that the kennel was a mess. I didn't see that from the outside. I saw a very small, specialized, elite unit. I think I was looking for a family.

Right away my dreams were being crushed. Training scenarios were a very valuable part of how we trained the dogs. We would place the handler and the dog into an environment that they did not know and we would test how they would react. One day Chief Toussaint decided that they were going to walk in on me pretending to go down on another service member. Why me? By that time it had already been promoted and condoned by Toussaint that I was gay; he had created an environment that allowed me to be punished for it. I think it was pretty clear that no one would be held accountable for it.

During that time the hazing and harassment included being forced to simulate gay sex on camera multiple times, being hosed down, being tied to a chair, left in a dog kennel with feces, being forced to eat dog food. As it got worse there was less chance in my mind that I could give up. If I was going through all of this abuse to become a handler and then going through all this abuse as a handler to get accepted into the Naval Academy, the more I had to lose and the less I could reason compromising myself in reporting what I had felt would threaten my career. But it never tarnished my love for the military, for the service members. I just was in the wrong place at the wrong time.

I had come from a background of violence and abuse. I wanted everything that I didn't have as a child. Honor, courage, and commitment meant everything to me. I went in thinking I was going to find integrity and it was really hard for me to understand how any of this was happening. I ended up right back where I was as a child. I think it was as simple as my never talking about a desire to have sex with a woman that really gave him the benefit of the doubt and the benefit of the doubt led to the question "Are you gay?" and I refused to answer. I think I was right not to answer, but I think that is what caused them to conclude that if I wouldn't answer, that I must be gay.

I can't carry hatred towards Toussaint or any of these other handlers that did anything to me. When I got out I was depressed. It's the same thing I learned from my childhood. You don't have to be friends with these people, but there has to be disengagement. You have to move on. I am not going to invest the energy to hate him, but I will invest the energy to see that he be punished. The Naval Academy sent word that if I put in writing that I wasn't gay that I could stay, which equated to the only way that I could stay was to deny who I am. That wasn't OK for me anymore. I'm just as ready to lead men and women. I'm just as ready to go to war. I am just as willing to die. All I care about is for this policy to be repealed. Everything that happened doesn't matter. It took a lot of my life away from me, it took my dream away from me. But, it had to happen to someone and people had to find out about it.

People have a right to intimacy. They have to have a human relationship—and that's really what it comes down to. These people think, "Just don't be gay, just don't let me know that [you're] gay." But that removes a possibility of me having that photo of my loved one on my desk or talking about my anniversary, or having a human aspect to my life. That kind of self-denial and that kind of duality is terrible.

I made myself a target, but I had too much pride to say no. And too much fear to say yes.

PAGES 72-73

VICTOR FEHRENBACH, BOISE, ID, 2011
LIEUTENANT COLONEL, U.S. AIR FORCE, 1991–2011

F-15E Fighter Pilot. Retired; tours of duty in Iraq, including Operation Iraqi Freedom, and in Kuwait and Afghanistan; 88 combat missions, 400 combat hours; successfully fought his discharge under DADT

After three years of not going to war, I was coming up on what I thought would be my last assignment. Our squadron was scheduled to deploy, so I was to take some time to relax, run, ride my bike, raft on the river, and do some quiet things at home with Nick. Nick and I ended up getting into one of those we're-broken-up fights. A night or two after that, I ended up meeting someone online who said he was in the Army and had a one-night stand during that brief time Nick and I were apart.

Three days later, May 16, 2008, my commander calls: "I have to take you to Air Force OSI" [Office of Special Investigations]. OSI introduced me to a Boise police officer [who asks] if I know the person that I had a one-night stand with five days before. "He's accusing you of rape." That was the end of my life. This person knew exactly what he was doing. Everyone investigating knew this person was a habitual liar and had done these things before. [The Air Force] continued to claim that they had brought him in as an informant to another case that was related to finding gay people in Boise but never used him. They brought civilians in to question me on something they weren't allowed to and then recorded it. I had to wait to see if the Air Force was going to charge me with a crime and discharge me. The lawyers from Servicemembers Legal Defense Network [SLDN] said that was a toss-up [because] they didn't ask and I didn't tell. I said, "Just cover this up. I'm not out to anyone—I'm not out to my friends, I'm not out to my family, no one." I'll just tell them I decided to get out of the Air Force and move on. Mike Almy contacted me: "You need to read about this Air Force major who was thrown out three years ago; she just won a case in the Ninth Circuit, and basically it says that the Air Force has to prove she is detrimental to good order, discipline, and morale. I called [SLDN] and said, "What do you guys think about me fighting and telling my story? Do you think that could be something that could help change Don't Ask, Don't Tell?" They all said, "That's what we wanted to hear."

On August 20, 2008, I got word that the Air Force found no grounds for any charges; the allegation was false and I would not be charged. I still hadn't been discharged yet, and I still hadn't received my letter notifying me. I went to my commander and said, "Can they expedite this? I want this to be the fastest discharge they've ever done." It was probably great news for the Air Force that I was going to stay quiet, sign a piece of paper, and move on so that no one would ever find out what they did. Within days, I got the letter saying, "You're being discharged for homosexual conduct." I went to my lawyer; they had the letter ready that said I will accept an honorable discharge and I waive my right to a board [review].

Even though everything was lined up, I started to not be able to sleep….I know I'm not doing what I know is right. I wrote to my civilian attorney and my military attorney

and said, "I need to fight. Is there a way we can take that letter back?" At the same time, [presidential candidate] Obama started doing well in poll numbers. "He said he's going to end DADT. Wouldn't this be a shame if I gave up? We could delay through January [when] we have a new president and DADT is gone." I sent my commander and group commander an email and said, "I'm going to fight my discharge." That night was the first night I slept.

In January, we had a preliminary hearing to invoke what came to be known as the Witt standard: the Air Force has to prove I am detrimental to discipline. They could never prove it. I'd been working in my squadron; never got fired; been doing the same job. My chain of command wanted to keep me. The Air Force blocked it. In April, I had my administrative discharge board, where I had to relive everything. I had to listen to the tape of myself telling everything. I almost quit. I called a friend of mine and he gave me the best advice I ever heard: "Why? You've already had your worst day. This is nothing." And he was so right. "I've already lived my worst day, so I can do this."

April 15, 2009, exactly thirty years after my dad died, they took everything. They took my flying, they took my career, [and] they took my retirement. I had nothing left. I contacted SLDN and said, "I told you I might want to come forward and tell my story. I'm ready." Within days, I was scheduled to be on the *Rachel Maddow Show*. I told my lawyer and the PR guy, "I am not out to my family. They don't know anything about this and they certainly don't know I'm going on national TV. I need to get with my entire family and tell every single one of them, and if any one of them says don't do it, I'm not." I didn't get to fly home, so the only way I could do it was write an email. I wrote it, hit Send, and then slept like a baby. I finally got the courage to start listening to voicemails and opening up emails, and one after one after one was, "We love you more than ever. We totally support you. You have to do this." My mom called me and said, "I love you and I'm proud of you. Let's do this." I flew out to New York the next day, and the rest is history.

At the time, I was the highest-ranking, most-decorated person discharged under Don't Ask, Don't Tell. My job was to protect the Marines and soldiers on the ground. The way I saw it was, if I'm the highest-ranking person, I have the leadership role by default. I have to lead and protect those under me. When I talked to my commander, the day after the first interview, he said, "Are you coming to work on Thursday? We're having a commander's call." When I drove to work and put my uniform on, I found myself walking with a pride I'd never felt before. I was about to walk [into the squadron] and never have to hide and never have to lie. I thought people would look away, ignore me. Nothing but handshakes and smiles and Congratulations!—we're happy for you. Nothing but support from total strangers to brothers I went to war with, including my buddy Flaps, who I flew over Baghdad with. He told me, "I'm proud of you for fighting. You've always been a fighter, and that's why I always want you with me in combat."

There were times along the way [when] I fought tooth and nail with my lawyers to get thrown out, because I thought, if I get thrown out, I'll be able to say more and do more. I was shackled through a lot of this because I was still active duty. Looking back on it, I see why they protected me; it was a symbol for the end of Don't Ask, Don't Tell. They could point to me and say, "He's serving openly and it's not a problem." Now I see how important it was for me to stay in uniform even though there were times when I was kicking and screaming to get discharged.

PAGE 75

LESLIE MOORE, BAYTOWN, TX, 2011
SEAMAN E-6, U.S. NAVY, 1991-95

Captain's Cook. Honorable discharge; investigated because of speculation of homosexual relationship; chose to leave when rank was stripped

My mom and dad gave me up when I was three years old. I been told that my mom was into drugs and I was addicted when I was born, that I was really small so I could fit into a chest of drawers. My grandmother said that they had beat me so bad. I was so proper I would stand in a corner and I wouldn't say anything. My mother died when she was about thirty-three years old. From the stories that I was told, she had kidney failure. My uncle told me it was heroin.

I have always been very tomboyish. I was very competitive, very headstrong and I wouldn't let any guy beat me. I never correlated it with being gay. Actually a rumor did start that I was gay, but it wasn't true because I didn't think about it. But, thinkin' back on it, when I was with guys, it wasn't exciting to me, if you can understand what I'm sayin'. It was good that I had a boyfriend and people saw me interacting like that. But I always thought that boys would stop me from being able to accomplish what I was trying to accomplish.

I became pregnant graduating from college. The person I was gonna have a baby by was white. He was from a prominent family. He told me he always wanted to know what it would be like to be with a black girl. I told my grandmother—I was scared to tell her —but at five months I told her. And she was like, "Well, that's not gonna work." For whatever reason, she wanted me to have an abortion. And that's what I did.

The military was my get-away-free card. I couldn't do what I wanted to do. I had a physical education degree and I went in as an E-3. I started goin' to the gym a lot. There was a bunch o' girls playin' basketball and I ended up bonding with them. All o' them were just like me 'cause all they wanted to do was play basketball. The subject of sexuality came up and somebody asked me about being gay. And I said, "Hell no. They goin' to hell. They goin' to hell and they're 'its.'" So they didn't open up to me with that and they left me alone with it. I just played ball. I don't know what happened. Every once in a while I would see a girl and I'd say, "She's cute." And I would shake it out of my mind.

But one girl—her name was Cynthia—started hangin' around me and was askin' all these what-if questions. "Would you judge me if I was... attracted to females?" I said, "To each his own. That's up to you. I have nothing to do with that." It started clickin' in my mind that it wasn't botherin' me anymore. She cornered me in the bathroom and kissed me and I didn't pull away. "What the hell am I doing? This is wrong." But I wanted to experience it because I guess it felt good. But in the back of my mind, I saw the preacher; I saw my father; I saw my grandmother. My grandmother would have never understood. My father would have never understood. I never came back home because I couldn't live my life the way I wanted to.

In the military you couldn't be out. We were still hiding 'cause we didn't trust DADT. Just because they can't ask, don't mean they don't persecute. That's why I'm not in the military now. This was gonna be my life? It ended up not bein' my life because the people around us complained to the master-at-arms and they ended up investigating. Although they didn't have any proof, they had speculation. I ended up losing my rank. I lost faith, so I didn't fight it. I got out because I was forced out.

Someone said something. I was close to this young lady but we were careful. I was too rules and regulations oriented. But the fact that we hung out together; and we would take our showers at the same time. They brought that up. But they didn't see me kissing her; they didn't see me hugging her; they didn't see me doing anything to her. They didn't even put the fact that I got kicked out on my DD-214. But if you go in and look at my records, they had inappropriate relationship with a female. And since they paid me to get out, I took it.

How do you discriminate against a certain person and you are supposed to be a part of the government and you are trying to deter discrimination. That's an oxymoron, isn't it?

PAGE 77

177

KEITH KERR, SANTA ROSA, CA, 2010
COLONEL, U.S. ARMY AND U.S. ARMY RESERVE, 1953-1986
BRIGADIER GENERAL, CALIFORNIA STATE MILITARY RESERVE,
1986-1991

Retired. Came out publicly in 2003 on the tenth anniversary of
Don't Ask, Don't Tell

My great-grandfather came ten years after the gold rush of 1849 and settled in the
Central Valley of California. I was born in 1931 in Marin County and raised in the
San Joaquin Valley. I had a very ordinary childhood. By the time I was in junior high
school, I worked summers on my uncle's dairy ranch in southern coastal Oregon. I did
have a girlfriend my last two years in high school, but never was interested in her
in a sexual way. I was attracted to my peers, but really suppressed those feelings. I
thought it was something temporary.

My father was a reserve officer who was called up in World War II. He fully expected
both of his sons to perform military duty. I wanted to get my bachelor's degree, so I
went to the University of California, Berkeley, and joined ROTC to become an officer.
My father was homophobic and he suspected I might be gay. He'd found this letter;
there were some statements that I was attracted to men, so he wanted me to go to
a psychiatrist he found at the college. The treatment was to give me injections of
testosterone. All that did was increase my sexual desire. I was concerned that I might
be drafted during my last year, so I volunteered and went into the Army in 1953. On
the one hand, [my father] was disappointed in me because I hadn't finished ROTC and
gotten a commission, but on the other hand, he didn't want me to delay going into
the military any longer. The question on the medical form—"Do you have homosexual
tendencies?"—I checked no, because I was still rationalizing that one day, I would be
attracted to the opposite sex.

After basic training, I was trained as a stenographer and assigned to an intelligence
unit in Germany. We were looking for strategic intelligence, what was going on, what
arms they were making, other information about a potential enemy. I enjoyed the Army
and did my job well. I tried to be as discreet as I could because a lot of people got
undesirable discharges. After my tour of duty in Germany, I was determined that I was
going to get an officer's commission. My last year of college I joined a reserve unit
to prepare myself to become an officer. I started dating a very lovely lady, who was
an acquaintance of a married couple that I knew. We went a lot of places, we did a
lot of things together, but I really had no particular sexual desire. Finally I said
to myself, "Keith, you are a gay man. You enjoy dinner and socializing with your male
friends. It would be a terrible mistake to marry this lovely lady because you'd probably
wreck her life and your own." That's the only wise decision I ever made in my life!
I thought I would try a reserve military career and build a civilian teaching career.
It won't be such a disaster having to start over if I'm investigated and dismissed
from the service for being a gay man. I was able to manage both careers successfully.
At some level, though, your military colleagues realize you're holding something back

from them. At one point, I was interviewed; there was some suspicion. But I signed an affidavit that I was not gay. I then found an intelligence school that relied a lot on reservists as instructors and went to the Special Forces course. I took a leave of absence and worked on my master's degree and got picked for the command at General Staff College, and also for the Army War College. I retired from the Army Reserve in 1985 and decided I would go into the Reserve of the California Guard another ten years. I was living in San Francisco—I lived there for thirty years—and I'd come home for the weekend from Southern California, where I was on duty, and decided to go to a disco one night. I was standing near a guy and asked him to dance and well, we saw one another regularly after that. Alvin owned a house in San Francisco also, but he moved in with me. By that time, I had over twenty years of active and reserve service, and I said to myself, "If there's any adverse information that turns up, I will just ask to retire." I was still paranoid in that respect. Perhaps I did introduce Alvin to one or two of my close military friends, but as far as they knew, he was just a buddy.

In 1998 Dixon Osbourne, executive director of Servicemembers Legal Defense Network, asked me to consider joining the board and reassured me that not everybody who was associated with SLDN was gay or lesbian. I joined and became chair of the military advisory committee. I was sitting home one evening watching a documentary on Elizabeth Cady Stanton and Susan B. Anthony, and the movement for women's suffrage. I was moved by how much they had endured, how much they struggled, how much they suffered—all of the ridicule that they were subject to. Neither of them lived to see the passage of the amendment giving women the right to vote. I looked in the mirror and said, "What have you done for gay rights?" The answer was, "Nothing."

It was shortly after that that Dixon asked me, "Would you consider coming out? Virgil Richard and Alan Steinman are willing, will you join them?" I said, "Yes." We wrote an op-ed for the *New York Times*. The *Times* said, "We don't want to publish it. We want to assign a reporter and do a bylined story." They did. They published our pictures in the *Times*, the *San Francisco Chronicle*, and in newspapers in Sydney and Melbourne. There was a lot of publicity. *People* magazine and other publications came around. I did get hate calls. I was a little scared, frankly. One man who'd been in the Special Forces called, "You never really served in Special Forces." I said, "Wait a minute—I did!" And I picked one of the certificates off the wall, and read it to him. He seemed a little calmer. I think it's fair to say that if a gay man can master certain military skills like parachuting, or [becoming] a Navy Seal, an Army Ranger, or Special Forces Trooper, then what does that say about them? I think [their masculinity] is threatened a little bit.

You've got to have your ticket punched—so much time as an operations officer, so much time in Supply, so much time as a commander. And ideally, you would have time in a combat situation. I would have volunteered for Vietnam, but Lyndon Johnson never called out Reserve units. With my specialties, I probably wouldn't have been exposed to first-line fighting. I've often asked myself, "Is it a good thing that you never saw combat?"

Whereas a heterosexual man or woman—if they get a promotion or an award—can say, "I need to thank my wife and my kids for their support and their understanding when I've had to be away," I could never acknowledge Alvin that way. That's perhaps the biggest regret about my military service and his passing. I did thank him privately. We had been partners for twenty-six years. I think he would've grown into it. I think he would've been pleased.

PAGE 79

TRAVIS JACKSON, MONTGOMERY, AL, 2011
SERGEANT, U.S. ARMY, 2004-2009

Chaplain's Assistant. Deployed to Iraq 2007-2008, general
discharge (under honorable conditions), patterns of misconduct

I was born on September 18, 1984, on a Wednesday morning at 9:30 on Fort Hood, Texas,
Darnall Army Hospital. I felt a sense of emptiness being raised in a home where my mom is
a minister and my father is a retired sergeant major. I believed if you're a homosexual,
you're bound to go to hell, which led to me thinking about suicide at the age of fourteen.
My main reason to join the military was to get away from home, so I joined [the U.S Army]
on Thursday evening, May 25, 2004, a year after graduating high school.

The old saying goes, "Young men will go to war and become real men." I felt like I was becoming
a man. The motivation from my parents telling me, "You're too young," other people telling
me that, "You won't make it," was more fuel to achieve my goal. The flames made me stronger.
They burnt me but they molded me into the man I needed to be. God does things for a reason.

The chaplaincy is a unique MOS [Military Occupational Specialty]. If you're a chaplain's
assistant, you know about the word of God. The chaplain's assistant is the chaplain's
bodyguard in time of war; you're trained to carry a weapon. It's a dangerous job, just like
any other combat MOS. I believe [it is] one of the most complex jobs anybody can have.
It's the small things and the small jobs with the small responsibilities that matter.

We had a policy in the Army Regulation for Chaplaincy on privileged communication—if
someone told us their sexual orientation, it is required to tell the training command,
squad leader, team leader, or commander. I felt like that was an option. If I were to
disclose that, not only am I hurting their morale, but I'm going to hurt my own morale
because I'm putting on a fake persona on who I really am.

On March 6, 2006, because of hiding my own sexuality, I felt hopeless again, but this time,
the hopelessness was worse than at the age of fourteen, because I am a grown man. I felt
life was meaningless. I did overdose on sleeping pills, along with a bottle of vodka. When
I was in the hospital, the doctor told me that I was dead for three days. After I got
out of the hospital, people would whisper whenever they would see my presence; they were
talking about either my suicide attempt or my sexual orientation.

In April 2007, I reenlisted becoming a part of President George Bush's Iraq Surge. I had
orders to go overseas and was deployed one month after. I'm actually fighting for my country
now. A sense of pride overcame me, "This is me; I'm serving my country now. I am the guy
that's in charge. I'm not too young and I have my M16 with me." When we were in Baghdad,
we took on twenty significant actions per week. Our unit lost ten guys within one month; two
came from our battalion. Those deaths made me realize that I'm fighting for my country, but
my country's not going to fight for me. If I come out, that would be grounds for termination.

I took pride that I survived fifteen months of the Iraq surge. When we came back, I came up
with symptoms of post-traumatic stress disorder [PTSD]—I would smoke a pack of Newports

and drink a fifth of vodka every day in order to get some rest. I would have unexplainable migraines; I had pains in my hip or in my back because of the vest that we had to carry overseas. It was small things that became very complex. Sometimes I would wake up in the morning and literally, I would not move because I would be afraid.

I guess you could say my performance became low. [I was] late to formation, dismissing myself early from work to go home, negative all the time, very bitter, mainly just negative attitude. We were back for seven months, and our commander broke the news that he volunteered the brigade to go overseas again. On March 15, 2009, they had a house party in the Dion Barracks. We all got drunk, and we had a good time. Two guys in uniform come upstairs and told me I need to leave. "We were told that you're up here making moves on the same sex." They escorted me down to the CQ [charge of quarters] and confiscated my car keys because they were saying I was too intoxicated to drive.

The next morning I told the chaplain what happened. I began to cry uncontrollably out of nowhere. The next day, two NCOs [non-commissioned officers] and my squad leader came to the door: "Get up, you need to get some counseling. We heard you're detrimental towards yourself." While in the psychiatric ward, I got investigated by Criminal Investigation Command [CID]. One of the soldiers didn't feel comfortable with me being there. Obviously there's some talk around the battalion about me, because I'm too quiet, and I mind my own business, and I'm not getting into any trouble. I don't have any DUIs, other prior misconducts. They did ask about my sexual orientation. I went to Iraq and fought for fifteen months; I take pride in that. I'm not going to sit back and deny myself anymore. I realized I was beating myself up more because I wasn't real to myself. When they asked me, I came out and told them. And I think that's what they waited for; that's what they wanted.

On July 30, 2009, the company commander calls me down to the company headquarters. "Before I start, I would just like to say that you are an outstanding NCO, and I would want to have you back in my company. However…" He opened up the folder to expose a DA4-458, which is a charge sheet: being disrespectful towards an officer, wrongful sexual contact, going AWOL. Three months later, I was kicked out on what's called discharge under honorable conditions. The reason for my discharge is patterns of misconduct. Those patterns of misconduct were mitigating factors because of my sexual orientation and the hostile environment that my behavior was creating.

I feel like God brought me through a lot to make me the man that I am to this day. After my discharge from the military, I went through three months of suicide ideation for the third time. I was just so fed up with life. I told God, "You do what you want to do, but I give up on life." He came to me in a dream and spoke to me, "I see your prayers, I see your tears, and I see your pain. I just want you to know that I love you and I will always be there for you. You've gone through a hard time, but you can be an influence on many people if you can just believe."

I began to research lawyers for my discharge upgrade. I found a lawyer and shipped him the CID file, the orders, and my own packet that my military lawyer made for the separating authority. He calls me back and tells me that I have a case based off of my PTSD and my sexual orientation. We can fight to get my benefits and back pay I was denied. I'm sharing my story because I figured if I can influence that one person from taking a razor to his or her wrists, then I know I've fulfilled my purpose.

PAGES 80–81

HEATHER DAVIES, ROUND ROCK, TX, 2010
LIEUTENANT, U.S. NAVY, 1989–1998

U.S. Naval Academy Graduate, Operations Watch Officer and Officer Recruiter. Resigned commission

My body does an amazing job of suppressing or repressing whatever is not going to be safe for me in my environment. I think that what my body said was, OK, this is a safe enough environment—even though it's not very safe—but it's safe enough. At the time it felt right and it felt crushing because I was on top of the world. It was the first time, I had let myself love somebody and feel all the feelings that come with love and intimacy and sex. I wanted to share it with somebody and I couldn't. It was awful. It was so painful.

The person I started dating in Wales was really helpful for me in terms of trying to find a new path that was going to help support me in terms of realizing who I was. Everything happened in extreme secrecy because we were both on the same small base. I still didn't have an awareness of DADT. But the person I was dating was older than me and had been in the Navy quite a bit longer. She grew up under the old regime where there were active witch-hunts to catch gay people in the act to get them out. I learned that culture. I was terrified the whole time I was in. I thought that's what was going to happen to us, that they were going to come, someone was going to break down the door, they were going to have a camera and were going to take pictures. That was the fear I lived under. I had no way to sort it out. It was so confusing.

My roommate, who was my best friend, was the one person that I could have talked to about it. She and I had always had this really tight friendship, and I remember her saying, "You can only love one person deeply and it's not me." We had never had a physical relationship, but as two women going through the Academy trying to make it—she was my plebe summer roommate—we got through the hardest times together. Our friendship broke up for a year because of who I entered into a relationship with. She had feelings towards the person also. I remember her walking out with her camping gear—she was going because she couldn't deal with it. I didn't know what was going to happen. We were both watch officers and we used to have to turn over watch sessions to each other. For six months the turnovers were brutal because we weren't talking to each other on a friend basis, it was just very professional: "This is what you need to do. This is what I saw last night."

I moved out. We weren't roommates anymore. I couldn't talk to the command chaplain, who would probably turn me in or would convince me that this was not a godly way. I ended up becoming a conduct case. They didn't take any official action against me, but I was warned that if I didn't get my attitude together, and get it together soon, they would take action against me. I got really angry and my performance started falling at work. I was so high strung. I was constantly in tears or angry; just pissed. They sent me to the chaplain, had to take a test around my functioning and make a plan about how I was going to improve. I turned it around and ended up being watch officer for the year on base.

PAGES 30–31, 83

BERT BARES, HOUSTON, TX, 2012

LANCE CORPORAL, U.S. MARINE CORPS, FIRST ANGLICO, 1966-1970

Served three tours of duty in Vietnam; received numerous commendations; awarded the Purple Heart and the Bronze Star

I'm known as the Reverend Doctor. I was born on August 7, 1947, in Houston, Texas. I had European culture—Castellóne, Spain—as well as conservative Catholicism from my father; the do or die, stand-high East Texas red-dirt upbringing from my mother; and my Jewish stepfamily. For six months each year I would live in New Orleans with my grandmother—I was her favorite, her chosen of all of her grandchildren—and for the remaining six months I would live in Houston with my mom and my stepfamily. My real dad loved women; he married many times. Mom had a nice place off Memorial Drive [in Houston]. She took care of business, lived her life enjoying her jewelry, her furs, her social life, and came home on weekends in Houston Heights, where I stayed with my stepdad. His dad lived with us as well and was determined I would be raised Jewish.

I was three years old the first time I had a sexual experience with my grandmother. That continued until I was seventeen years old. When I was eight years old, my stepdad and stepgranddad started sexually abusing me, and in rather horrible ways. Since mom stayed in town, they had unfettered access to me Monday through Friday. I always knew what kind of day I was going to have if my stepdad knocked on my bedroom door, stuck his head in; "I'm going to need my little girl today." They would strip and hold me in hot water or lock me in a car trunk or [hold] pillows over the head to get me shocked enough to do whatever they wanted. My sole job for all those years was to please. Everything I learned about sex was from those experiences. At no time was I given a benchmark of sexual orientation.

The authorities put me into a foster home when I was twelve years old. They weren't going to prosecute my stepdad or his dad; they have a huge name in Houston and the Texas Gold Coast. There's a different law and set of rules for people who have wealth and power. I was the one who was going to suffer the consequences. I remember begging my mother to let me stay. She finished packing my bag, handed it to child welfare, looked at me and says, "Maybe you can come home someday, when you learn how not to cause problems."

In my family, if somebody told me, "I love you," I was either about to get hit or I had just been hit. If they hugged me, it was either to hit me, or to take my clothes off and rape me. This family said, "I love you," and nobody got hit. They hugged you, and nobody got raped. They laughed and they loved each other, and enjoyed each other's company. There was no drama, no violence, and I didn't know what the heck to do. I figured I had a job. I failed with my family, so I wasn't going to fail with them. I offered myself to them sexually and acted out so they would beat me. Violence had become instilled in me from youth. I started cutting to release the pain that had built up inside. I continued to be a cutter for

forty-seven years—through my teens, in the Marine Corps, and in Vietnam. Throughout my life I was a cutter. It was something I had to do.

Dad was my grandmother's chosen child before me, so the things she did to me, she did to my daddy. Where he and I were different is that never in my life have I had the thought, or acted out anything that was done to me as a kid. But my father molested his stepdaughters. Grandmother couldn't get to me for a year, and it made her insane. She told dad he better take custody of me, or he would be cut off. So they got me. But dad was worried that with the experience I had with my stepdad and my stepgranddad, that they had made me a homosexual—he didn't want no homosexual for a son. When I was thirteen years old, he started taking me to Mexico, introducing me to prostitutes. He would stay in the room to teach me to have sex with women. He would beat me in the shoulders, buttocks, and thighs. "Don't you know I love you?" Then dad got caught having sex with one of his stepdaughters—he was having an affair with her. So he went to prison.

There's no way I wanted to go with grandmother. I was seventeen; I knew I wanted to be a Marine, but I needed some place to live until I could join the Marine Corps. I went to my stepfamily's house and told my mother I wanted to talk to my stepdad. She said, "You know he's not going to want to talk to you." I looked at her, "Just tell him his little girl is here." Sure enough he said, "Yeah, I'll see him."

My stepdad had a philosophy that if you share your emotions, you've given away your power. You've given the other person control. They would strip me down and put me at attention to prepare me to be a Marine and be a real man. My stepgranddad had an old-fashioned straight razor; he would take that razor across my chest; hit and flick, nick and bleed, hit and flick, nick and bleed until I showed no pain, no reaction, no emotion. I got real good at it. It's what I used most of my life, and it's one reason why I was such a great Marine. Before I left, I got the Star of David tattooed on my chest to ensure that those men could never touch me again. They had me in life; they're not going to have me in death.

The Marines promoted values I didn't experience; they were warriors. I was with First Anglico [Air Naval Gunfire Liaison Company], the elite of all Marine Corps units. They gave us vials of morphine, so we would not be captured. Anglico had one of the highest mortality rates—also Purple Hearts and medals of valor—than any other unit. At no time was I a "gay" Marine. I was a Marine. But the Marine Corps had the highest incidence of same-sex [preference] than any other branch of service. They broke down every type of barrier or inhibition. They made you love each other.

In Vietnam you had that buddy thing—he had your back, you had his. You could figure out who the couples were, especially when they volunteered to do guard duty together. There were three of us; we were generally behind enemy lines. We had this three-way relationship. No jealousies or anything. It was spiritual; it was physical; it was emotional. It felt like I belonged, and I felt like somebody really cared. It didn't seem dirty; there was completeness and wholesomeness to it.

After my first tour in Vietnam, I'd come back to Houston for a brief time. This girlfriend of mine from high school introduced me to this guy, who was my first no-restrictions, free-emotions gay experience. I felt liberated in Vietnam; now I was able to experience that with somebody who was totally comfortable being a

gay male. And to find the most profound word I can to describe the situation: wow. It was wonderful. I went back to the Marine Corps air wing for rehab until going back for my second tour. I wanted to be with this guy, so I told my commanding officer I was homosexual. This was 1968. He said, "Something else has gotta be wrong." I was a warrior. I represented the Marine Corps.

I went through intense psychological evaluation and the Naval Criminal Investigative Service [NCIS] investigated me. After ninety days, I was brought back to the air station for a hearing. The night before, I had a field grade officer come into my room and talk to me: "At the hearing tomorrow, you will say that your combat experience was such that you did not know what you were doing, that what you said was false. And since you are an NCO, you will ask permission to file charges against yourself for making false charges and filing false official government documents." I did. The psychiatrist said in no way, shape, or form was I homosexual. The NCIS investigation proved that there were aberrations of my childhood, and that I was not in fact homosexual. They fined me thirty days' pay, gave me thirty days' barracks restriction, and on the thirty-first day gave me my travel orders to go back for my second tour of Vietnam. Major told me the day that I left, "You have been a consummate Marine. You have besmirched yourself and your Marine Corps. You know what you need to do." I was supposed to die. And they made sure that I was in situations where it would be highly likely. And I nearly did.

When I got out of the Marine Corps after my third tour, my record was exemplary. I came back to Houston and started drinking. I had that Marine Corps body and was exceptionally hung and good-looking. I did pornography, dancing; I was a callboy. The only way to get out of it was to disappear for five years. Go underground. I couldn't speculate how many times I've moved. I was hustling; I did hotel bars and airports. The drinking stopped working and I got introduced to drugs. I could start consuming mass quantities of alcohol again. It was all about feeding the disease.

My partner told me when they bust us, we tell them we're on heroin and instead of taking us to jail, they're going to take us to the hospital. That is not what they did. They took me to jail in this big concrete room with no beds, just a ceramic stand to lay on and a big drain in the middle. Took all my clothes off. I detoxed off heroin cold turkey. June 1, 1985, was the last time I put a needle in my arm. There's been relapses—one on crack cocaine. I'd [met] this beautiful sensual sex-fiend boyfriend. We would have sex, but he would keep disappearing. He kept telling me, "Daddy, if we try it just one time on Friday night, I promise it will be beyond your wildest dreams." And I did it truly thinking I'd be able to do a little on a Friday night and be back in the program on Monday.

The second time I went to prison was June 13, 2005. I got tired of being down; it didn't make any sense anymore. I have a right to live and enjoy life. That's when change came. There was a program called Bridges to Life, a restorative healing program facilitated by victims of crime. They come with no judgment; they come with love, compassion, and forgiveness. This course makes you go inside yourself and face your demons. For the first time in my life, they introduced hope. I felt for many years that when God made me, he put a sign on my back everybody could see except me, saying "Not my best effort." One week before I graduated from the course was also one week before I got out of prison. I stopped cutting. That was my catharsis; that was my epiphany. All those people who did those things to me—I

don't forgive what they did, because they were horrific, and they were sinful. But I have to forgive them for doing it. I couldn't do that for years. And as long as I couldn't do that, I was their prisoner. They owned me. I was stuck in the past. Forgiveness is not a feeling; it's a decision. It's a decision that you make when you get tired of being tired, and living in darkness, and struggling for survival. I don't struggle for survival anymore—I fight to win. Every morning when I get up I stand in front of a mirror and say, "Today I will not fail." If I can just be a better person than I was the day before, and know who the man in the mirror is at the end of the day, I haven't failed.

I'm sixty-four and I have low self-esteem and thank God for that. From where I came from, I had no self-esteem. But self-esteem is intangible. It can depend upon what you're wearing; it can depend upon whom you're with. Two things were deprived of me as a child. They robbed me of my innocence. I have no concept of what that is. Seeing a puppy in the car window when you're driving. Taking a baby to an amusement park for the first time. I think that's probably innocence. But I shouldn't have to think, I should be able to know. And the other thing they took away from me was a sense of self-worth, which I think is absolutely more vital than self-esteem. I believe that self-worth is our foundation. Self-worth determines what we will allow people to do to us. And more importantly, what we will allow ourselves to do to ourselves. I didn't matter, so why tell anybody anything about what's going on in my life. They don't care. That's how I felt most of my life.

My body's breaking down. I'm PTSD from Vietnam. I also have cancer from Agent Orange exposure. I've been HIV positive since 1987, full-blown AIDS since 1994, and I have Hepatitis C since 1989. Dying is not my responsibility; it's part of nature. I recognize not all battles can be won. I'm going to lose the physical battle, but it is well with my soul.

I have been pronounced clinically dead twice. I've been in all these situations, yet I'm always pulled back. I've attempted suicide eight times. I've learned that some things belong exclusively to God. Time and manner of my death is his, living is mine. He gave me free will when he gave me life. It's a matter of focusing how I live my life. Who we are is God's gift to us, who we become is our gift to him.

PAGES 83, 242

JASE DANIELS, PACIFIC GROVE, CA, 2012
PETTY OFFICER SECOND CLASS, U.S. NAVY, 2001–2005,
2006–2007, AND 2011–PRESENT

Hebrew Linguist. Active duty; discharged twice; first service
member to be reinstated after repeal of Don't Ask, Don't Tell

I didn't have that connection with my family that normal kids do. My parents
divorced when I was five years old. Me and my brothers were in and out of
different [foster] homes for a couple years. I was a good kid, quiet, but really
good, and I was devoted to church. [When] I started to become aware of my
sexuality, I felt this repression. I became my own bully and attempted suicide
twice. They assumed it was because of the issues with foster care and the
relationship I didn't have with my father.

After high school, I wanted to go to college, but I couldn't really afford it.
I was dealing with my sexuality and just wanted to escape. So, I went to the
Navy recruiter's office on a Friday, signed the papers, and I was in boot camp by
Monday. I needed to get out of the rut I was in. I wanted to be my own person. And
the Navy really harped on education.

My first duty station was in Washington, D.C. I was part of the firing party in
the Ceremonial Guard, the guys who do the twenty-one gun salute. I was going to
church. I still believed in waiting to get married, still trying to conform even
though it was a battle. It seemed like everyone knew about my sexuality but me.
I started dating a girl and we decided to get married about a year after I was
transferred to Monterey. The wedding night rolls around and I realized that doing
this was not going to change who I was. I had been drinking; so when we got back
to the hotel room, I was just going to bed. When I got back to Monterey, I didn't
know what to do with myself. My grades started dropping. Four weeks later, she
called, "I'm twenty minutes away and I want to come see you."

I knew that I couldn't hide anymore. I called her and she could hear that I
was crying. "I don't think this is going to work." I couldn't even say that
I was gay yet. I could barely say it to myself, let alone to the person I had
married. She hung up. A month later I got the annulment papers in the mail. I had
transferred to my next duty station in Georgia when it was finalized and had to
turn in paperwork to my command to change my status from married to single. They
asked, "Why the annulment?" I told them because I'm gay. They immediately started
procedures to process me out under Don't Ask, Don't Tell. They read me my rights,
pulled me out, revoked my clearance, recouped my sign-on bonus, and ushered me
to the gate and said, "Have a good one." I felt like a criminal, like I had done
something wrong. I had nowhere to go. I had no money. I didn't know what to do.
Luckily I was able to get a job and rented a room from a friend until I was
finally able to get my own place. I got my discharge paperwork back, and they had
inadvertently put me in active reserve. A year later, I get a recall letter to
go back into the service. I was sent to Kuwait for a year, working with the Navy

Customs Battalion. I wasn't going back into the closet. I was open and honest with everybody. My command was very progressive and everyone knew I was kicked out once before. It felt much easier to do my job since I had support from my friends and my coworkers.

Then, a former chairman of the Joint Chiefs of Staff made comments in the *Stars and Stripes* newspaper alluding to gays having no place in the military and that they were immoral. I sent a letter to the editor: "How can one of our most senior leaders hate a group of people who are serving honorably?" They wrote back, "We want to do a story since you're serving openly." They not only interviewed me, but parts of my chain of command and people I was serving with. They intentionally waited until the day I got on the plane to leave Kuwait. It printed on the front cover: "Gay Sailor Recalled Back to Service." As soon as I got home, I did an interview with *Good Morning America*. It was an incredible opportunity because I could speak on behalf of people that couldn't speak for themselves.

I had fifteen days of terminal leave left before I was to be placed into inactive duty status. I got a call from the lieutenant in San Diego, "This is not coming from me. This isn't coming from your chain of command. This is coming from higher up. I regret having to do this, but you're being discharged again under Don't Ask, Don't Tell. I think what you're doing is incredible and I think it's going to change things." This led to my second discharge.

I knew what to expect this time. I started telling my story and how careers are being ruined for people who are otherwise incredible service members. Then in 2010, Mike Almy, Anthony Loverde, and I filed the lawsuit saying that Don't Ask, Don't Tell is unconstitutional and we want our jobs back. But by September 2011 [DADT] was finally repealed and I had to do what everybody else had to do to enlist, going to the recruiters and getting all of your medical stuff done. My command at Defense Language Institute knew that I was coming back. The media had already called them. When I got there, they said, "We're going to support you any way we can."

This is what America is. This is the fabric of our country. We embrace differences. We all learn integrity. Finally, I'm in a position where I get to take care of me now. My job is solidified; there's no question about it. I know I have stability and I know I'm going to make it a career. I'm actually dating someone now and plan on making it a lifetime commitment. I think that my whole journey so far has brought me to that point.

PAGES 5, 85

JEFF KEY, SALT LAKE CITY, UT, 2010
LANCE CORPORAL, U.S. MARINE CORPS, 2000-2004

Used Don't Ask, Don't Tell purposefully to leave the military by coming out publicly and opposing the war in Iraq; writer, peace activist, civil rights activist, founder of the Mehadi Foundation, a nonprofit organization assisting veterans with PTSD

I was a hypersensitive, wildly creative child and sexually attracted to people of my own gender. Just about every way that somebody could be different, I was. I remember being a teenager when I first admitted that I was gay. By the time I was in the tenth grade we were slipping off to Birmingham to go to gay bars. There was this small group of kids there who were completely OK with who they were. We all slept together—gay boys and lesbians as well—'cause we relied on one another. We'd spend weekends together and read poetry, drink copious amounts of liquor, talk about things that infected us in our world, and sing our way through the gospel hymnal. There was a place outside the small insular world of Alabama.

I wanted to commit suicide for years because all my defenses were no match for the exorbitant homophobia that poured on me in my surroundings. There was nothing about that experience that told me it was OK to be gay. I did every drug I saw, but mostly drinking. So when I was twenty-three I hacked my wrists open with a razor blade. My friends taped me together with duct tape and I lived. Alcohol had become a crutch. Life without drinking seemed impossible, but life with drinking had become impossible. I was a year sober four times over an eight-year period. I finally was able to start seeing that there wasn't anything wrong with the kid. That he was fine in all those ways—many ways really—that he was told he wasn't OK.

I started to reawaken my spiritual path and consider what's important to me in this world. Part of who I am is the part that claims patriotism while openly and unapologetically criticizing nationalism—my country right or wrong will be the demise of America. I distrust my government. And I don't believe there are political solutions to spiritual problems. I became a Marine as a continuation of that emotional and spiritual process. I was raised in the Church of Christ and I carried the good from that religion into my adult life—the compassionate resolve to stand against oppression. I took the oath of office on the sixth of June in 2000. As a Marine, I wanted to stand up for defenseless people, even if I have to sacrifice myself. No matter what's wrong with America and the mistakes we've made, I still love this country. They're fucking with my flag by trying to make it into something it's not, where government is run by religion and it's OK to oppress. That's not my country.

I love the Marine Corps. I miss it every day. I will be a Marine until I die. I was probably the Marine who joined for patriotic reasons. Some people say being a good service member is unquestioningly following orders. In that case, I'm a

terrible Marine. Because of my epiphanies, I can't be a part of the military because of the horrible torture of people around the world.

And those people running their mouth about Don't Ask, Don't Tell and talk about unit cohesion couldn't march a mile in my boots. They couldn't take the youth that I grew up in. That battlefield made me a good Marine. I have skills they could never develop in any kind of training because of my experience. So fuck them. [My sexuality] had absolutely nothing to do with anything they ever list as a reason for not lifting the ban.

I split my abs open in Iraq, from my belly button up—two inches. If my buddies had been getting fired on, I probably would have taped up my stomach and untaped it when I got back to America. But my buddies were like, "Get the fuck out of here and go. You need surgery." And so they put me in the medevac. All the way through Charlie surgical to Baghdad to Kuwait to Germany down home, I saw war injuries; the worst carnage I had seen. "Oh my fucking God, what's going on?" I started to think about what we were doing there. Pointing our weapons, telling them what they were allowed and not allowed to do over and over every day. Somehow, that's supposed to be OK with these people. Why do Americans think somebody else is so essentially different? Like they're gonna roll over and piss themselves and let us paint fuckin' red, white and blue all over their world. This hubris is not going to lead us to safety from terrorism. Hubris causes that. We cannot go around the world taking what we please and expect that people are going to let it happen. It's never ever going to happen. No matter how long we stay, the impetus for us being in Iraq is bullshit. And so I made the difficult decision to leave the Marine Corps. I knew after I did that interview with Paula Zahn, there would be no place to hide. If I did it publicly, they'd have to lift Don't Ask, Don't Tell or let me out.

When I drove off Camp Pendleton for the last time, it felt like a part of me was being ripped out. I wanted to pick up dirt and put it in my truck and run the flag down the flagpole and take it with me. There's so much I miss. Even some of the shitty things. I'm still a Marine in those ways.

My unit did not get into firefights after I left. But, it wasn't until some of them were in a peer support retreat that I was part of, that I heard them finally talk about the impact my leaving had on them. I did abandon them and I never will forgive myself for that.

I run my mouth about these things a lot. And a lot of people get to hear me. Seven years later I'm just plugging into the post-traumatic stress program at the VA because I have PTSD. I was saying the experience in Iraq had no impact on me. But I roam the house at night in my boxers with my Marine knife because I heard some noise. I have bizarre dreams. The first thing I do in the morning is write in my journal, because that's the best my life is, sharing my art. My life is about writing and performing those things. It would be tragic if I had gone through all this and I can't share what I've learned.

PAGE 87

TRAVIS, CHICAGO, IL, 2010

RADIOMAN-PETTY OFFICER SECOND CLASS, US NAVY, 1963-1969

Communication Specialist. Honorable discharge; top security
clearance; communication supervisor at Guantanamo Bay and on the
USS *America* during the Middle East War

I was born in Mississippi. I wanted to join the Navy and see the world, as the sign
said. My mother signed for me at the age of seventeen. The papers came and the last
two questions on the form had to do with, have you ever engaged in sexual relations
with a person of the same sex, yes or no? And if yes, were you the active or passive
partner? And then they defined sodomy. The idea of sodomy completely terrified me
because in Mississippi that's a word that you did not breathe. You don't discuss Sodom
and Gomorrah. This is Bible Belt. It terrified me incredibly that on forms from the
government, there it is and they were asking me if I had done this. Well I hadn't.
But I had to SAY that I hadn't. It made me feel very badly because it also reflected
on things that happened to me very long before at age thirteen, when people had tried
to take advantage of me in Mississippi. Men. But they would never call it sodomy. Of
course there was never penetration. This document was just distressing.

I went to boot camp. I did not have problems with the men in my company. They were
totally unlike me in every way. I had never been around men. They somehow took to me
and I took to them. They saw me as odd but no one ever called me a screaming queen
or faggot. I was aware there were issues being raised, because the company commander
would ask me if anybody had bothered me and if so let him know. I get to Bainbridge,
Maryland, and similar things happen. I had teachers who called me aside, "Does anybody
bother you?" They would want to know that. They asked me if anybody bothers me.

About halfway through the six-month class, people started fading away—a lot of bad
behavior. And as many of them faded away, somehow I went in the other direction. I
was outstanding man every month. Eventually, I was selected to be on the Drill and
Honor Guard to represent the Navy. I loved it! The man who was in charge was this
incredibly beautiful black man who had spent seven years in the Air Force and now
had switched to the Navy. He and his family were on base. It was he who allowed me
to know that I was also attracted to men. In retrospect I don't think it was a good
thing, but I think that the way that it happened, I am very happy that it happened.

He came to my bed one evening. Everyone is on weekend liberty except four people. I can
tell you what everybody looks like, their names. I was on my rack; across the hall was
Smith; down the hall Turret is doing all his Jayne Mansfield fan club stuff. And then
the drill sergeant comes to my bed and he's drunk. He starts kissing me; he first starts
touching me. That was not unusual because in boot camp, guys would do that. It was no big
deal. It was even less of a deal because he was a drill instructor; he was in charge.

But eventually, there on that rack with nothing but my skivvy shorts, I'm fading
and he's kissing me and biting me. It was complete removal from the earth. It was
a profound disengagement from any person that I had ever known before, but at the

same time it was like putting on new clothes. He was whispering in my ear about his needs and this idea of words didn't have any place where I was at that moment. I start feeling pain and aching and wondering, well, "Is this what they mean by sodomy?" Remember sodomy doesn't have a real tangible meaning to me at that point. I start getting sick and go to the other people in the barracks and we convince the DI to leave.

It was never, ever discussed. No word ever. But I was changed. The way I drilled was changed. I felt more masculine. I could feel it in the way I walked. I could feel it when I spoke. I felt bigger. I was 136 pounds but nobody could touch me. It was transformative in a way that I am happy, because it didn't lead to a discharge, which would have put an entirely different color on it. He treated me just as he did before, which was frightening to me because I was changed. I graduated at the top of my class at Bainbridge and I get my choice of duty stations. I go to Guantanamo Bay, Cuba, on my nineteenth birthday. One day I get a call at eight o'clock in the morning—my commander. For the rest of the day he sits me in a little room; he puts straps across my body; he attaches wires to my fingers and these meters are on each side of me, measuring my responses. Lie detectors! He starts drilling me, "Have you ever committed sodomy?" I had to sign that I would never tell anyone about this. It was degrading; it was dehumanizing. In the middle of that, I am now flashing on everything that he could possibly mean by sodomy. It was this completely horrific experience. It's like my guts were being displayed. And he never said why.

There was the assumption made by me that it had to do with my security clearance. Well, I already had my clearance. I had no control here. All I could do is sit there in this room, which was like an electric chair because I got straps crossing my body; my whole torso had straps on it. I've got blinking lights and meters attached to me. About SODOMY? I do not, to this day, understand why. And this was the Office of Navy Intelligence! I was changed in more profound ways than I had been with my drill instructor; suddenly it is as if I didn't exist anymore.

After it was over, he couldn't find anything to prove that I had ever had sodomy. All those meters and all that time it took. And I hadn't. I felt unclean. I felt I could never face my mother again. In fact, I did not see my mother again for fifteen years after that. It was that extreme. The effect is still with me. Whenever I have to go for my physical exams now, I get this white-coat hypertension. I could tell you the smell of the room, the size of the room and the voice, the repetition. It was a punishment that I didn't understand. What was he looking for? This goes on all day long. I remember completely surrendering. I began to hallucinate. I felt as if I was in my grandmother's womb again. I floated in midair. I decided that my life was over. Why didn't it stop? Why go on? But it never stopped. It just went on. I did not even remember the scooter ride back to the barracks.

I got back to the barracks to find my closest friends had all disappeared. The people who were closest to me that I talked to—we went on liberty together–were gone. Their beds were folded back; the mattresses were folded back; their lockers were clean. No one who was there ever spoke their names again, ever. Nobody ever mentioned them. Their names disappeared from watch lists; their names disappeared from everything. And so I waited for my turn to disappear.

JSB, SCRANTON, PA, 2009

PRIVATE FIRST CLASS, U.S. ARMY NATIONAL GUARD, 2005-PRESENT

Active duty

I joined the National Guard in 2005 for the college tuition and the fact that I come from a military family. I went through basic and Advanced Individual Training [AIT] for seven months. People didn't seem to have a problem with gay guys in the military. They want to serve their time, why not let them? During AIT, I did have a relationship. We had to be very secretive about it. I graduated AIT and he was still going to class. Once I left we couldn't maintain a relationship. I found out later that he actually chaptered out of the military. Last time I heard, he was in Florida.

I was [in Iraq] for eight months, in Tajid. The unit I was with would tease me, but they didn't hold it against me, except one guy. They were all waiting for me to lash out or beat him up because every time I would bump into him he always had a snide comment. But I never paid him no heed and nobody took him serious. He was obsessed to the point that we were wondering whether he was gay and he was in the closet or something. It's not the fact that he was making gay jokes but he was getting on my nerves every time. Inside the platoon they wouldn't have done nothing about it. There would be no investigation.

I have no problem with being in the military. It's a job. It's actually one of the easiest jobs in the world. They tell you where to be. They tell you where to go, how to dress, what to bring. They give you everything. And all you really have to do is follow orders. There's nothing hard about it.

From what I understand, the U.S. Army doesn't allow [gays in the military] just for the fact that it would destroy soldier morale. I know the British Army allows it. From what I understand, no other army has had issues about it. There would probably be some people who don't care for it, but what are you going to do? In all walks of life there will always be people who don't care for it.

You never know who's watching, who might know someone in the military who knows you. Here, it's a small community. You wouldn't want to run the risk 'cause they can hold an investigation due to hearsay if someone were to mention it. The commander could actually hold an investigation. People stick their noses into everyone's business. They need to not worry about everyone else.

The military is a part of my life; it's not my entire life. Same with my sexuality; it's a part of my life but it doesn't define everything about me.

PAGE 91

LARRY BAXLEY, WASHINGTON, D.C., 2010
LIEUTENANT COMMANDER, U.S. NAVY, 1997–2005

Senior Intelligence Officer. Operation Iraqi Freedom; resigned
commission due to Don't Ask, Don't Tell

I left the Navy to be with someone. It would not have worked out well. I would
have been faced with periodic deployments given my specialty, and [my partner]
didn't like the deployments, so I decided to leave. It's difficult to hide a gay
relationship. When you're single, the fifth senior officer on the ship, and always
being the one who shows up alone at formal functions, it's difficult to maintain a
charade. I grew accustomed to the fear of what would happen if I were caught. But
I also knew that if something did happen, I would not ever admit that I was gay.

I was born and raised in Atlanta in 1967. My biological father was out of the
picture early on. He beat my mother, so she left him. I had an older sister. Tommy
Lamar Baxley came along and he adopted the two of us. My name completely changed
and he was out of the picture in a few years too. My mom was faced with raising
three kids alone and it was tough for her. I wasn't necessarily the best kid at
home, although in school I made very good grades and was well behaved. Wasn't till
college that I became close to my mother.

We never had money and I didn't get to experience things like the other kids did.
So I never grew, socially. I did not really have girlfriends, but I did consider
myself straight. My attempts to have girlfriends didn't work out very well.
It wasn't until my late twenties that I outgrew a lot of stupidity. Throughout
college I had no idea what I wanted to do. I changed my major several times
and ended up a psychology major. I had a few fraternity brothers in the Navy
ROTC program, so I joined. I didn't have a philosophical reason, per se. It was
something to do and something I just fell into. I'm patriotic and I need to serve
my country? Very few people join the military for that reason.

I went to technical school and started out as a ship driver. I changed to
intelligence and started leading men. I was deployed five times, and each of those
times I went to the Persian Gulf. My ship, the USS *Independence*, was the first to
respond in Operation Desert Shield in '90. On my second deployment, we went to
conclude Desert Storm and support Southern Watch, the joint effort to monitor
the fly zone. My 2004 deployment, we went post-Iraq War under Iraqi Freedom. I was
stationed in Riyadh for a year as the chief of the Intelligence Center's Air
Defense Desk. It was my job to monitor all the surface-to-air missile activity
below the 32nd parallel in Iraq.

I was a very young ensign when the Tailhook Scandal ripped. Every naval officer
had to be addressed by an admiral about the proper standards of behavior. I
was brainwashed very early in my career that sexual harassment, or any sexual-
related abuses in the workplace, was not going to be tolerated. People got fired.
Promotions got held up. I never saw any woman or man in the Navy as a potential

sexual partner. I went to work. Period. There were gay people on the ship who knew other people [who] were gay; it was completely underground. They didn't even engage me because I was senior to them.

But I wouldn't have been able to, with good conscience, be a part of someone's processing out for being gay. If I had discovered one of my subordinates was gay, I would not have turned them in. Thankfully, I never had that situation come up. There were witch-hunts going on when I came in, but it was always outside of my sphere of operation. By the time I was figuring it out, Don't Ask, Don't Tell had arrived, so witch-hunts were over. That would have been absolutely terrible to be asked to look for gay people as a junior officer.

I was a very good intelligence analyst, a very good leader on my ship, probably the most trusted command duty officer that the commanding officer had. I loved operations in the Navy. I also liked finding the bad guy and shooting them. This was intrinsically rewarding and I was good at it. I did grow into my feelings of patriotism being in the Navy, especially during homecoming. It felt like you've done something important when your ship pulls back in. There are tons of people on the pier. Bands are playing. You get a sense of really having done some service. It was not my original motivation, but I'm very proud of what I've done for my country.

I think it's more important to be gay and in the military than it is to create a political victory by forcing a discharge. It's more important for the cause that we have successful gay people serving in our military.

PAGES 92-93

DENNY MEYER, BRONX, NY, 2010
PETTY OFFICER SECOND CLASS, U.S. NAVY, 1968–1972
Yeoman, USS *Forrestal*, Helicopter Squadron
SERGEANT FIRST CLASS, U.S. ARMY RESERVE, 1972–1978
Administrator at the Department of the Army Reserve

My parents were Holocaust refugees from Germany. These were not religious Jews; these were Social Democrats. We were raised to believe in freedom and to speak up. Fast-forward to 1968. I'm in college and there are anti-Vietnam War student protests going on. I'm neutral because I am too busy enjoying being a young gay man with freedom. Then they burned the American flag. How dare you! That's my flag! This is my country! None of these people ever suffered prejudice. If you ask any first-generation American, we wanted to pay our country back because we've seen where our families came from. So I joined the Navy. My friends told me, "You can't do that, you're a little faggot."

This was the middle of the Vietnam War; they were raking in 4,000 people a day at every recruiting station. This was not a pleasant experience. You go from one desk to another. "Open your eyes, say 'ah.' OK, spread your cheeks." And then you get to a shrink. "You don't have any problem with homosexuality, do you?" I said "No" honestly. "Next." They didn't ask it very well. But it didn't matter. I would have lied just like everybody else. You had straight people lying and saying "I'm gay" so they could get out of serving. Then there were gay people who were lying because they wanted to serve.

In 1968 everybody was in the closet, inside the military or outside the military. Serving in silence wasn't that difficult; you're used to doing it. Nobody expected to find gays in the military, but you had to be careful. If you were found out, shipmates would throw you overboard just on general principal. If you lived, you were dishonorably discharged. You were ruined because in those days you couldn't ever get a job doing anything with that kind of discharge. And if one person got caught, then everybody got caught; they threatened you with life in prison so you would give them names.

After four years I was up for reenlistment. I was one of the first people to make E-5 petty officer second class. I was the yeoman, the typist, the clerk. They wanted me to reenlist, but I didn't because I had enough after four years. I wanted to go back to being a free gay person. So I left.

It took me a while to realize, at age twenty-five, that I had one skill: military administration. I finally got a federal job as a civilian employee in the Department of the Army to administer reserve units. They only hired veterans with an administrative background. Washington said, If we activated the reserves, these civilians will be the only ones who know what's going on. Require them to be a member of the unit they administer. There I was, back in uniform in the Army

Reserve. It was the last thing I had intended. But I knew how to get promoted, and ten years later, I was a sergeant first class. Now I was at the halfway mark for retirement from a twenty-year military career. It was also 1978 and gay rights were emerging right outside the base gates. I had a lover for many years and got tired of looking over my shoulder at the supermarket to see if anybody saw us together.

The first time I left, I was still young and wanted to live freely as a gay person. The second time I left, I was more conscious and more mature, realizing I'm leading a double life that I didn't want to live. Had I retired, I'd have more benefits. Gay people didn't think about this because they served and then went on with their lives. They didn't want to look back because it was so unpleasant being a queer in the military.

Straight military friends can't imagine you could be gay. And your gay friends cannot see why the hell you'd ever want to be in the military. It's the same reason other people join: patriotism, we're fighting for oppressed people, economic opportunity, learning a job. And it doesn't cost you anything. In fact you get paid; it's a way out of poverty for lots of people. It doesn't matter if you're black or white or Asian or Hispanic, the military offered opportunity for everybody, except queers, since 1948.

My answer to every super-duper pacifist, is "If we did what you say, we'd all be speaking German now. And if you think they would have only gone after Jews, just wait until they got to you." Remember the words of the Lutheran minister Martin Niemoller, who spoke up, was sent to a concentration camp, and almost died. He wrote a simple poem after the war: First they came for the Jews and I did not speak out because I was not a Jew. Then they came for the communists, and I did not speak out because I was not a communist. Then they came for the trade unionists, and I did not speak out because I was not a trade unionist. Then they came for me, and there was no one left to speak out for me.

The two most satisfying things in my life were my lover and my writing. I am immensely proud of my time in the military and having served my country. But the most fulfilling things are what I'm doing now. Six or seven years ago I was multiply disabled, unable to work and unable to find anyone interested in my body. Even though the body is wretched, I'm in constant pain from spinal degeneration, and I can't remember anything, I help veterans around the country. I have a purpose in life for however long it lasts.

PAGE 95

JOHN O'BRIEN, NEW YORK, NY, 2010
LIEUTENANT COLONEL, U.S ARMY, 1980-2010

Retired. Deployed on three tours of duty in Iraq; suffers post-traumatic stress disorder

I loved the military. I love my country. I loved serving. The Army was going to be my life. The Army was my family. The Army was everything to me. It was the greatest sense of accomplishment and the greatest bond of friendship and love I've ever experienced in my life. I've got the chest full of medals, promotions, assignments, and all that. When I think about romantic love—I avoided it. I put an awful lot into the military, so I decided to compartmentalize these emotions that I had. Put them away, put them aside; [but] you don't forget them. They're always a part of you and they shake you, and they turn you ultimately into the person that you are.

We would never allow the unit to leave anybody behind. Everybody knows the mission and you want to execute it; you want to help your buddy execute it. You're not going to leave him hanging. And you're going to fight for him 'cause you love him. Maybe you hate him, but he's still part of the family. So that's why I think this whole issue of [gays in the military] being disruptive to morale and breaking up unit cohesion is bullshit. You know what breaks up unit cohesion? You know what disrupts morale? It's a witch-hunt.

I go back to when I was a lieutenant, when I was directed to run one, having to go around the company and read people their rights. Then somebody came up with photographs of one of the guys and gave them to the company commander. I was told to get him and bring him in. [The soldier] literally pissed his pants. He was so scared, afraid that his mother would find out. He pissed himself. Airborne infantry soldier. Shaking. So afraid that his mother's going to find out he's gay. Here we are, reading him his rights, basically prosecuting him and persecuting him, and I felt like shit. Ultimately it led to the ferreting out—and I hate using that term, but that's basically what it was—about six or seven gay guys. And this came from the battalion command to my company commander to me.

I wonder about those guys, that I had a direct hand in their elimination and the destruction of their life. Their DD-214s were less-than-honorable discharges for homosexual conduct. The absolute fear that I directly put into people. "Are you a homosexual? Have you ever had sex with another man?" I feel sick in my stomach thinking about it. I feel this guilt because I sat on the fence and played whatever side was beneficial to me. And even to this day I still wrestle with that. Was that being selfish? Is the Army more important to me than myself? than my mental health? Think about a nineteen-, twenty-, twenty-one-year-old who doesn't have the support mechanisms or the mental development at that age if they are feeling suicidal and despondent, what that could be like for them. Nothing I can do about it now.

We all go through the internalized homophobia ourselves. I did. And I was good at the lingo. I could fag bash just as good as anybody else. It almost became a survival tool, because if I did that, then how could I be gay? How could I ever be suspected of being gay? Here we are in the middle of Don't Ask, Don't Tell. People are being thrown out in droves and there's still violence against gay people.

When I started having feelings for [a] lieutenant, I was trying to fight back. There was no way I could deal with that. I didn't want to get caught. He would invite me to stay over; I'd sleep in the bed with him. I could see he was physically aroused, but I wouldn't touch him. I couldn't do it. The abject fear of being exposed and people finding out that I was gay was probably the biggest thing that kept me from doing that. Negative reinforcements have always put a block up against my sexuality. I had choices to make and the Army was the safest, the place that throws people out for being what I am; the place where you can get killed. The place you go to war. What's the spirit of the bayonet? You stomp your foot and shout three times, "Kill! Kill! Kill!" That was the safest place for me.

It provided an emotional attachment collectively, especially in Iraq. Every time you come home or leave, you're alone. Even if there was someone special, would they notify him if I were killed? No. I could not fill this emotional void that was growing stronger and bothered me more and more, especially as the war progressed and got worse—the carnage, the mayhem, the decapitations. I wanted someone [with whom] I could share more. How can you not be crazy after going through all that? I **see** my psychotherapist once a week and I see my psychiatrist once every two weeks. I've talked to both of them about this intense fear—the fear of rejection, the fear of losing that Army family that I still have to this day. I always wondered, though, what would happen if I got found out. I still wonder.

PAGE 97

DON BAREFOOT, SAN DIEGO, CA, 2010
LANCE CORPORAL E-3, U.S. MARINE CORPS, 1983-1985

Cryptology Specialist. Top-secret security clearance; honorable discharge after coming out as being gay

I do not want to get emotional about this. I don't want to give my father the power he used to have over me. It's not about me being gay, because I've come to terms with that and let that go. When I talk about it, it makes me mad. I let people [who] supposedly love me tell me I was wrong, that I chose to be this way, that I wasn't born this way.

I grew up in a religious Pentecostal family. I was a momma's boy. My mother had twins when I was thirteen and I helped her raise them because my dad was never there. Besides being a preacher, he had an electrical business. I never got in trouble, never grounded. I didn't have a curfew. I didn't curse. I didn't do drugs, didn't drink. I would be at church on Sunday morning. I was a youth counselor and went to Bible College in summers. I knew I was gay early, but from the time I started going to church to the time I went into the Marine Corps, it was faggots are going to hell. It's a sin. I fought it nonstop. Every night I went to bed praying to wake up straight.

I went in the Marine Corps to make myself a man. I joined February of my junior year; I was seventeen. I thought, maybe something will change. When they asked, "Have you ever had homosexual inclinations or experiences?" I lied. You had to lie. But I was fighting it; I was hoping I could get cured. A lot of it had to do with getting away from my family. I had to get out or I'd be stuck in Fayetteville, North Carolina, for the rest of my life. The proudest moment was the day I graduated [from boot camp]; no one will ever take that from me. Call me all kinds of names, tell me I'm going to hell, I don't care. I did it.

My boot camp [at Parris Island] was a little different from other people's, 'cause I had a year and a half of training and working with recruiters. I knew my MOS [Military Occupational Specialty] was going to be cryptology and [I would] have a top-secret security clearance. They were doing background checks all the time and my drill instructors didn't like that. My parents came to visit; that's not really allowed. Sundays between noon and five was your time, so I would have a picnic with my parents and my little brothers. And the pastor of my church wrote me at least two or three times a week. I had an outlet that a lot of guys in my platoon didn't have. But my drill instructors jumped on me like I thought I was something special.

When I went to Pensacola I was a loner 'cause I didn't know anybody. Growing up I was a loner completely. When I got to Iwakuni, there was a community of [gay Marines] in Japan and they brought me out. I met Phillip at the bowling alley and became friends with him and his wife. He was gay and she had a boyfriend. Him and I would go out. And from that time on, I had someone to talk to. He got me out

of the closet, and once I got out, I really came out. I think he saw something in me that I didn't. I was nineteen. He was six years older. I met someone else and pushed him aside. It wasn't very nice of me. But I was nineteen.

The little click in Japan ended up being quite a large click. A few hundred [of us] would go to the NCO club on Saturday nights for private parties—all gays and lesbians. The military didn't know they were hosting gay parties on base. It was eye opening. When you start seeing all these gay and lesbian Marines, you go, "Wow. There's all these other bases all over the world. How many more of us are there? I'm not different. There's nothing wrong with me. Time to start dealing with it and get over it."

I wish I could go back to that time, 'cause I had the option of staying in Japan another year. But then I wouldn't have been out; I wouldn't have gotten out of the military either. When I came back, I was a totally different person and my parents knew it. I would come home every weekend—take a bus from Camp Lejeune on Fridays and go back on Sundays—just to see my family. Once I got my car, I would drive home, hang out a little bit, then I was out to the gay bar. I was coming home at two in the morning. I wasn't going to church with them, so they knew something was goin' on.

I segregated myself from people in my unit 'cause they would get drunk and get in fights outside the barracks. I didn't want any part of that. In the summer of 1985, two guys in our barracks across the hall from me were caught having sex. They were beat. Hospitalized. And nothing was ever done to the guys that did it. They beat up a bunch of faggots, so who cared? That's what started me coming out [to the military]. Do I really want to be in this environment where my life could be in danger?

I was driving home from Fayetteville. I started to drive my car off the road into a tree and I stopped on the side of the road. A lot was going on inside my family; they were coming to know that I was gay. It was all kinds of conflicts going on in my head and I was just like, it ain't worth living. It's the one time in my life I thought about suicide.

Something happened at home that day and I don't know if I've blocked it or don't want to remember it. I feel like there was an argument about something. It might have been me saying, "I want to get out of the military." My mom looked at me and said, "It's because you're gay, isn't it?" I looked at her and said yes. My dad said, "Get out of my house." It was my father being disappointed. There it was again. I would never please him or my family and I was a failure. They didn't understand why I wanted to get out of the military.

PAGE 99

KEN SHEPPERD, SAN ANTONIO, TX, 2011
LIEUTENANT COLONEL, U.S. AIR FORCE, 1987–2009
Detachment Commander, Retired

I was born in 1963 in Houston and raised there. My dad was with the National Guard for about forty years. He was enlisted, so with four kids we were struggling. We were a deeply religious family, somewhat fundamentalist. My father and I were disconnected from each other. I think [he] sensed something different about me. I certainly sensed something different and struggled with that a lot. We did not discuss that in the South. It was extremely taboo and I knew I couldn't be guilty of something like that.

The only way to cope was to be nothing. I became contemplative and extremely quiet. I had friends, but I steered away from anything that was group oriented. I never had a girlfriend, but always had a date, so I didn't miss a prom. I graduated from high school in 1981, when they first started putting the word AIDS together. I remember seeing it on the news and being mortified that it was going to happen to me just because of my thoughts.

I had a crush on my best friend in high school and persuaded him to go to college with me. We roomed together for two years. There was tension always; we had very small quarters—a college dorm room—and I couldn't take that proximity anymore. I think he was beginning to suspect. After two years, it was too much, so I transferred to another university out of state. I have not spoken to him since.

I moved back to Houston [after graduating]. My dad was encouraging me to consider the military, so I started the interview process. They overtly ask you the question: Have you ever engaged in homosexual activity? Of course I said, "No," knowing I had never done anything. I also signed a paper [with] the questions: Have you ever smoked marijuana? Have you ever been arrested? Are you homosexual? I was able to check no in all of those. I was totally mortified—having fear that somebody could read my thoughts, that somebody would know.

I ended up being a military aviator in a fighter community for many years and got a command-level position very quickly. I kept thinking they were going to discover me, so I found a reparative therapy group—Exodus International. I did think it would at least help me keep it at bay a little bit longer. I'm proud to say I failed miserably. I went through critical times in my life extremely numb being as asexual as a person could be. I was thirty before I ever went out on a date, before I ever had any kind of sexual relations.

[My mother] gave me an opportunity to talk to her, but I was still wrestling considerably with that whole thing. I did come out to my younger brother. He struggled with it for a long time and eventually became very supportive. It wasn't until I got my family together and told them that we were going to have a kid, that my dad could no longer deny that Juan and I were a couple. They were very much against it. My sister didn't want me to be with Juan. There was a big

rift in the family; it was religion based. I was thinking they were going to be happy that I had children and assumed they had accepted it.

There were several times where Juan and I were [at] a restaurant and commanders had come in. You either pretend they don't see you or hope they don't see you, or you be brave and act like you're friends. You can get by with that so many times. But I felt the burden of proof was on them. People weren't going to actively pursue us, and we didn't have to be blatantly dishonest. We just had to be quiet. The previous policy was simpler; it was clear-cut, either you lied or you didn't. [With Don't Ask, Don't Tell] there was more ambiguity, but I felt that gave me a little more elbow room—I didn't feel like I was lying. I was just keeping to myself. I could navigate through that a little easier than just pretending.

I can't ever say that I had a burning passion to fly planes. Not having been married, I knew that it was going to be hard to get much past lieutenant colonel. Maybe you could eke out colonel. But I became less and less tolerant of not being able to say [whom] I was going home to. I had a family now, and another business, and it was just time to move on.

———————
PAGE 101

BRYAN SCOTT LAMBERT, WEST IRONDOQUOIT, NY, 2011
PERSONNELMAN THIRD CLASS, U.S. NAVY, 1992–1994

National Defense Service Medal, Accelerated Advancement, and Commander Sixth Fleet Letter of Commendation; honorable discharge: personality disorder

I was born in 1972 and grew up in a small rural community outside of town, removed from everything. My parents are devout born-again Christians. I was forced to be part of that community. I knew I was different and I knew it was something I could never tell anyone because homosexuality was a horrible thing. AIDS was considered a gay disease. In the eyes of the church, "If you're gay, you'll die. When you die, you will go to hell."

My father was abusive. My mother didn't participate in the abusive behaviors, but she allowed the things to happen. I was rebelling against my upbringing and made every attempt I could not to be part of it. Got my driver license when I turned sixteen, stopped going to church, and was able to get away from home. I dated girls because I figured if people see me out with women, whatever else they might think gets glossed over.

I was working three jobs to pay my rent and I was barely getting by. My roommate wanted me to go to the recruiter's station with him for moral support. I ended up getting sucked in. We were going in on the buddy program. It all came together for me. I don't have a college education. I cannot work three jobs the rest of my life. I got sold on having one job and the opportunity to travel. I went in October '91. He never did. I was delayed entry and wasn't going to leave for boot camp until April of the following year.

I had to sign an affidavit stating that I am not a homosexual. I knew I was lying, but I've been living a lie all my life. I got scared that the military would find out, so I met a woman and five weeks later we got married. It was a good cover-up. I have an alibi. I have a wedding ring. I have a wife. I think she was looking for a way to get out of town, so we served each other's purposes.

I worked hard and was determined I was going to make this my life. I excelled in boot camp and in training school. I graduated top of my class and was offered an accelerated advancement program. I took on leadership roles designed for commissioned officers and was the vision of your perfect sailor. I think I took what I was lacking in other areas of my life and put that energy into the work I was doing.

I knew how it felt inside, but I didn't know how to live as a gay man. I didn't want anyone to know. I wanted a family and I wanted children. After we got married and I got out of boot camp, I was stationed in Norfolk. Shortly after, I was on deployment, training in the Mediterranean and the Persian Gulf. When I first left, my wife and I were fine. I knew something was happening the longer I was gone. Her

communications became less. When I got back, she wasn't there; she had met someone shortly after I left. I filed for divorce and ended up in bankruptcy at twenty-one.

I was two years into my five-year enlistment. I got thinking about the events in my life. So many people were getting discharged for personality disorders or not being able to deal with military life. I started giving cues to my boss about feeling depressed. I knew I was about to lead her on to the biggest lie that I had ever pulled off. She got me in touch with the chaplain and the ship's doctor, who gave me a quick psych eval. I was admitted to the Portsmouth Naval Hospital suicide ward. I ended up getting sent back to my ship with a recommendation for an administrative discharge with a history of issues.

I waited a couple weeks trying to figure out how I could make this happen. Then I got in the shower with my clothes on. I was soaking wet head to foot, got in my truck, drove to the hospital, and walked in asking to be admitted. I said I was feeling depressed and went out to the beach walking out into the water. It got me admitted. I decided I'm going to go off my fucking rocker. I played it up the best I could and thought I was doing a great job.

The psychiatrist on the ward called me in. "What is it you're looking for? You should not be here and you know it. Tell me what you want me to do, because there are people here that need my help and you're not one of them. Do you want to be in the Navy?" She knew I wanted out. "I don't have time for this. I'm writing a recommendation for a discharge based on personality disorder. Get out of my office." I was OK with that because I could explain all that at any job interview. "You know what? I had a rough time. I had been out on deployment, my wife left me, and I was depressed." I was discharged from the Navy the following Wednesday.

Shortly after I was discharged, I made up my mind that I'm tired of living lies, I'm tired of telling lies, I want my life to be honest. And that needs to start with me. I started telling everyone. It was a hard conversation, but my life completely changed. I fully immersed myself into gay culture. For the first time in my life, I was in a place where I experienced joy; I don't have to censor myself. I don't have to watch what I say to people. Had I had that opportunity to be that person in the military, it's more than likely that I'd still be there. Did I do stupid things? Yes. Things I would never relive.

I loved what I did. It wasn't patriotism and serving my country, it was a job that I loved. Patriotism is something that I've always had a conflict with. I think putting pride into something you were born into is misplaced. I'm happy that I'm an American. I'm happy that I live in a country where I am free to be myself. But, I was born here. I think pride suggests that you had some part in the decision. That just doesn't feel right to me.

PAGE 102

JOANNA GASCA, SURPRISE, AZ, 2012
SENIOR MASTER SERGEANT E-5,
U.S. AIR FORCE, 1983-1987 AND 2000-PRESENT, AND
U.S. AIR FORCE RESERVE, 1987-2000
Senior Recruiter. Active duty

I was born in Loma Linda, California, November 1964. My mom's a clinical social
worker and was in the thick of the women's movement. My dad was in the Air Force,
then got a civil service job at North Island Naval Air Station. After that we
moved to San Diego. My parents divorced when I was nine. My brother went into the
Army and my sister moved in with her boyfriend, so it was just my mom and I for
many years.

In ninth grade I had my first feelings for women. I knew my parents were not going
to get it and I couldn't say anything to anybody about it. I met this girl and
she was dealing with the same thing. She was the one person I could talk to. In
high school, I was dating a boy and I had a crush on a girl. This guy was good-
looking, a triathlete, spoke fluent Spanish. Wowed the parents. I told him, "I really
can't see you anymore because I like this girl." One night, I went out to dinner
with my girlfriend. I come home and he and my mother are at the house. I got
really angry, and I felt betrayed.

I went to community college and then left. I didn't really care for school. I
needed to gain confidence to be on my own. The military ads looked great: They'll
feed you. They'll house you. They'll train you. Shortly after that, I was talking
to a recruiter. A year later I went into the Air Force. I remember my first official
document had the statement about homosexuality. The recruiter even asked, "Are you
gay? Do you know of anybody that is? Do you have any friends that are gay?" My
heart was beating. I said, "No." It was so difficult to lie. I sold my soul right
there. On the other hand, I thought I was getting something that would help me. In
October of 1983, I went to basic training.

I remember telling myself I'm going to be straight. I won't have to hide, won't
have to deal with the stress, and could just live my life as a straight person
and there would be no problems. It didn't work. You feel claustrophobic. Sneaking
around, hiding. You can't sleep at night wondering if somebody is going to knock
on your door, open up your closet and look at the letters a girlfriend has
written you. I was a young kid; this was the first job I ever had. It was exciting
and I didn't want to lose that.

I actually had a girlfriend; we were together about a year. She got an assignment
and I got an assignment, and that was the end of that. She went to Japan. I went
to Greece. After I arrived on base, a couple other girls—lesbians—had come,
so there was a handful of us that hung out. My boss was dating a Security
Forces guy, and I later found out he was reporting us to the [Office of Special

Investigations] folks. I never got called in, but a couple women were discharged. I needed somebody to talk to about this, but I couldn't talk to a soul. You don't know who you can trust and who is saying what. So I shut down completely. I was in my own world. I had to come out to my mom over the phone and explain to her what was going on. She could hear in my voice that I was scared and on the verge of tears. I needed her support. I don't believe she was accepting of it. I know she wasn't. But I was in a bind.

Another time, there was an investigation at McConnell Air Force Base. I was working in Security Forces in the operations office. I remember getting called in by OSI. They had me stand up against the wall to take a picture. It was awkward. I knew something was not right. A young gay man was called in and he named a bunch of people. One other lesbian gal who worked in Security Forces got called in and she ended up getting kicked out. I remember her coming up to me before she had to leave the base; the document from her lawyer had my name in it. But, they never interviewed me! They just took that picture.

As a reservist you are a part-time Airman one weekend a month, two weeks out of the year, so for the most part, you are able to live your life the way you want on the outside. During those thirty years, I was growing into being a lesbian in the Air Force. Who I'm dating had no consequence on what I'm doing in the office. There was a time when I would lie, then one day I said screw that. One starts making rank; you get to a certain level; you get older, more experienced; you mature. I got tired of it. I'm doing my job, sucker, just leave me alone.

[When] Don't Ask, Don't Tell went away, it was like a weight lifted off my shoulders. I used to joke with my family that I'm going to need counseling after I retire, because I wouldn't have to be in the closet. I am beginning to feel all the years of not being me…coming to a head. Sometimes the tears fall and I can't stop them. The good thing is—I'm aware and am going in for an evaluation and then long-term, one-on-one counseling. It's sad, and I get mad and frustrated. The strength will come later I'm sure.

PAGE 103

ALAN M. STEINMAN, OLYMPIA, WA, 2010

REAR ADMIRAL, U.S. PUBLIC HEALTH SERVICE AND U.S. COAST GUARD, 1972–1997

Retired, came out publicly in 2003 on the tenth anniversary of Don't Ask, Don't Tell

I was born in Newark, Ohio, in 1945. I began having sexual fantasies about men as a kid. But you know very early in life that to be a fag is the worst thing you can be. I was so deep in the closet that I had no sexual experience whatsoever as a young gay man. That's part of the tragedy in my life.

I joined the military in 1972 as a commissioned officer in the Coast Guard, subject to all rules and regulations of the Uniform Code of Military Justice [UCMJ]. I knew I was gay, but I knew I could never say anything and wasn't about to tell anybody or do anything to jeopardize my career or violate the rules of the UCMJ. I loved my job. I loved the people. I lived the mission of the Coast Guard. I was totally repressed. I never violated the rules. I never lied and I never regretted a single day of it. That's the sacrifice that I had to make and I was willing to make that sacrifice.

When I became selected for officer, I began to think about the issue of politics and being a member of the gay community. I also knew that if I got selected as an admiral, there are a lot of social obligations. It was no longer optional. I had to have a female companion and I went about trying to find a female companion who would go with me to these things. I put an ad in the men seeking men section that said, "Gay male executive seeks female for meeting social obligations and companionship." There was one that was absolutely head and shoulders above the rest. And so we agreed to have dinner. I told her my story and she told me her story and she began to go to the military events with me.

Looking back, it's probably tragic that I had to be denied having a family, sharing my life with a loved one, doing all of the things that my heterosexual peers were doing without giving a second thought. And for that reason, lots of gay people walk out, tired of having to deal with the lies, the stress, and the fear. And every one of those people who walk out takes with them years of training, experience, and money that has been invested in them.

It was four years after Don't Ask, Don't Tell that I retired. I made huge contributions to the Coast Guard and my commander said I was responsible for saving more lives than any other Coast Guard person he'd ever met. However, I wanted to live my life honestly as a gay man. Everything a teenager does sexually when they normally start exploring their sexuality, I had to do at the age of 52. It was compressed adolescence. It was almost like being back in the military. I had to learn the culture, the language. I wanted to be honest with myself, my friends, and my family about who I was, but professionally, I still had to be in the closet.

I was appointed by [President] Clinton to be on a presidential advisory panel to look at the Gulf War illness resulting from the war in 1991-1992. I was dating, but it was unlikely that anybody on the committee was going to discover it. In 2000, I contacted Servicemembers Legal Defense Network, because I wanted to become politically active, and in 2003 the pressure of 9/11 had worn off. We had the tenth anniversary of Don't Ask, Don't Tell coming up. It was a perfect opportunity to [come out publicly]. We decided—myself and Keith Kerr and Virgil Richard—to do it together. There was tremendous media after we did, so I was able to share the burden. It certainly hasn't inhibited me from speaking out on a public stage.

PAGE 105

JACK STROUSS, ATLANTA, GA, 2010
CORPORAL, U.S. ARMY SIGNAL CORPS, 1942–1946

Clerk, U.S. Army Headquarters. Troopship was torpedoed in the
English Channel, December 28, 1944; saved by a Free French frigate

I was born in Atlanta in 1923 and grew up in the middle of the awful depression.
About the time I graduated from high school, World War II had already commenced
in Europe, and the peacetime draft had been instigated. I decided the best thing
to do was to enlist, so I could pick my branch of service and it would possibly
keep me out of the infantry. I had a buddy in the neighborhood—a straight fellow—
[who] said, "Why don't we enlist in the Signal Corps? We'll have a chance to
advance our radio and maybe radar." Randall and I made our enlistment in October
of 1942.

By that time, I already knew about my orientation. I had met this fellow Tim—we
were seventeen—and we were very close to each other. I thought he was the cat's
whiskers and I was very fond of his family. His mom was a dream! People in my
generation know about "it" and they don't ever want to embarrass; they're just
so accepting. His mother was like that, and I appreciated that because I felt so
comfortable in his home. We swam together and we both loved dancing. We were
squiring these girls around, primarily to dance. Then, we had to say good-bye when
I volunteered. He enlisted in the Navy.

At the end of six months, we had to go on active duty; we raised our right hands
and were inducted. Randall and I went for our physicals at Fort McPherson; poor
Randall didn't pass. I hated that, because I was counting on us staying together.
I was sent to Camp Crowder, Missouri, for basic training. I arrived there and it
was flat as far as I could see, and no trees. I thought it looked like [a scene
out of] *Spartacus*—I never saw so many telephone poles. And I thought, "Oh, Lord,
have mercy. Surely they're not going have me climbing poles!" Once you were in a
combat area, you were a sitting duck hanging on a pole stringing wires.

I had been in Camp Crowder five or six weeks and I was beginning to make friends.
One of them looked at me, and I looked at Roger and said, "Of course there's got
to be people like me here!" The next thing I knew, they were just scattered here
and there like salt and pepper! They had movies and things. There were recreation
halls and I met people at church. We would go into the PX [post exchange, the
retail store on base] and we just picked each other out! Toward the end of
basic training, we had such a group of friends that we would all pile on the bus
Saturday after inspection and rush to the nearest town and have a great time.
We just cut up and carried on. That was a wonderful relief. Whatever we did on
weekends was away from the normal military situation.

Some of the boys were talking about this physical. We had to be butt naked
through everything, and nobody cared. And we didn't know really what a psychiatrist
was, but we knew that it could be the ultimate in this physical. So we're lined

up and some GI walks out of the office, and the medic is sitting there by the door and said, "Next." I walked in and there's a doctor sitting behind a desk, his eyeglasses pulled down. I'm standing there in front of the desk, and he looked and he said, "Do you like girls?" I said, "Oh, yeah! And I love to dance!" "Next!" So, that was it; I was in! I never thought about psychiatrists again after that. We finished our training and I went to clerk school—I didn't have to climb telephone poles. I went across Europe with a typewriter, a car, and a piano.

We were very classified, very secret. We couldn't say anything about our movements for the longest time. We went from San Antonio to Canada, then down into New York, and they dropped us off at Fort Slocum. And in the dead of night, they took us down river. All of a sudden I looked, "What in the world?" It was the RMS *Aquatania*; this was our troopship. We had 13,000 [men] on a ship that's used to taking 2,000 people on a cruise. It was like being inside of a big metal can. The living quarters was just shelves and bunks as high as you can get. The promenade decks were still there, but there was no furniture. We sat on the floor, leaned against the wall, and we could look at the ocean and smoke cigarettes.

We ended up in Scotland at Clyde Bank, a former English camp. I had weekend leave and we got on the train and went to London to go to a play. We were sitting right at the edge of the stage! That was my first taste of what it was like to be in a war zone. The program told you what to do, where the exits were. If a red light came on, that meant it was an air attack. You could either stay in the theater, or they would show you where the nearest shelter was.

I did go back to London one more time. It was blackout time. There were little lights here and there in red or amber, so you could find your way. There was a park in Leicester Square, the theater district. In the daytime, families would come with their buggies and the babies and the kids. But at night it was a cruising spot. There were lots of gay people piling; it suddenly dawned on me what was happening. I went in a couple of times, and sat near the edges. I was very naive, a little bit nervous, too, so I was very careful.

The war [was now] over and I'm home. As soon as I got in the house, mom started telling me all my friends that called. "Tim called. He's just gotten back." My heart leapt, and I said, "Dad needs gas in the old Ford!" (Gas was rationed; he had three gallons a week.) He said, "Yes." I flew over to Holland Avenue, parked the car, rushed up the front steps, and he came running out of the house, and we fell into each other's arms right in front of his mother. And we were all three crying. That's why she was just so wonderful. She knew we'd been good friends— she may not have thought anything beyond that, but she just was so nice. When Tim and I got back, we were different. We had grown up, matured, and been through a lot of hell, and we were just different. But we picked right up, found some of these old girls that had not married because nobody was around and went on with our dancing.

PAGE 107

ANTHONY LOVERDE, LITTLE ROCK, AR, 2012
STAFF SERGEANT, U.S. AIR FORCE, 2001–PRESENT

Loadmaster. Active duty; honorable discharge, homosexual conduct; deployed to Iraq and Afghanistan; reinstated in 2012 at previous rank; continued career as if uninterrupted

Growing up, my parents had gay friends, so every time I saw a gay person they were much older than myself and they were established in their careers. But I didn't know anyone my age that was gay. There was one kid in school—everyone knew he was gay; he was the most picked-on kid, which reinforced me to not want to accept that for myself.

After high school, I went to community college in the foothills and had three roommates, guys from my youth group. I was still going to church, fighting these thoughts, not accepting myself as gay. I was working so much and I wasn't going anywhere. That's when the military came to mind. I enlisted in the Air Force—I thought I'd learn some secret skill that would help maintain my heterosexuality. I still identified myself as straight and didn't question my beliefs. The one good, and bad, thing about religion is it doesn't need to be logical because you have this thing called faith. You just believe. I didn't feel my spirituality being challenged at all. I went through basic training at Biloxi Keesler Air Force Base in 2001 and made these new friends. One of them disclosed that [they] were going to gay bars. Apparently I made friends with three gay guys and two lesbians. I guess I've had small interactions with other gay people, but I always shut them out of my life. I never really befriended other gays my age even though they were trying to. I felt like I could only be friends with people in the church. Not with these heathen sinners. I had to convince myself that it was OK. I went back to my family teachings to accept everyone for who they are and love everyone. My parents have gay friends, so it was OK for me to be friends with them.

I saw how happy they were; they accepted themselves. I was miserable because I was fighting who I was. I started to see there might be another way of living where you're not questioning who you are. I started becoming comfortable with my sexuality. Religion went on the back burner while I took time to understand how that would fit into my life being a gay man. An immediate concern—which I did not think about when I entered the military—was now how do I live under Don't Ask, Don't Tell. I asked gay friends how they deal with that. A lot of them felt it wasn't a problem; they didn't seem that concerned. I felt threatened. I went online to figure out the concerns of being gay in the military and that's when I stumbled across Servicemembers Legal Defense Network [SLDN]. I wasn't thinking a lot about dating, but if I'm going to date, how can I date and live in the military? I started educating myself, and with that knowledge I was able to live within those rules.

When I got to Germany, it was the first time I had to start juggling and separating the two lives. I did date occasionally; they were always short-lived.

After three years, I went to Edwards [Air Force Base] in California and I did the same thing, where I had my straight friends and I had my gay friends. During the end of my enlistment, I had my first deployment to the Middle East supporting the war effort. There was more purpose in that. I didn't feel as needed in the States as I felt when I was deployed. I wanted to apply for a job in Operations as loadmaster in the direct support of troops overseas—they deployed all the time—so I [would] be so busy supporting these missions that I wouldn't even have time to consider juggling two lives. What I did not foresee was you become very close with your crew. You're constantly traveling with them for days on end, sleeping, eating, doing everything together, and sharing your life stories more so than in my other job. It's this intimacy I didn't expect.

I found myself more times than not having to come up with stories or flat out lie about my personal life because of Don't Ask, Don't Tell. I felt the freedom of coming out to myself back in 2001 was starting to be reversed—I'm enslaved to this secret. I went back to this miserable period of struggle again. I didn't feel like I [could] handle it anymore. I just need to come out to everyone 'cause I can't play this game.

The second time I deployed, I was on an aircraft and our mission was moving fallen soldiers out of Iraq. Seeing soldiers with missing limbs is emotional. The great thing about cargo missions is everyone we move in the air are men that we save from moving on the ground. Every day I take great pleasure in keeping those people safe. So it's hard to go back home and get a normal job while your brothers and sisters are serving overseas, dying, getting shot at. Whether I agree with war or not, the fact is, we're over there; we have people dying and I can help save lives. When I can't contribute anymore, it will be easier for me to move on. After my deployment to Iraq, I got back to Germany in 2008. I came out to my command and told them I wasn't going to lie anymore and that my crew deserved honesty, I deserved honesty. This law is asking me to lie. I was hoping my command would find some loophole to allow me to stay. I asked them, but they legally couldn't. I was discharged in July of 2008.

My commander was supportive throughout this process; he told me his hands are tied; it does not reflect my character and service to my country. Coworkers and crewmembers wrote letters to my commander recommending to keep me in the military. My DD-214 says honorable discharge, homosexual conduct (statement). The military defines a statement as intention to conduct yourself as a homosexual. Conduct leads to discharge. My commander told me to start applying for jobs to transition back to civilian life. I started sending out applications for defense jobs that I knew I [qualified for] based on my experience. KBR, one of Halliburton's big companies, picked me up. They wanted me to go to Iraq and work for the Army doing my old job in electronics. I accepted the job.

SLDN [Servicemembers Legal Defense Network] liked my story—being discharged and hired three weeks later doing the same job—to tell how absurd Don't Ask, Don't Tell really is. I'm in Iraq and I get a call from SLDN. They said, "We are considering another legal challenge to help force the issue of reinstating some members. Would you be interested in being in that lawsuit?" I said, "Of course. I want to go back in the military." So Mike Almy, Jase Daniels, and myself ended up filing our case in December 2010, weeks before the actual vote, on the repeal.

I was very grateful they fought for me to come on board. In 2010 when it looked like the repeal was going to happen, I started thinking I might be able to go back in.

If I was going to stay in the military, I wouldn't be able to juggle two lives. I needed to be open to those that are close to me. I started with my family. Everyone was supportive and everyone let me know that they love me and they're proud of me. Some friends are still friends today but our friendship has changed. They're saying that they love me although they hate my sin and they will pray for me. I told them to stop praying for me because I don't need their prayers. God has accepted me. I think I'm a sinner for a lot of reasons, but I don't think being gay is one of them. The church [gave me] a sense of spirituality, community, and family, except that it caused me so much frustration and hardship. It was replaced by the military.

We filed our court case in December. The repeal was passed a couple weeks after filing our case. The government was filing motion after motion to delay our case, trying to get it thrown out. We couldn't go down to the recruiter's office because they haven't certified DADT. And there was no timeline. September 2011, when DADT was certified, both parties decided to settle through the normal process. My recruiters started my paperwork, but the normal process didn't support me going back because technically I did not fit the [jobs] they were looking for. I said, "Lets get the paperwork started, but I'm telling you upfront, I want my old job back. I'm not giving up the lawsuit just for any job."

When the Air Force kicked me out in 2008, they lost my medical records. They made me go through psych evaluations. They made me answer questions of medical history and get physicals, and that took time. There was delay after delay after delay. It wasn't till March of 2012 that we finally got the paperwork. The recruiter told me they had no jobs for me; I'd have to wait till September. SLDN had to get involved. The Department of Justice got involved. Two days later I got a call saying they got a loadmaster position for me. That required another physical and a day of processing. On May 23, 2012, I came back in. I had to report to Little Rock by June 6. I did my oath and I was back in the military.

I'm still waiting on aeronautical orders so I can start flying again. Everyone knows my situation; there's no resistance to it, but it's part of the big military machine. Things do not move fast. We're very close to getting me back into the air. I feel more confident at work. I feel more transparent and open with my coworkers. I feel like we're actually closer because it is building trust. People do casually use the word fag towards other people and I can actually stand up for myself now. Using derogatory terms is part of the culture and somewhat part of [being] young; that's how they talk. If we're going to ever expect any kind of change, leaders have to lead. They have to set that tone. The more people I'm out to, the better my life is with these people. Relationships are enhanced because I'm honest. I'm in an amazing place now and it's because of everyone supporting me. Sometimes things not only get better for you, but also for the people around you.

PAGES 108–109

MARIA ZOE DUNNING, SAN FRANCISCO, CA, 2012

COMMANDER, U.S. NAVY AND U.S. NAVY RESERVE, 1981-2007

Supply Officer. U.S. Naval Academy graduate; Navy and Marine Corps Commendation Medal; challenged the constitutionality of Don't Ask, Don't Tell; only openly gay service member allowed to remain on active duty

I always thought of the military growing up. Both my parents served in World War II. I was the youngest of seven kids and never had those highly defined gender roles. I knew from an early age I was going to need a scholarship to go to college. The Naval Academy was a meritocracy. Everyone's hair gets cut off. You wear the same uniform. You attend the same classes. You have the same experience. This institution wanted women to be tough and strong. I felt very comfortable being a trailblazer and doing something typically reserved only for boys. I hadn't quite tied that into sexuality.

When I entered the Naval Academy, I was going to do my minimum obligation and then decide at that point whether I was going to stay or continue to serve. In fact, I did six years of active duty and then two years of reserve duty. I came out in January of 1993. Coming out felt very natural to me. I didn't have any self-hate or self-loathing. I didn't have any religious constraints. The biggest struggle was that it would put my college education and my future career at risk. My whole reason for coming out was to challenge the constitutionality of the policy prior to Don't Ask, Don't Tell; I came out at a [political] rally at Moffett Naval Air Station to encourage [President] Clinton to fulfill his campaign pledge to lift the ban on gays in the military. I weighed the risks: I've got a spotless record in the Navy and I'm in the reserves, so it's not my main source of income. I'm going to Stanford Business School and I have a good job offer. The media, the Pentagon, and gay rights activists were chiming in on this issue for those who were actually impacted by it, gays and lesbians in the military. There was no voice for those currently serving in silence. This would be an opportunity to speak out on their behalf. I was also frustrated by the lack of discussion about women in the military.

That next morning, I spoke at the rally. My unit found out. The next weekend when I reported, they informed me that I was on administrative leave and I was being processed for discharge. In some ways I was prepared for it. I knew what I had done. Here's an organization that I've devoted my life to since I was seventeen and it's been telling me this entire time how great I am, given me positive fitness reports, given me ribbons, medals, promotions. And then by just telling the truth about who I am, they say, "We do not want you anymore. You must go." The rejection and betrayal was very painful.

I had two discharge hearings. The first was under the policy prior to Don't Ask, Don't Tell in June of 1993. I took the stand and was open for cross-examination

by the board of officers, but they never asked if I had engaged in conduct. They voted unanimously against me. I was beginning to be processed for discharge, but then Clinton announced Don't Ask, Don't Tell in July of '93. They didn't know what to do with people convicted under the prior policy. They decided to try me all over again.

When I had my second discharge hearing, my attorneys could ask me questions but their attorney couldn't ask me anything because they already had their chance to examine me. I took the stand and my attorney asked me, "When you came out in January 1993, what did you mean when you said you're both a naval officer and a lesbian?" I said, "I meant just that. I meant to discuss who I am. I didn't mean to create a presumption of conduct." And for whatever reason, that board of officers voted unanimously to keep me in. Ironically, between my two discharge hearings, I got a letter in the mail notifying me that I was selected for promotion to lieutenant commander. On the one hand they were trying to kick me out, and then on the other hand they were selecting me for promotion. Clearly my career was doing all right despite all of this. Because I won my case, I had no basis for a constitutional challenge. At least we've come up with a legal strategy that will allow others to stay in. But the Pentagon issued a memorandum that said no one else can use that legal strategy. So I became the only person to have beaten a Don't Ask, Don't Tell case and allowed to stay in.

When you're gay and lesbian in the military and someone asks you point-blank if you are gay or lesbian, it's fight or flight, a gut instinct to not react and to not admit it, because that's what you have been trained to do for years, to deny that part of you and to prevent that moment from ever happening. Every day you're hiding who you are; it's death by a thousand tiny cuts because you're constantly obfuscating the truth or trying to defer questions or pretend you're something that you're not. You get the most innocuous memo from your commanding officer saying that they want to talk to you, and your heart skips a beat. Is this that meeting I feared? Is this the time they're going to ask me these questions? Living with that hatchet over your head waiting to drop takes a huge toll.

I retired on June 2, 2007, on the flight deck of the USS *Hornet*. I decided that even though I had to hide I was in a relationship because I'd won my case on this assumption that I don't engage in conduct, I just didn't care anymore. I took my wife, Pam, on my arm and we walked down the red carpet and were piped over the side together in the first same-sex piping ceremony in U.S. Navy history. I was working with Servicemembers Legal Defense Network [SLDN] lobbying on the Hill. DADT repeal was going to a House vote and then a Senate vote [in December 2010]. I flew to Washington, D.C., and went to the LGBT community center to watch the vote on the Senate floor. "We got it! We got it!" I wouldn't believe it until I actually heard the gavel strike down that the bill had passed. That was the moment—elation and then release of eighteen years holding this in and working on it.

I called up SLDN and they said, "You're going to be up on stage with the president." I was honored and excited. There's literally hundreds of thousands of people who worked on this issue, have fought and put their own careers on the line and deserved to be up there. I felt a tremendous responsibility to represent not only all those who had fought to repeal Don't Ask, Don't Tell and the policies prior to it but also to represent all of those who had been kicked out under the policies.

We filed into the auditorium; I stood closest to the podium where the president spoke. When he was done, there were shouts of joy, tears of joy, and tears of relief. I was trying to memorize every single detail. President Obama walks past me to sit down at his desk. I'm standing shoulder-to-shoulder with him as he signs the document. He got about halfway through and I was thinking to myself, "I've had so many ups and downs and so many times it seemed close but then been taken away. What could possibly go wrong now?" I blurted out, "Make sure you spell it right!" to the president of the United States. He laughed; the Secret Service didn't tackle me. All I could do is picture John McCain running down the aisles screaming, "It's not valid!" Fortunately, he did spell it right.

PAGE 111

CHARLES A. MAXWELL, DECATUR, GA, 2010
CAPTAIN, U.S. AIR FORCE, 1985–1991

Graduate of the Citadel; Commissioned Officer, Second Lieutenant. Dismissed for conduct unbecoming an officer, participating in homosexual acts

I was born in Denver, Colorado, and grew up in Charleston, South Carolina, near the Air Force base in a mobile home. I shared the same room with my three sisters; we weren't rich by any means. My father was in the Air Force. I remember his uniform, the base housing, and trips to the Air Force Academy and the Citadel. I remember I was with my father, and I saw these guys in uniform. He said those are Citadel cadets; I asked if I can I go there. He stammered, "Well, if you want to go there, Lord willing, you will go there."

I felt an attraction to men ever since I was five years old, but I've always wanted to serve. Being in the military was a way for me to make a better life for myself. I had my sights set on being an officer. When it came time to look for colleges, the first place I thought of was the Air Force Academy. I applied and did not get in because my SAT scores weren't high enough. I got into the Citadel based on the SAT scores, 'cause I was an in-state student.

I'm proud I went to the Citadel. The Blue Book—the rules and regulations—was part of your regular issue. The last few pages had "homosexuality: punishable by dismissal from the Citadel." I read that and said, "OK, gotta let that go." I put any kind of sexual interest in guys out of my mind. If I wanted those three diamonds of a Cadet Regimental Commander, I had to do what no other black person could do and do it twice as [well as] a white person could.

I went to Minot Air Force Base, North Dakota, my first assignment. I was a security police officer. It was where I experienced my first witch-hunt. I found something [to] escape to while I'm playing lieutenant in charge of protecting nuclear weapons. I went to this party; nobody was dressed in uniform. Guys were dancing with each other; people were having a great time. A week after that party, there was a dragnet. Twenty people were called into the Office of Special Investigations [OSI], interrogated, and kicked out. OSI flew in investigators who were younger from a different base. They infiltrated the gay community. Forget about the Soviets who were supposed to be our enemy; my country was chasing after me. I started getting angry, but even more scared. At RAF Upper Heyford [in England], I was in charge of a flight of sixty men and women. My sponsor, a white captain, drove me to the Security Police Headquarters. He said, "You're the first black person this Security Police Squadron has ever seen." "OK. You don't have to say any more." I knew I wasn't going to make the Air Force a career. I could see myself as captain, maybe a major, but I could not see myself any higher than that. Name one openly gay four-star general in the United States military, black or white.

When I was promoted to captain, I also received a regular commission. My friend said, "They're grooming you for general. I'm not bullshitting you—they're grooming YOU for general." I had it in the back of my head, "I'm a fag. I can't be a general." You are scrutinized with every officer report, every quarter, every year. They'll make sure the boxes are checked. Is he married? Is his wife a member of the Women's Officer Auxiliary? Does he have kids? Is he a member of the Officer's Club? When you're gay, none of those boxes are checked. I had to give the Air Force four years; I gave them five. And so I put my resignation papers in. A week later, the wing commander's secretary called me: "The wing commander wants to meet with you." The day I went, he called me into his office, "The Air Force needs officers like you; I want you to reconsider." A couple days after, the 3rd Air Force's "top cop" colonel was on base and I got a radio call saying, "Colonel Colleen wants to meet with you, sir." I go to his room, and he says, "I can guarantee you an assignment at Ramstein Air Base." Heyford was rough, but I enjoyed it. Ramstein is headquarters for United States Air Forces in Europe. For any officer, that's gold.

My ego just went out of control. That was the beginning of my downfall. I was young; I took more risks. My rule was never to date a military person. I broke my rule and coordinated with a seemingly gay airman who was having problems. I took him to my place, got drunk, some things happened during that night, which I regret to this day. Three days after, OSI said they wanted to talk to me about something. I had been into OSI's office two times before for alleged homosexuality. The third time OSI called me in, they read me my rights. The investigator started going into the story about this airman. They kept pushing me. My Citadel creed came into my mind: "We will not lie, cheat, or steal, nor tolerate those that do." I looked at the investigators, "I need you all to leave the room. I need to pray." "The truth will set you free" came into my head. They came back in, and I told them what happened, giving them all the evidence. I left the interrogation room and went into the Security Police Office. That's when I noticed things weren't right. The NCOs were acting funny toward me.

I went home and got the call that I needed to see a lawyer. [The airman] told OSI I forced myself upon him; the charges were sodomy. They wanted to throw the book at me. Long story short, I was dismissed from the Air Force and sentenced fifty days in military confinement. I admitted to homosexual activity. On my DD-214, it has "Dismissal, Conduct Unbecoming an Officer." It was hell. I even thought about taking my own life because I let down my family, I let down my father, I let down a lot of people. I felt I let down myself. I had my security police badge and my beret taken away; my top-secret clearance was taken away. Everything was stripped from me. It was in the *Stars and Stripes* newspaper. I started thinking, "Oh God, I'm just like any other black person now. Written up in the newspaper in a bad story." This country spent so much more money chasing after homosexuals than actually chasing after the people that were threats to this country. They were chasing fags.

I've come to terms with and learned a huge lesson. I've written to Randolph Air Force Base to have my discharge recharacterized. I want to be able to say, "Yes, I've served in the military, and I served honorably." I've told the truth. That's all I'm asking for is my second chance.

PAGE 113

VIRGIL RICHARD, AUSTIN, TX, 2010
BRIGADIER GENERAL, U.S. ARMY, 1959–1991

Retired. Came out publicly in 2003 on the tenth anniversary of
Don't Ask, Don't Tell

There was a defining moment in my military career that happened sometime around 1965 at Fort Rucker, Alabama, when I was the financial accounting officer. We were building up our military because of the Vietnam War and because of the need for helicopter pilots. I had to hire an accountant and the person who came in on the referral list was a black lady. And there weren't any blacks in my office, none. In fact there were no blacks in civil service in Fort Rucker, Alabama. But she was head and shoulders above everybody else and so I hired her.

I came to work one morning and the women in my office were all lined up outside my door and they read me the riot act, saying that she wasn't going to use the break room, she wasn't going to use the restroom, and she wasn't going to do this and she wasn't going to do that. I said, "I'm sorry, but you are mistaken, she's got as much right to do that as you do." "Well we'll just go to the next building." And they did for about a week. It was wintertime and the inconvenience of having to go to the next-door building to use the bathroom or the break room was more than they eventually wanted to accept. And so they broke down. They didn't have a warm and fuzzy relationship, but it was a tolerant relationship. That was only because I stuck to my guns. My mind was focused on something that I thought was right and that's been a part of who I am all my life. I remember thinking…I wonder what forces were at work that allows this to happen?

I certainly led a straight life, but there were a few times that I strayed. I wasn't happy with my sexual life because I just wasn't attracted to… I liked my wife, I respected her, but our relationship wasn't one of love. And that was missing in my life and it wasn't until I met a guy in 1994 that I finally experienced it. It made a difference in how happy I was. I was always focused on work when I was in the military and I didn't allow myself to enjoy life. I was respected by everybody and I would have lost that respect if I came out publicly. I guess it was about 2002 and Dickson Osbourne, who used to be the executive director of Servicemembers Legal Defense Network [SLDN], was told by a retired army chaplain that I was gay, in the closet. Dickson flew to Austin and met me here in my living room one day. He wanted me to join what was then called the Honorary Board of SLDN. He said, "It doesn't mean you are gay, because we have board members who are straight."

I agreed to serve on the board. Admiral Steinman and General Kerr and myself were the three flag officers on the board at that time. At one of the board meetings, Dickson said, "It's going to be ten years since DADT was enacted in 1993. I'd like to have some big event occur, and I think you all three should come out publicly and we can get it in the *New York Times* or *Washington Post*." We all hemmed and hawed about that and said no, we had to think about it.

I went to Sydney with David and went to the Gay Games and wound up seeing most of the games from the opening ceremony to the closing ceremony. The lives that I saw these gay athletes leading just so impressed me. There was an event, it was a marathon—and I could never finish the story without crying—but it ended up inside a stadium with a running track around it. They had to run around the track to get to the finish. The first person [crossed] the finish line; the audience stood and cheered and clapped—and the second person came, and the third person came, and the fourth person came, and [the audience] did the same thing. Then they just sat down and visited and whatever, and then nobody else came! But nothing went on for thirty minutes. And I thought, "What's going on?" Then all of a sudden into the stadium [pauses] comes this guy in a wheelchair. And he was the last person in the race to finish. But this is what got me: everybody in the stadium jumped up and started clapping and cheering, and I just couldn't believe it, that they had that much respect for him.

When I came back I called Dickson and said I am ready to come out. And coincidentally, the other two told him the same thing.

PAGE 115

221

KEVIN BRANNAMAN, SEATTLE, WA, 2011
SPECIALIST E-4, U.S. ARMY, 1978-1981

Cook. Sexually assaulted by drill sergeant during basic
training at Fort Jackson, South Carolina

I was born in November 1959 and raised in Mechanicsville, Iowa. My father was physically and mentally abusive; he had a drinking problem. He passed away when I was in the military. Around seventeen, I was having fantasies of sexual relationships—some days it'd be a guy, next day it would be a female—and then senior year, I had an experience with an older gentleman. After that, I pretty much knew I was gay. It was frightening because being gay was not easy. I'm lucky my family accepts; they don't question homosexuality.

My junior year felt lonely; it seemed I could not keep friends. Everything started to click senior year: started to make more friends, going to parties and having a good time, so I thought, "I don't want to go into the military," but I already raised my hand and swore that I would join. There was no way my family or I could afford college. They have a delayed entry program—you sign up when you're seventeen and when you graduate the following summer, you go into basic training. I made a three-year calendar and each day I marked off how many days I had left. I said, "I'll put in my three years. I'll do a good job. I'll do what I'm told to do. Three years isn't that long; should be a good experience."

Fort Jackson, South Carolina. Hotter than hell. They picked us up at the airport in this old beat-up, army-green school bus. Everybody had their heads shaved already. I had long hair. They started yelling. "Get in order." "Shut up." It was quite a eye-opening experience. You're being told how to act, what to say, what not to say, where to go, where to sleep, what to eat. A couple hours before that, I was a free man. I could think. I could eat whenever I wanted to. If you wanted to slouch and not stand up straight, I could do that. Now you have somebody ordering you to stand up straight, ordering attention or whatever.

Three weeks into basic training my drill sergeant came in around midnight and turned the lights on in the barracks. He screamed out, "Private Brannaman!" I was terrified. I was in my boxers. He ordered me to go outside and body crawl underneath the barracks. "There was rumors that Private Brannaman was calling his drill sergeant a stinking nigger." He ordered me to walk to the end of the sewage pipe and get down on my hands and knees. He had this red wrench to open up the pipe; sewage came out and dumped all over me. He put on surgical gloves and took the feces and toilet paper and forced them down my mouth and smeared it all over my face, "Now you know what a stinking nigger smells like." I was trying to get up while he was forcing me to eat the sewage and smearing it. He ended up tying my hands behind my back and proceeded to put his dick in my ass. He got off and I just laid there and was in total shock. Just can't believe what happened.

During that assault, I could see my fellow recruits lookin' out the window, watching and not saying anything. The drill sergeant cleaned up and said if I ever told anybody about this, "I'd kill you. I'd hunt you down and take your M16 and shoot you." He left and, I was laying there with my mouth open, sewage all over me. Three recruits came out, picked me up, took me into the shower, cleaned me up and put on a fresh pair of boxers and put me back to bed. There was no mention. Nothing. There was no sly remarks. No faggot remarks. There was no, "How ya doin'? You OK?" It was like nothing happened.

I figured if it happened to me, it happened more than once 'cause he felt very secure that he wasn't going to get caught. Everybody was terrified. I also feel that another soldier went through the same experience. The next morning, another drill sergeant woke us up. When we were in formation after breakfast, the drill sergeant that assaulted me showed up. I was scared to death. I didn't know what to say or how to act or… Should I say something? Should I go to the doctor's or medic's? He didn't say nothing. He didn't look at me. Later in the afternoon he looked me in the eyes and told me to give him twenty-five push-ups.

A couple days went by and memories started being… I kept pushing it down and pushing it down to the point where I didn't even remember it until 2010, when I tried to commit suicide and ended up in the hospital. All those memories came flooding back about the sexual assault that happened over thirty years ago in basic training.

It was always easy for me to get into a relationship, but I found myself being angry. Things set me off, small things, "Where'd you go? Why didn't you meet me at this time?" I mean very small things and I blew it out of proportion. Sometimes my anger got totally out of control to where I would trash the house, throw everything through the window, break plates and everything. Where'd that anger come from? I never really dealt with it.

I have Parkinson's and [have] been dealing with depression after the military. Being a veteran, you can get medical services and free medication. So, in February of 2010, I decided to go to the VA hospital in Seattle and see if I can sign up and get care there. When I walked through the front doors of the hospital, it was like a wave of big clouds [was] going to come down, sweep me up, and take me away. I was pushing memories and everything about the military out of my brain, pushing it way down somewhere in my body. The memory of being sexually assaulted didn't come up. My depression got worse. Anxiety got worse, especially in social situations. I was terrified, feeling shame. I was always thinking people were talking about me. "He's no good." "He's stupid." "He's ugly." Then, one night, my partner and I had a little argument; it blew up into a big fight. I told him I'm going to leave and I'm not coming back. I left in my truck and took some pills. That's when the flood of memories of the assault came out. It was pretty nasty and fucking hard. Luckily they found me asleep, still alive in the car.

I got scared and didn't want to deal with it. Smells will trigger my thought process or memory of that night and the drill sergeant who assaulted me. At first I thought it was about sex, but most rapes are about control. He had the power to control us, eighteen-year-olds, seventeen-year-olds. We were just kids, scared to death. I still have thoughts of suicide.

He fucked up my life. I realize more and more that I have not forgiven him. I'm still fucking pissed at him. I still have a lot of anger. I still have a hard time loving myself. Goes back to my father telling me to shut up, you're stupid, you're not a worthy human being. I don't even know how to describe it; it's just terrible. Being depressed and anxious is not a good mix with a relationship. I'm working with my therapist and psychiatrist to show compassion for myself, love myself. You are smart. You are handsome. You don't have to be shameful. You don't have to be fearful. It's a long process. It will always be there in my memory.

The smells, the brutal force. At some point you have to move on. 'Cause if you don't, your relationship's going to die, you're going to fear. Fear holds you back. And I hate that.

PAGE 116

MARTHA TAYLOR, ORLANDO, FLORIDA, 2011

FIRST LIEUTENANT, U.S. AIR FORCE, 1975–1980

Supply Operations Officer. Honorable discharge; forced out as a result of a witch-hunt

I was born in Orlando, Florida in 1950. Sports were my whole life... and books. I love books. I had crushes on my gym teachers. It wasn't a sexual thing. Even up until I was in college, I had no sexual feelings. I just was so involved in sports and books that there was nothing else. I went to Florida State University in 1968. I was a physical education major. There was a girl down the hall from me that I fell in love with. I still don't know if she was gay, but I did have a sexual relationship with her. When I graduated, she wrote me a letter and told me she could never see me again. That was my first broken heart.

After college, in 1975, I went in the Air Force. I enlisted because a recruiter told me it would be easier to go to Officer Training School [OTS]. I was going to be a welder. I got to basic training at Lackland Air Force Base in San Antonio and some guy decided that since I had a degree in recreation I should be a recreation specialist. Remember this is 1975 and there was still not a lot of women in the military. I was twenty-five, so I was a lot older than the other recruits. I knew I was attracted to women, but I was going to hide it. I wanted to be with a woman, and as long I stayed in the military, the worse it got.

After basic training, I got stationed across town in San Antonio at Randolph Air Force Base. People were going to these exotic places around the world and I had a bus ticket for five bucks to go across town. I met an officer that was really nice and he wanted me to run a camp for underprivileged kids on the base. He kept telling me I should go to OTS and put the paperwork in motion. I spent nine months in Okinawa and then was accepted to OTS back in San Antonio. I met a woman at OTS and fell in love. She went to Illinois and then got stationed in Okinawa. I got stationed in Minnesota, Duluth. She was the love of my life, and it drifted apart. From Duluth I went to Quebec in 1979. Quebec was a year tour. I was asked if I wanted to stay another tour and I said yes.

I wanted to be with a woman more than ever. I was so starved for attention that I let my emotions get the better of me. I met a Canadian enlisted woman and moved in with her off base. I used to go to the softball games downtown where gay women congregate. There was a civilian investigation of gay women from the local authorities. Apparently they told the Air Force what they were doing, and why. To this day, I don't know why they were investigating these women. They all named names. [The enlisted woman I was living with] was asked if I was gay, if I was her lover. And she said, "Yes." I asked her, "Why in the hell didn't you just lie?" She never had a really good answer.

I was guilty by association. The civilian authorities wanted a statement. So they came to the base and interviewed me in my old barracks room. I was scared to death

when they told me why. I didn't want to leave the military. I was hurt and angry and embarrassed. Everybody I knew in the detachment shunned me. They didn't even want to speak to me. They were my troops; these people were my friends.

The detachment commander, a colonel, came from Plattsburgh to start the paperwork for my court martial. He was homophobic and the way he talked to me was like I was scum. He waved a letter saying that I had been selected for promotion to captain and a regular commission: "You'll never see this. See what you lost." His whole attitude was really nasty. I talked to my commander and told him I wasn't gay and I wanted to know what this would do to my career if I went before the court martial and survived. He told me I would never advance beyond captain or major. It will always be a blemish on my file. I knew that I had nothing left. "Will you see that I get an honorable discharge?" He said yes. It doesn't say anything in my DD-214 that I was gay, but I have no benefits.

I processed out and went back to the officers' barracks. I stood by the dumpster and took off my uniform piece by piece, and threw it in until I was just in my underwear in the snow. I never wanted to see it again. That's the way it ended. I got a letter afterwards from the Air Force Reserve wanting to know what was my experience like in the military. I wrote on my form that I'd never ever defend my country again. I don't care if we went to war, I would never fight for my country because I am "less" than a person. I sent it back and I never heard anything from them again.

When I told my mom about [my sexuality] eight or nine years ago, I was fed up from hiding. I couldn't stand it anymore. She said, "God doesn't make mistakes," and it's never been discussed since. After my dad died in 1976, my sister moved in with my mom. I was in school and in the military since 1968 and didn't come home again until 1982. I worked at Disney until 2009, then made a mistake and lost my job; never found another. My mother has congestive heart failure and she's blind. [My sister] lost her pension in the stock market, so she had to go back to work. We all live together. Between what little I get on my pension, my mom's Social Security and what she makes, we scrape by. There's a lot of animosity because of having to take care of my mom. I haven't been in a relationship for a long while. Right now, life is just survival. Some days I wish I had a partner and my sister had someone to love besides me. But I don't see it happening.

PAGE 117

ANTHONY CHIFFOLO, HARTSDALE, NY, 2010
LIEUTENANT, U.S. NAVY, 1977–1997

Naval Flight Officer. Retired as lieutenant commander in the U.S. Naval Reserve

I grew up outside of Albany, New York. It was very sheltered; it was a bit isolated, it was very conservative. There was very little racial diversity or religious diversity. I recognized that I was attracted to boys, but I didn't really understand exactly what that meant—whether it was something that was a phase or something that was permanent; something that everybody went through or something that was…unusual. I didn't know any gay people, no adult gay people. I didn't know any kids who were gay, so it was hard to know anything. I didn't really know what to think.

I was conflicted sexually because I did not find girls attractive. So, I was not sexually active when I was a teenager, and I didn't envision anything except what I had been brought up with as an Italian Roman Catholic—you grow up, you get married, you have a family. That's what surrounded me, that's what I knew, so that's what I expected, and I didn't really know or I just couldn't imagine anything different.

At the age of seventeen, I went away to the Naval Academy in Annapolis, Maryland, and spent four years in that very intense environment. After graduation I went to Pensacola, Florida, for flight training. I qualified as a navy flight officer and ended up in an early warning plane and was sent to Norfolk for more training. I was in a squadron that deployed in the USS *John F. Kennedy* aircraft carrier. I made a couple of deployments in the 1980s and then left active duty and remained in the reserves.

When I was in the Navy there were men that I felt very attracted to, and not just physically but emotionally as well. I felt really connected. Of course it's kind of pointless because if they are straight they are not going to have that same response. And so it was very frustrating and I had to be very much on my guard. I had to suppress how I was feeling, especially when I was around other officers or other Navy folks because it just wasn't allowed. You were kicked out. That's all there is to it. That was impressed upon us from the very beginning. You kept it under wraps or you just didn't do anything. You could never be yourself; you could never feel comfortable. You could never just let loose. There was always that threat. It was always hanging over you.

I met a man my same age. He was an Army enlisted guy. I really felt the exhilaration. And I really felt like, oh my gosh, this is what it was supposed to be. And yet there was so much baggage that I was carrying, so much that I couldn't get rid of because I was an officer and he was not. I felt like it was double danger for me and it was still…the religion, the family, the whole thing. I just couldn't break away from the expectations or the values that I had grown up with. Unfortunately, I felt really bad about that because it was such a great experience and he was a really nice man. I wish that I would have been able to move forward at that time instead of moving backward, but I couldn't.

I really liked him and that wasn't the part that was hard. It was the other stuff, it was the fear, the risk I guess. And also, this was 1987. People were scared about HIV. And nobody really understood what it was or how it spread or anything. That was a part of it too. I was afraid. I felt really bad. I was just so unable to deal with it that I felt sick. He wanted to get together and I just said I can't, really, that I was not feeling well. And I just fell apart from there. I was really sad because I wasn't able to express myself to him and enjoy being with him as much as I felt the possibility. And I felt sad because I think that he didn't understand what was happening with me and so that was hurtful to him.

I deal with a lot of depression and so it's hard for me to feel happy—you know, bubbly type of thing. In a sense there's a certain level of contentment, of feeling comfortable in my skin, so to speak. But not fulfillment, because I haven't fulfilled whatever it is that I am supposed to do in this life, or my destiny or my purpose. I get some satisfaction from singing. I get some peace from yoga.

It's possible that I may have seen him in passing once, but I'm not sure. And then I did look for him online and I did find him and we did exchange a few emails, but that was it.

PAGE 119

BRIAN FRICKE, WASHINGTON, D.C., 2011
SERGEANT, U.S. MARINE CORPS, 2000-2005

Aviation Electrician. Operation Iraqi Freedom; honorable
discharge; did not reenlist because of (and to fight for the
repeal of) Don't Ask, Don't Tell

I was born in 1981 in Albany, Georgia. I knew that I was gay at age twelve. I was in
the closet the whole time I was growing up and quiet about who I was. I think it
evolved into not being able to talk about those feelings with anybody. I remember
prior to high school, having suicidal thoughts; I didn't think that I should be
happy—that you're not allowed to be happy, and you will not be able to have a
partner.

Knowing how fervently Christian my parents were, if I were to come out, they would
not love me anymore. That was how I thought at the time. I ended up joining the
Marines in 2000, after I graduated [high school] to prove that I'm a man and I can do
whatever challenges came.

I remember signing a piece of paper that explained Don't Ask, Don't Tell, but I don't
remember the content. I knew I could not be openly gay anyway, and now that I'm
joining the military, not much was changing for me. But there was indignation, You're
not going to tell me that I'm not allowed to serve in the military because I'm gay.
I'm going to prove to you I'm capable.

I joined in 2000 and went to boot camp. I met a guy through AOL. He was on another Navy
base. I didn't have a car, so I was stuck to Naval Air Station Pensacola. He could
come and go on base as he pleased. But there was a lot of fear. I think part of the
excitement is being afraid of being caught. Then I graduated in 2001 and went to the
Marine Corps Station New River in Jacksonville, North Carolina. I didn't have a car, so
I basically stuck to Naval Air Station Pensacola and had a relationship with a guy in
Goldsboro, North Carolina. Unfortunately I got stationed out in San Diego, California,
so he wasn't able to come and we broke it off. So, it was kind of business as usual as
far the military. I ended up leaving, going to San Diego, and that's actually the first
time I met Brad, my husband—the first time we laid eyes on each other.

I had to play the he/she game if I was going to go out. And that would bring you
back to reality. I felt conflicted because it is lying, but as humans, we rationalize
things. Lying conflicts with the core values that the Marine Corps teaches: honor,
courage, commitment. Marines never lie, cheat, or steal—they ingrained them in you, and
you were held to the highest standards of conduct and personal integrity. And I am
having to lie about who I am for fear I might get fired or beat up. So the rationale
was, these are the rules of the game. I know the rules of the game—I'll play by the
rules of the game.

In July of 2002, I was deployed to Okinawa, Japan. I threw myself into my work.
In the middle of this Americanized military zone you had this gay bar, a little

cross-section of Air Force, Army, Navy, Marines, this little oasis in the desert to meet people and not worry about being caught. We were in Okinawa for a full year. I returned from that deployment back to San Diego in July 2003. Brad had returned to San Diego from Paris. We were still in communication through email and chat. We saw each other on the dance floor at San Diego Pride in the summer and we were inseparable. At that point I'm on cloud nine.

In February of 2004, our unit got orders to mobilize and deploy to Al-Asad, Iraq. We were one of the first Marine units there. Brad drove me to the base. It was four in the morning, there were Marines everywhere loading up vehicles, saying good-bye to their girlfriends, their wives, their families, kissing them good-bye. I grabbed my bag in the backseat; he was in the driver's seat. I gave him a kiss, "I'll see you when I get back." I shut the door and he drove off. I went on into the squadron and didn't get to enjoy that departure like the other troops when they say good-bye to their girlfriends, their wives, and their husbands. It was one of the first times I felt really disenfranchised and robbed from the military because of Don't Ask, Don't Tell.

The whole time I was deployed, Brad was not able to get updates. He wasn't privy to those support structures. When I returned, we landed in Miramar on a commercial 747. I look out my window, and I remember seeing American flags and "Welcome Home!" signs, a huge crowd, and old friends and new babies, and husbands and wives and moms and dads and brothers and sisters. I just served with my unit, and my partner, the person who means everything to me, could not be in that crowd.

There were designated huggers to hug the single Marines. I didn't care. I cared about coming back home to Brad. I debarked the aircraft; we got in a squadron formation and our commanding officer dismissed us. I took a cab home.

I chose not to reenlist. I wanted to help change this law so that people don't have to feel that isolation and abandonment, and feel like they don't belong. That was the choice I felt I had.

PAGE 121

JOHN AFFUSO, NEWTONVILLE, MA, 2010
FIRST LIEUTENANT, NEW JERSEY ARMY NATIONAL GUARD, 1986–1990, AND U.S. ARMY RESERVE, 1990–1996

Signal Platoon Leader. Lawyer and civil rights activist; lobbied to repeal Don't Ask, Don't Tell

I was born in Hoboken, New Jersey, and grew up one town over in a blue-collar, middle-class family of police officers and firefighters. I was the first in my family to go to college. I knew I wanted to go to law school and work in government. I had a girlfriend in high school, but she lived fifty miles away, so that made it more convenient. There were guys in high school that I was attracted to, but there was no way I was going to act on it. I graduated in '85 and applied for an ROTC scholarship to help pay for college, but my left eye is 20/40 so I wasn't eligible. I enlisted in the New Jersey Army National Guard, went to basic training at Fort Benning my sophomore year, and then was in the Army ROTC at Rutgers for the rest of college.

I took a year off between college and law school because I had to do my six months of Signal Officer Basic Course at Fort Gordon. On the weekend I'd go for long walks on the trails in the woods behind our quarters. I would expend energy worrying about whether someone was going to figure me out. You had to compartmentalize things, and that affects your ability to be close with folks in your unit because you're withholding information.

I wanted to go to Atlanta to go out, but in my mind, I couldn't do that. It was pre-Don't Ask, Don't Tell; they would actually send [officers] to bars finding people on witch-hunts. The chances of being found out were probably slim to none, but that was just not an option. If I get caught, I'm going to get thrown out. I'm going to have to explain to my parents why I got thrown out, which means I have to come out, and I was nowhere near ready to do that. The best thing to do is keep your head down and do your job. Put the blinders on and try to not think about it.

When I came to law school, the National Guard transferred me to Army Reserve. When I left my unit, my motor sergeant told me that I was one of the few lieutenants that he ever liked, and that meant a lot to me. "I've seen a lot of really bad lieutenants and you're not one of them. You get it. You're around and you know. You check on the guys. I see people leave this unit all the time and they might as well be invisible because nobody says, 'Hi.' Nobody says, 'How you doing?' Nobody says, 'What are you doing?'"

If I had gone to law school in New Jersey, I would have remained in my Guard unit. I don't know where that would have led. I was trying to get a couple hundred miles away so that I could come out. The three hundred miles between Boston and New Jersey seemed appropriate. In my first year of law school I started coming out to people, and in 1994, I became the mayor's liaison to the gay community for Boston. So clearly, I wasn't going to be in any military capacity once I took that job.

I [served] under the predecessor to Don't Ask, Don't Tell. The tail end of my time [was] when the policy got put into place. It's seventeen years later and over 14,000 people have been discharged. The policy has been wrong the entire time. I have an obligation to people who can't speak up and who are getting kicked out and mistreated. I intend to keep working for the repeal. My last military mission is to be rid of this policy.

I went to Lobby Day [in Washington, D.C.], and one of the things I experienced was the bond; we had a couple hundred gay and lesbian vets who had the commonality of military service. It was the first time I was with that many who had that same experience, and I found it to be far more powerful than I anticipated. I met all these wonderful folks working for the same thing and it strengthened my resolve to speak out. I continued to lobby my senator because I felt more strongly than ever that I needed to keep staying involved in this issue.

The opponents [of the repeal of DADT] underestimate the ability of the military to put policy into action. An order comes down; they'll do some training. Soldiers want to do their job, focus on their mission, and not be terrified if someone's going to find them out. The ironic part is expending that mental energy worrying about getting caught or acting in any way that someone could suspect you're gay. That takes away from what really you should be completely focused on, your mission.

PAGE 123

COREY SANBORN, BOSTON, MA, 2011
CORPORAL, U.S. MARINE CORPS RESERVE, 1996-2004

Machine Gunner. Deployed to Okinawa and Philippines; deflected accusations of being gay; suffering from PTSD

I think I always felt different growing up. I wasn't compelled to do what everyone else was doing. I used to lock myself in my room and listen to the radio. I wasn't interested in sports or playing with other kids. I guess I was a lonely kid, but I was OK with it. When there were group activities, I would hang with the girls, because that seemed more fun. I remember when I started noticing feelings about men: being around my older brother's friends. That fascinated me—the way guys were with each other.

I didn't want people to know me because I didn't want them to find out what I was realizing about myself. So I didn't hang out after school. I didn't go to parties because I wasn't invited; I wasn't one of the cool kids. I was called "fag," but I was never pushed into lockers, never roughed up. I used to dread going to school. Why did I have to go to that place and see those people? I was ready to be in an environment where I could breathe. While still in high school, I got a job at a local radio station that played dance music. There were lots of gay folks there; it was the perfect place for me. There were guys like me that could see what I was going through and made it OK for me to finally say the words. They would tease me. I resisted at first, but I was staring at acceptance. Then I came out to my high school guidance counselor and I felt free afterward.

Once I got to college, and was around kids in performing arts school, I knew I wasn't alone. I didn't need to hide. When I went home to visit [my parents], many times the words were coming and I just couldn't say it. I didn't feel it would be well received. And when I came out to them, it was everything I feared. My dad's always been stoic. My mom had a meltdown. I was forbidden to tell my siblings. My brother was engaged at the time, and my mom said, "You can't tell your brother because his fiancée will leave him." I was in an apartment that they were paying for. They decided to stop and threatened not to send me back to college. They only agreed to keep paying under the conditions that I keep going to school and live in their house and change. They made me go to a therapist. I commuted to school my sophomore year and put up a front. I found every reason to stay overnight at school so I didn't have to be home. Then they let me move back into Boston the following summer between my sophomore and junior year and I graduated in 1994.

I was twenty-two and didn't know what I wanted to do. I was looking for a challenge. The Marines were the most elite. I arrived at a recruiting station and met with the staff sergeant. "I want to be a Marine. I want to be in infantry." The recruiter saw my transcript from college and my entrance exam score. "What do you want to do in the military? You can have any job." I said, "I don't want to sit at a desk. I want to learn how to kill people!" "OK! It's infantry, I guess!" I ended up a machine gunner and I was psyched about it.

After boot camp, I went to the School of Infantry at Camp Geiger in Jacksonville, North Carolina. I did not have any intention of telling anyone anything about being gay. I knew there was a lot of talk about me, and it was getting under my skin. No one ever got in my face about it because I was good at what I did. One day I went out with my buddies. We got pretty buzzed and got back to the barracks. This sergeant was asking where one particular guy was, and I said, "I think he's here." It was the first time he'd heard me speak. He looked at me really strange, "Are you gay?" I fucking lost it. I blew up. I had a magazine in my hand and I threw it across the squad bay. I said, "That is FUCKING it, I am sick of it." I stormed out of the barracks, went outside, and just sat. I kept thinking, "Don't lose it." When I went back in, the sergeant asked me to his office and said, "I'm gonna overlook the fact that you swore at me. If you are, you know that the military has a policy where you can't be." I said, "You want to know? Yeah, I am. But I'm here to train, I'm a good Marine." He didn't know what to do. "I'm not going to mention this. Go back, and we'll forget about this." I was miserable. Two days before graduation, I was called into a room with every higher-up in the company. I sat down and the first sergeant did all the talking.

"It's come to our attention that you had spoken to a sergeant, and he asked you if you were…homosexual, and you indicated that you were." He started reading me my rights. I was so confused, "Am I under arrest?" He repeated himself and I said, "I had plenty to drink, and I can't recall the conversation. So if that's what he told you, I can't say whether that's true or not." He asked me, "Are you a homosexual?" I said, "Can you do that?" And he said, "I'm asking you that." I said, "Since you're asking me, I'm telling you no, I'm not. I wouldn't be here. I came here to train." I was dismissed and returned to duty.

I graduated, made it home, got released to my unit, completed my fours years, and was released to Inactive Ready Reserve. Shortly after September 11, I started feeling a lot of guilt. When my reserve unit was called up, I had a meltdown. I couldn't sleep. I couldn't eat. So in 2003, I joined my unit down in Camp Lejeune. A good number of my buddies had left the military or were in different units. Then word was some higher-up delayed our medical immunizations so we weren't ready to go [to Iraq]; another unit got the slot.

When we got back home we were welcomed like heroes. None of us felt like heroes—we didn't do anything to deserve it. My contract officially ended in March of 2004.

It's a mixed blessing I did not make it to Iraq. I am alive and didn't have to deal with any aftermath. But I think I'm always going to wish I was back in. I don't know how anyone walks away feeling satisfied, "I did enough. I did my part." Mostly I beat myself up thinking, "Chickenshit, why did you walk away?" Some things always have me on alert. I'm always looking for kill points on people when I look at them. I'm always sitting on an aisle seat on a plane in case someone's going to do something. I'm always looking for emergency exits in public places in case something happens and I have to usher these people out. I don't walk down the street with both hands in my pockets so no one can surprise me. I don't know what's going to make me feel satisfied. I'm seeing a therapist right now to work through feelings of inadequacy and failure for not having been to war. Maybe I'm always on alert looking for a real-life situation to prove myself, like busting up a robbery at a convenience store or something.

———————

PAGE 125

234

DON BRAMER, WASHINGTON, D.C., 2011
LIEUTENANT O-3, U.S. NAVY, 2002-PRESENT

Intelligence Officer. Top-secret security clearance; multiple deployments to the Middle East; numerous medals and commendations from combat operations; provided anonymous testimony during the hearings to repeal Don't Ask, Don't Tell

I deploy with the Special Warfare Community as an intelligence officer. My job is sitting down with the bad guy and having a conversation to gather information. You learn to talk to people, and you learn how to engage and participate in all sorts of cultures. I found hiding my own sexuality prepped me for this. "OK, you need to learn to be somebody else? Great! I've been doing that all my life."

I'm like everybody else. I have a job. I have a career. I want the same things: a home, family, everything else. I'm not any different. I never did let being gay become an issue, because I think that who I love really doesn't play any part in the rest of my life. While I did not agree with Don't Ask, Don't Tell, that was a sacrifice that I was willing to make. If so many other people can sacrifice so much, including their lives, then I can sacrifice this part of me that identified as being gay. But it really touched home with me when I was deployed. I felt like I was living three lives… There was me, there was the person I had to be in order to conform within the military, and then now, all of a sudden, because of my career path, I had to create another identity. You come back and it's harder to figure out who the fuck you are.

Through two of those deployments, I was in a relationship. A lot of people [were] getting discharged, so my partner and I learned our own coding system. We would write, but we never signed a letter. We developed symbols that only we knew what they meant. You can't share this most intimate part of yourself with friends who you're extremely close to and would die for. And they're talking about their plans. "Hey, when we get home, are you going on vacation? Are you going to do this?" And they're talking about their wives, their kids, families, and you can't do that. You learn how to refer to your partner in opposite pronouns. He becomes she. You create a name for them because you want to share these things about your life, but you got to protect yourself and protect that person. Michael now is Michelle. My partner had it easy: instead of being Don, I became Dawn.

In a lot of ways I blame the policy for ending my relationship. [My partner] would not go to therapy because he was so afraid of anything that would come out during his sessions would be releasable to his chain of command and that would end his career. I saw a stellar soldier deteriorate before my eyes. Quit working out. Lost all intimacy. Because of the stigma associated with [PTSD] and because of his sexuality, his coping mechanism was through food and acting out sexually to a point where it caused him to become [HIV] positive, which led to our breakup. After that, I had another deployment, and I came back and had the same, similar thought process. I don't want to seek military means because I don't want to ruin my career. I don't want it on my clearance. But, I knew that it was affecting my life. I knew that

it was affecting my relationship with my friends and my peers and other dating relationships I tried to get into.

Because you've lived so many years in other identities, you've got this internal struggle. It was just building up, building up, building up… A lot of it is still a blur. I came home one night, sat on the front porch, fired up a cigar and made a drink. I basically killed a bottle of bourbon. I sent a friend of mine a text: "You probably need to come over." I was checking out. A lot of the guilt for things you do in combat all surfaced. I can't have a great relationship and I have nightmares and demons. "I'm done, I'm tired. I just can't do this." He tackled me and took every weapon I had away from me. The next day, I called one of my best friends. Through his help, I found somebody who helped people come out of their ulterior identity and had dealt with gay issues before for law enforcement. So, we began that very painful process. He had a guerilla-style therapy; for six months it was three or four nights a week and most nights were with written homework. My last session was the week before my commissioning ceremony. I went in and said I got my speech done, so I read it to him and he just looked at me and smiled and said, "This is your graduation ceremony. We're done." Through that I started doing my volunteer work with homeless veterans, helping them with their PTSD issues; that was my way of taking the bad part and doing something good with it.

PAGES 33, 127

TIM THOMAS, DOUGLASVILLE, GA, 2012
U.S. NAVY, 1981-1985

I was born in November of 1962 at Georgia Baptist Hospital in Atlanta and grew up in Douglasville. I've only moved across the street, regarding my home place, where I was raised. Everybody up the road knows my whole family because of us all living together on the street. But it seems as though, in little ways, that people tend not to visit with you or come around as often because of you being gay. I see myself as being gay more so than bisexual. I fought with that a good bit. I had always been led to believe there's abomination of mankind. I finally come to terms with that. Although I do believe in the good in the Bible, the Bible was a history book. The Bible is knowledge of mankind and its beliefs. But, you can't let the Bible be the leader, because you don't know what interpretations are really meant to be.

I had a friend that I had had a relationship with and nobody ever knew it. We did things, but never did we take it to the extreme that we was callin' ourselves boyfriends. I was about fourteen. It was a touchy relationship. Then he died; he drowned in a lake. I wish I had been there. I never realized he couldn't swim till I heard that he died. But it affected me because I didn't want him to be shunned or looked at by the Church in a bad light. People would say "fag" and "homo" and things like that. You learn to brush 'em off and walk away like it don't bother you, although it does, and did at the time. I never took it upon myself to talk to anybody about it.

You know when a child is molested, they don't say anything, in fear of others knowing. I never felt as though I was trapped or made to do anything. They were boys, too, probably about six, eight, and twelve. Their father was a preacher. I don't know what transpired in their own lives that would've brought this knowledge to them. But they are the ones that instigated it. Molestation is a weird thing. It's a mixture of emotions.

I joined [the Navy] in 1981. I had gotten my GED and then I went into the military in May of '82. I was in almost four years. I forget what I wrote down [to the question on homosexuality]; I probably lied and put no. I wanted to begin a career and I wanted to get my parents' good expectations of myself. I just wanted to be the best young man, soldier, or good son that a parent could have. I felt proud to serve my country. I was attracted to guys, but I wouldn't do anything in fear of reprimand or embarrassment by my family or the community. It's kinda like I was tied to a railroad track in a way.

I haven't had any serious relationships with anyone. I regret the fact that there were several guys that I would love to have relationships with. And I kinda resent that in some respect, 'cause who knows [how] the cards would've fell. It has nothin' to do with bein' in the Navy or in the Marines or the Army or the Air Force. It has to do with us as persons as a whole. After several experiences, [intimacy] can damage a person as well. You don't wanna let someone get that close to you. They all seem to think that just because you are gay, that you just do it with anyone. We all know that's not the case. It's hard to rationalize feelings when you know that probably deep down they still have the feelings they've always thought. And they're just sayin' this—whatever—to comfort you.

PAGES 32

GREER PUCKETT, SAN JOSE, CA, 2010
LIEUTENANT JG, U.S. NAVY, 1971-1978

Deck Division Officer. Honorable discharge; brought under
investigation and forced to resign on charges of homosexuality by
an enlisted man, who had heard rumors he was gay

I was born in 1952 in Oak Ridge, Tennessee, a town used by the Manhattan Project during
World War II. My parents were very patriotic with conservative values. When I was ten or
eleven years old, I became interested in military things, and in high school I decided I
wanted to go to West Point. I applied in junior year and was given a principal nomination
from my congressman. I couldn't admit to myself at the time that I was gay. I was going to
be straight, and I was going to get married and live a life in the military.

July 1970 was my plebe summer. I didn't really understand the rigors. As plebes, you
had to [follow orders from] members of all upper classes and perform duties for
them along with all the studies you had to do. I'm not sure I was really succeeding,
but at least I was working, trying to get along. Then one cold day in November, while
standing in formation, one of the second-class cadets asked when I had last shined
my shoes. I said, "Sir, yesterday." I wasn't telling the truth. This cadet was not
fond of me for some reason. He was harassing me and I didn't want to get berated
again. I came back to my room, and told my roommate that I had lied. My roommate now
had to turn me in, or he, too, has committed an offense. So I walked down the hall to
the company honor representative's room, and I told them that I had told a lie about
shining my shoes. The company honor rep decided to tell the brigade honor rep that I
had committed this offense.

I found out within a couple of days that I was going to have to go to the cadet
honor court, where [other cadets] actually try you in court. I was sitting outside
the door with my counsel while the cadets in this large room talked about the
case. They brought me in and asked me questions about what had occurred. I told
them what had happened. I don't think I was in that room more than fifteen minutes.
I went outside the room and after a few minutes, they made a vote. As each one
said "Guilty," my head sank lower. They called me back in and told me I was going
to be separated from West Point. I called my parents and told them what happened;
I was devastated, but they were supportive. I flew back home; my parents picked me
up at the airport and told me they contacted my congressman. They were trying to
get me reinstated. I was interviewed in newspapers, on television, even *NBC Nightly
News*. West Point still denied my entry. My congressman then gave me a principal
nomination to the U.S. Naval Academy. I entered the Academy in 1971 and graduated
in 1975 as a commissioned ensign in the Navy. While at the Academy, I started
reconciling myself with who I really was.

In February of 1977, I was transferred to the USS *Cleveland* in Long Beach, California.
I made lieutenant JG [junior grade], and felt like I could keep this life that I
had as a gay person separate from my navy officer life. A couple of my navy officer
friends knew I was gay, and even knew my lover. I thought I was going to do OK.

I was in charge of thirty young sailors. Late that summer, one sailor told me he'd heard a rumor that I was gay. I said, "I don't know what you've heard. It doesn't matter what you've heard. I expect you to do your job according to Navy regulations, and if you don't do your job, you will then pay for it with a trip to the captain's mast," I wasn't going to be bullied by some young sailor. This sailor was getting in trouble a lot. One day, he was late to work and my leading petty officer came up to me and said this sailor needs to go to captain's mast. About a week later, they would hold captain's mast in the admiral's bridge on my ship. We were waiting in line and the recording person came out saying that this individual had asked for a "closed mast." I knew right then he was going to turn me in. I turned to my leading petty officer and said, "In two weeks, I'll be off this ship, and in four months, I'll be out of the Navy."

That kid did turn me in. I was absolutely devastated. My career was going to end again! First West Point, and now, the Navy! I didn't want the Naval Investigative Service [NIS] chasing me around. Even if they could never find anything on me, there was always going to be suspicion. I wasn't going to get anywhere in the Navy. I knocked on the captain's door. "Sir, I know that I'm being followed by the NIS. I'd like to get out of the Navy [with an honorable discharge], and if you don't, then I'll fight." I wanted it to all be over with—and go on with my life. We went out to sea that week. We got back into port and I was [transferred] off the ship. Usually, when you leave a ship, they give you a hail and farewell party. All I got was, "Request to leave ship, Sir!" and then away I went and never went back. I was transferred to the crew of an amphibious ship for the next few months; it was a nightmare. I was sent to a small desk in the back of this building to make copies. Here I was, a lieutenant JG of the United States Navy.

Sure enough, the NIS brought me in and treated me like I was some kind of criminal. "Who do you know that's homosexual? Do you know any other people on your ship that are homosexual?" I just said, "On the advice of counsel, I've been told to say nothing." I said that to every single question they asked. About a week later, I received word that I was going to get an honorable discharge, and I was going to be leaving the Navy. I remember walking over to the admin area, and signing a few papers and walking off the base. Somebody saluted me, and I said, "You don't have to salute me anymore, I've just been kicked [out of] the Navy." I never had the same relationship with my parents after that. I told them the day I came back from the NIS interview. It was the worst phone call I'd ever had in my life, even worse than the night I got kicked out of West Point. I had been forced to leave the Navy because I was gay. And from that point on, I never had the same relationship. I had no job, no prospect for a job, bills I owe on the car, and not a lot of money. I didn't have much of anything.

The person that turned me in was found guilty that day. He went from seaman to seaman apprentice and put on restriction. He was transferred off the ship, because they didn't want him to be around me. I was kicked out of the Navy and my life ruined for that! I was twenty-five at the time, and he was probably nineteen or twenty. I was doing my job. I didn't hold good feelings for him for a long time. And now, I don't think about it too much because I've done OK. He was from Texas and he lives in Texas still; I found him on Google. I don't know why I looked him up. It doesn't matter; I'm never going to contact him. I don't ever really want to know what he's doing. I don't care. But for some reason I felt compelled to look.

PAGE 35

EPILOGUE

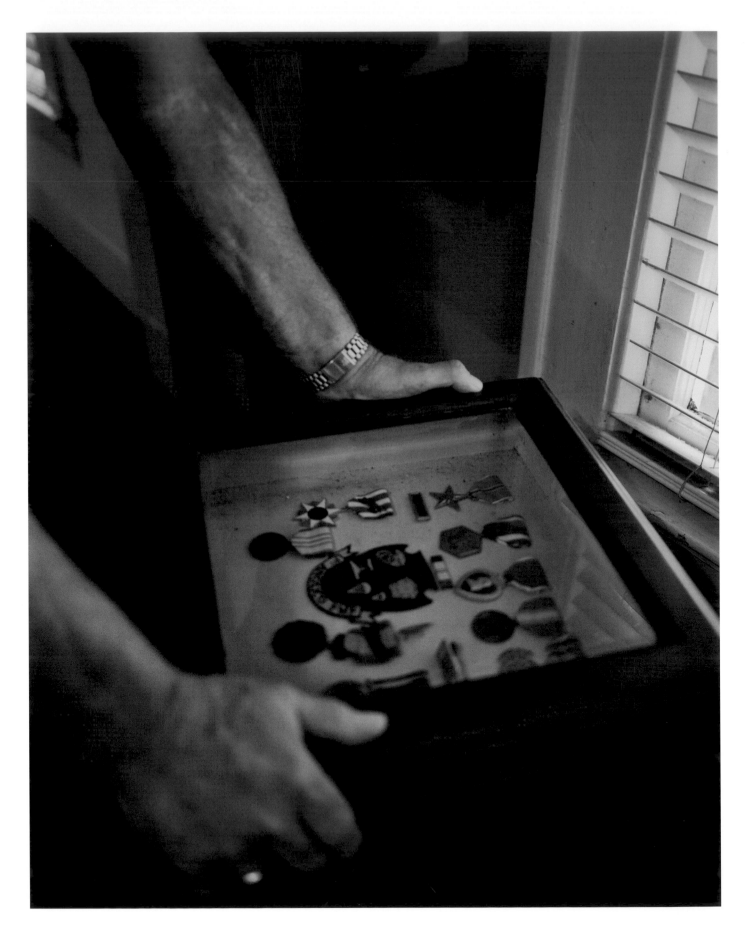

The Secretary of the Navy takes pleasure in presenting the NAVY COMMENDATION MEDAL to

CORPORAL BERT L. BARES

UNITED STATES MARINE CORPS

for service as set forth in the following

CITATION:

"For meritorious service while serving as a Shore Fire Control Party Man and Aerial Observer with Sub Unit One, First Air and Naval Gunfire Liaison Company in connection with operations against the enemy in the Republic of Vietnam from 14 July 1967 to 13 April 1968. During this period, Corporal BARES performed his duties in an exceptionally competent manner. Although not formally trained, he quickly acquired a superb knowledge of planning, coordinating and adjusting naval gunfire and displayed outstanding proficiency as both a Ground and Aerial Observer. His familiarity with the technique of fire procedures enabled him on occasions when naval gunfire was not available to adjust Army artillery fire on enemy positions. On the occasions when his team officer was absent, he efficiently performed advisory duties at division Combat Operations Centers, consistently providing outstanding support to the United States Army Americal Division and subsequently to the First Air Cavalry Division. Throughout the Tet Offensive, he skillfully assisted in planning and adjusting supporting arms fires for a total of thirteen naval ships, which materially contributed to the defeat of the enemy. By his tireless initiative, outstanding professional skill and unswerving devotion to duty throughout, Corporal BARES inspired all who observed him and upheld the finest traditions of the Marine Corps and of the United States Naval Service."

Corporal BARES is authorized to wear the Combat "V".

FOR THE SECRETARY OF THE NAVY,

H. W. Buse jr

H. W. BUSE, JR.
LIEUTENANT GENERAL, U. S. MARINE CORPS
COMMANDING GENERAL, FLEET MARINE FORCE, PACIFIC

"All human beings are born free and equal in dignity and rights. They are endowed with reason and conscience and should act towards one another in a spirit of brotherhood."

—UN General Assembly, Universal Declaration of Human Rights, 10 December 1948. 217 A (III), Article 1.

GAYS IN THE MILITARY

Vincent Cianni

What if you had to remain invisible, could not speak of your loved one, had to lie about what you did last night? What if you had to suppress feelings of loneliness, fear, betrayal, joy, or anger? What if you questioned your integrity after you took an oath of honor? What if you were required to be celibate, were interrogated, ridiculed, and called derogatory names? What if you had to tolerate hatred directed toward others who were like you? What if you could not confide in anyone or seek support in traumatic situations—personal or work-related? What if your civil rights were stripped away? What if you had no legal rights? What if your dignity was violated? What if you were treated in a manner that was less than human? What if it was necessary to pretend to be someone you were not, or to do things you did not want to do? What if you could not tell anyone who you really were, could not disclose your sexuality? What if you were tortured, beaten, or killed because of whom you loved? What if you were gay or lesbian?

The portraits and testimonies in this book bear witness to what are ultimately vague and complex questions. Why would LGBT (lesbian, gay, bisexual, and transgender) men and women enter the military, an organization that shuns them? To what extent must they assert or compromise their political beliefs and moral principles to serve their country—to defend liberty, justice, and the greater good; to protect the vulnerable, oppressed, and victimized; to inflict harm on the enemy; or for a job and economic security—and at what personal cost? How much does an individual sacrifice and how much power does an individual relinquish to such an organization (or to a cause)?

What are the benefits that we civilians—onlookers and outsiders, critics and supporters of our country's military policies—receive? What battles are just? What wars are just? What military is just or has integrity?

These are questions I was asking myself when I embarked on a project to investigate these people's lives—lives about which I knew very little. I seemed to spend most of my life uninterested in knowing because I believed in peace and the struggle to end violence and injustice. I refused to support wars that were fought for economic and political gain. I could not support an organization that I felt trampled on human rights and human dignity, that waged war on and killed innocent people. I believed my inaction demonstrated somehow that I was more humane and, therefore, also more human.

When I first heard the mother of Nathanael Bodon (page 43), who had been discharged while serving in Iraq because he was gay, speak about him so proudly and so lovingly, I was moved in a way that I never thought possible. I recognized my inability—or was it a stubbornness?—to remain open-minded while still maintaining my ethical, moral, and political beliefs. I first turned to the facts. War has been waged for millennia, both justly and without any justifiable reason. (What is just in the eyes of one nationality,

religion, ethnic group, or military is, more often than not, unjust in the eyes of its enemy. Conversely, what is unjust in war perhaps can never be considered justifiable.) As an observer, a visual anthropologist, a documentary photographer, and a storyteller, I realized that no matter what my personal experience and principles were, these were the experiences and stories of people who were denied their civil rights and, in many cases, were subjected to unfair and unwarranted treatment and human rights abuses. As someone who is part of a community that continues to struggle for equality, I could not turn my back on its humanity. I could not turn a blind eye to a community that I felt I belonged to in some way. And I could not disregard a history that is part of our history as a political community and our history as a nation. How can the rights of one be denied while the rights of others are preserved?

One may argue that, by its very nature, the right to choose to join the military and fight to preserve democracy and liberty denies the rights and dignity of others by supporting the notion of organized and calculated killing. However, as stated by many of the people I interviewed, particularly enlisted service members, going to war and killing were not part of their decisions to join the military. Serving their country, job and career opportunities, education, and personal growth were more common reasons stated. Nancy Russell suggests, "Very few people would tell me that they were there because they like to kill people; that just isn't the reason why they go in. They are patriotic, they love their country, and they want to serve their country. And it's when the politicians tell them they have to go to war that they have to make that choice to kill in order to protect

their country. They really and truly want to create and keep the peace."

The photographs in this book evoke an understanding of their humanity, their strengths and their weaknesses, and possibly our role as complicit observers in their histories. The testimonies provide us with facts of the economic, emotional, and psychological effects they have experienced in their careers and lives as a result of harassment and discrimination based on sexual preference.

In many cases the men and women that I photographed and interviewed were highly skilled, well educated, patriotic, courageous, and productive; they attained high rank, received numerous medals, and held top-level jobs that were essential to the military. Over the decades, the ban against homosexuals compromised the civil rights of a significant portion of the military—over 14,000 LGBT service members under Don't Ask, Don't Tell alone—and resulted in discharges that cost the armed forces and the American taxpayer billions of dollars. The ban also penalized and prohibited many of these veterans from receiving an honorable discharge, thus denying the benefits due to them for their service to their country. Yet, these service members suffered the same medical, physical, and psychological consequences of serving. And the stigma attached to these discharges oftentimes brought worse repercussions in civilian life, where it prevented many from securing employment that matched their skills and education and "outed" them before they were emotionally or socially ready to do so.

From November 2009 to June 2013, I traveled the United States recording oral histories and making portraits of approximately 100 gay and lesbian veterans and active-duty service

members who recounted the effects that the ban on homosexuals had on their careers in the armed forces and their lives afterward. I remember asking myself, why would they want to open up and disclose the intimate details of their experiences to someone they have never met? The effort to gain their trust was a delicate process, and the resolve to achieve it proved to be fruitful in many ways, particularly on a personal level. I walked into their homes and entered their lives as a stranger, mindful of my role as a photographer and aware of the responsibility they implicitly placed in me as a caretaker and guardian of their humanity. They related stories and recollected memories that were oftentimes difficult and harsh, sometimes violent and degrading; at times they revisited a past that they had forgotten or chose not to remember. I became both their confessor and confidant—and at times their friend. I remember leaving each time as emotionally drained as they were. And many times I was moved to tears while sitting in my car with their words and voices still fresh in my mind, recognizing how horrible some of their experiences had been and what personal sacrifices had been made. But most of all, the invisibility that they endured, the capacity to love and the need to be loved that slipped through their fingers or was never consummated because they had to hide, not only from the military but also from family and friends, and from religious and political turpitude. Their memories were all they could regain from what was lost or missing in their lives while serving in the military.

For the most part, the photographs—exposed on analog film—were made after the interviews were conducted, so we had already created our own brief history of intimacy and vulnerability.

We shared each other's humanity. The act of photographing served as an exchange of the implicit trust we placed in each other. I gained a greater sense of responsibility to protect their dignity, and they placed intrinsic faith in me that the latent image and recorded words—both as concealed as they once were—would reveal their faces and stories honestly and openly and would, in a sense, validate what they struggled to achieve.

The veterans and service members came from diverse socioeconomic, ethnic, and racial backgrounds and from all ranks in the military. The stories are different in every instance, but they have a common element: they relay how each of these men and women were stripped of their rights and at times suffered human indignities because of whom they loved. And although I would not choose to enter the military or choose to go to war myself, meeting these service members has opened my eyes to the reasons why they chose to do so. I hope these photographs and interviews honor their lives and their service to their country and stand as a testament to the indignities they endured at a time when it was not acceptable to be gay in the military.

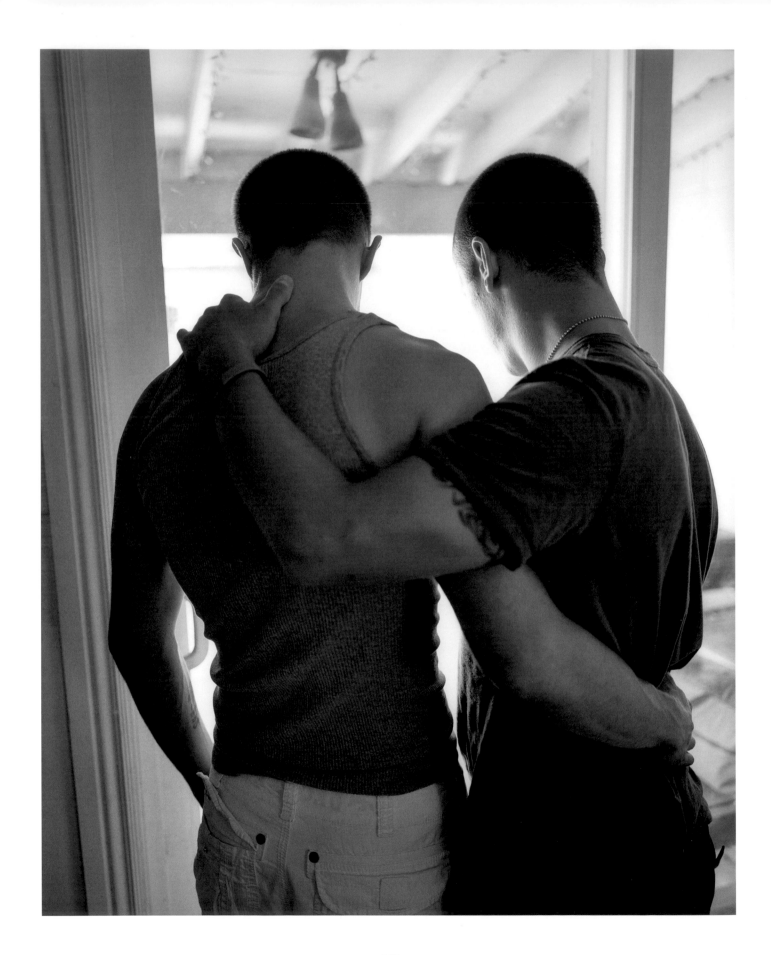

ACKNOWLEDGMENTS

First and foremost, I wish to thank Mary Cianni and Richard Caputo for their extraordinary support for the publication of *Gays in the Military*.

A Very Special Thank You:

Gay Block, Candace Gaudiani, Joan Morgenstern, Anatole Pohorilenko, and Alison Rossiter

A Special Thank You:

Thomas Adams, Martin McNamara, Ed Osowski, Joseph Scott, and Robert Venuti

Thank you:

Geoffrey Biddle, Dennis Grousosky, W.M. Hunt, and Suzanne and Roy Vollmer

Julie Begley, Yvonne Bisbee, Judy Murray, Jase Daniels, Ben Gondron, Bob Gross, Keith Kerr, Erica Lansner, Bill Mindlin, Dorothy O'Beirne, Malte Schutz and Kermit Berg, Tim Robbins, Mary Roman, Alan Steinman, Barbara Tannenbaum, Maria Nardone, Anne Tucker/MFAH, Frances Cianni, and Louis Cable Cianni

I am deeply grateful to Angela Cino for the countless hours devoted to transcribing interviews and her continued dedication to the project. To Anthony Brickner, Chris Haney, and Matthew Weinberg for their tireless and enthusiastic commitment as interns. And to Anthony Bui, Amber Pollack, Andrew Williams, and Monica Terrero for their additional assistance.

Thank you to Alison Nordström, Don Bramer, and Alan Steinman for their insightful and fervent essays. To Mike Itkoff and Taj Forer for recognizing the importance and impact of the publication, and to Ursula Damm for conveying the heart and soul of the project through her design. To Chris Allan of Bridge Photographic for his invaluable contribution in producing the scans for reproduction and making them come alive. Thank you to Laura Fredrickson for her copyediting proficiency. My appreciation to Stephen Mayes, Susan Hartman, Stacey Tesseyman, and Ed Osowski for their additional editing of the photographs and text. To Stephen Daiter and Paul Berlanga, of Stephen Daiter Gallery, and Stephanie Heinman and Sabine Meyer, of Fovea Exhibitions, who first exhibited the work. To Craig Breadon and Kirston Johnson, of the Rubenstein Library at Duke University, and Anatole Pohorilenko, for coming to the rescue of the audio files when technical problems arose.

Thank you to Antonio Laudermilch for accompanying me on the road trips and assisting me in the photographing and interviewing, and to Nancy Martin, Michael Calogero, Charles Maxwell, Duane Peal, Ed Osowski, Lucretia Carney, Anthony Loverde, David Waller, Kirk Baxter, Vicki Topaz, Radek Skrivanek, and the many hotels and motels across America for providing a comfortable bed and respite along the way. This project would not have been possible without the backing of the many Kickstarter supporters of *Gays in the Military*, The New School, and the Palm Center—and the assistance of Talking Eyes Media. Finally, to Michael Schreier for his early support of the project and to John Affuso for that pivotal $2!

This project would not be possible without the courage, frankness, and generosity of the veterans and service members who chose to tell their stories. This is for you and thousands of others.

In memory of Bert Bares, Will Chandlee, Virgil Richard, and Henry Thomas, who have left before being able to experience this acknowledgment and affirmation of their service.

D

10 YEAR
ANNIVERSARY

Cofounders: Taj Forer and Michael Itkoff

Design: Ursula Damm

Copyediting: Laura Fredrickson

1st edition, 2nd printing 2014

ISBN 978-0-9889831-5-1

Printed in China

Daylight Books

E-mail: info@daylightbooks.org

Web: www.daylightbooks.org